JohnPaulJones

THE PURSUIT OF BEAUTY'S PERFECT PROOF

Main Art Gallery, California State University, Fullerton
Frank M. Doyle Arts Pavilion, Orange Coast College

Published in conjunction with the exhibition
John Paul Jones: A Retrospective by
California State University, Fullerton, Main Art Gallery and
Orange Coast College, Frank M. Doyle Arts Pavilion

Organized by Mike McGee

California State University Fullerton
800 North State College Blvd.
Fullerton, California 92834-6850
www.fullerton.edu

Orange Coast College, Frank M. Doyle Arts Pavilion
2701 Fairview Road
Costa Mesa, California 92626
www.orangecoastcollege.edu

ISBN:978-0-935314-75-5

Cover: John Paul Jones, Wood Sketch 2, 1986, Pine, 9$\frac{1}{2}$"x 11$\frac{1}{16}$." Dowling Family Collection

Contents

Foreword

Born in the small town of Indianola, Iowa, John Paul Jones was named after the renowned naval officer of the Revolutionary War, whose remark "I have not yet begun to fight" has gone into legendary history. Although he served in the U.S. Army 750th Field Artillery Battalion in Okinawa, the artist's fifty-year career as fine printmaker, painter, and sculptor was not dashing. In fact, he always avoided the public limelight, pursuing his work as artist and teacher.

In 1946 he entered the University of Iowa and studied printmaking under the guidance of Mauricio Lasansky, one of the leaders of the American printmaking renaissance. A highly talented draftsman, Jones became an outstanding printmaker, whom Una Johnson, the doyenne of the subject, likened to Odilon Redon, on the occasion of the John Paul Jones print retrospective she curated at the Brooklyn Museum in 1963.

I recall my first encounter with the artist's work, when I saw his intaglio *White Table* (1957), a carefully structured still life of invented geometric shapes, at the Felix Landau Gallery in Los Angeles in 1958. Most of his work, beginning with an outstanding expressionist *Self Portrait* in 1950 and continuing through the '50s, '60s, and into the '70s, should be seen as part of the New Figuration of the postwar period. Jones, like de Kooning in New York, Giacometti and Dubuffet in Paris, and Francis Bacon in London, depicted the human figure in a tragic mode, fraught with the experience of the War, of Auschwitz and Hiroshima. In Los Angeles it was Rico Lebrun who had the courage to produce death-camp images, saying that "pain had a geometry of its own." Lebrun reconnected contemporary art to the tradition of religious painting and its human passion. Jones, who taught at UCLA from 1953 to 1963, was surely aware of the older painter's *Crucifixion* triptych of 1950 and his widely acclaimed *Genesis* mural at Pomona College. Working on a much smaller scale and in intaglio, Jones, too, turned to religious subjects, creating deeply moving works such as his *Pieta* of 1957 and *Annunciation* (1959, p. 57) of a year later. In this twentieth-century *Annunciation* there is no archangel—only a solitary woman, emerging from a dark interior, as she is seated against the light of a window, perhaps in expectation of a mysterious message from afar.

John Paul Jones, 1963
UCLA, Los Angeles, CA

After a trip to Europe with an important stay in Italy on a Guggenheim Fellowship (1960-61), he began working in bronze and also used pastels as well as color intaglio to make a fine series of isolated heads that were personal renderings of the traditional portrait bust. Then, after a trip to Spain in the late 1960s, he turned to all-over abstract painting in dark, dramatic acrylics on paper. During these years John Paul Jones had innumerable solo exhibitions and awards. After teaching at the University of California Irvine from 1969-1990, he retired to live and work in relative isolation in Ashland, Oregon.

Beginning in the 1980s, he turned to sculpture, constructing works that differed significantly from his renowned prints and paintings. These new works, made from mostly local wood such as sugar pine or basswood, at times combined with polished metal, are meticulously structured. Jones may have been influenced by minimalism, which was the leading form in mainstream American sculpture at the time, but these clear-cut, open constructions, in which solid forms serve as envelopes of space, relate historically to the work of the Russian Constructivists, of Tatlin, Pevsner and Gabo, sculptors who revolutionized sculpture by renouncing mass as its medium. John Paul Jones, who had come to sculpture through drawing, was now using thin materials to draw in space. He also produced a series of mirror sculptures in which thin plates of stainless steel serve as reflecting surfaces. These pieces, too, seem as great contrasts to his earlier figurative work, but Phyllis Lutjeans, who in 1990 curated the artist's exhibition at the Art Institute of Southern California (now the Laguna College of Art and Design), observed that "The mirror works continue John Paul's fascination with the figure, as the viewer, dimly reflected in the stainless steel, serves as the artist's figurative subject matter."

Peter Selz
Former curator for the Museum of Modern Art, New York,
founder of the Berkeley Art Museum, art historian and author.

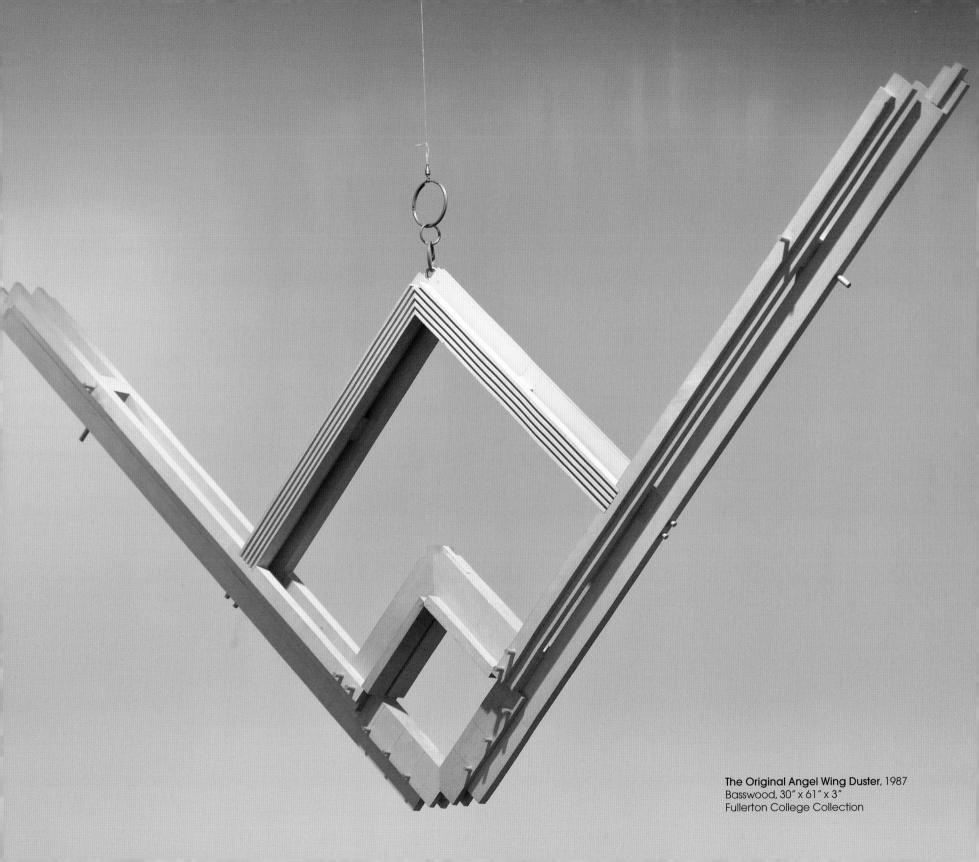

The Original Angel Wing Duster, 1987
Basswood, 30" x 61" x 3"
Fullerton College Collection

Early Works

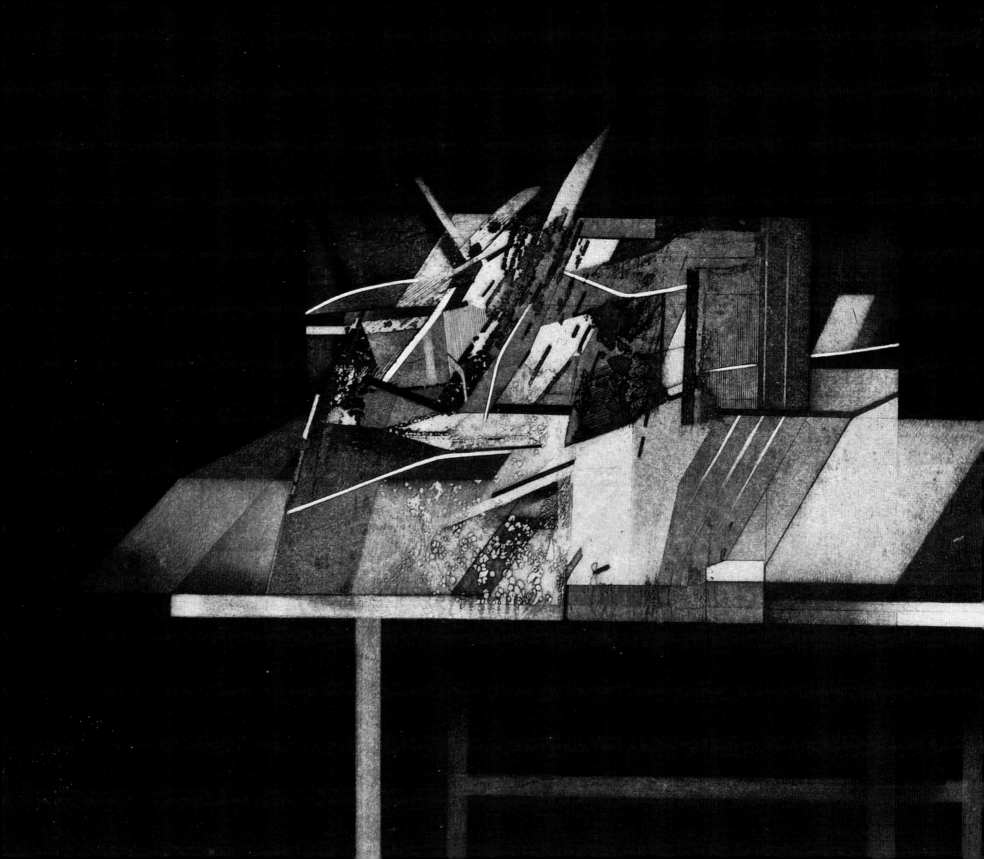

From Essence to Quintessence:
The Figurative Art of John Paul Jones

Susan Landauer

John Paul Jones' place in art history bears an uncanny resemblance to the trajectory of his own remarkable work. After his shift to the figure, Jones' art became ever more elusive; indeed, so much so that *New York Times* critic John Canaday—never at a loss for words—finally confessed, after numerous "embarrassing" attempts to pin Jones down, that when "faced with the alternative of groping or of admitting he is licked, the critic had best admit he is licked." [1] Stranger still, the conceptually enigmatic nature of Jones' figurative art was accompanied quite literally by its disappearance from collective memory. Since ephemerality was its essence—its meaning and form were ultimately about the slippage of expression, time, and perception—it is as if the artist's own awareness of life's transience succumbed to the fate of what his art so frequently resembled: Leonardo's *sfumato*, meaning clearing mist or smoke on the cusp of fading to nothingness. And yet, Jones' shadowy utterances have survived. After disappearing from art historical record for nearly half a century, they have now resurfaced with a quiet, mysterious power that has finally defied their own perishability.

Even taking into consideration the fickleness of art trends, it is surprising to find that in the 1950s and 1960s John Paul Jones was widely and consistently ranked as among America's leading printmakers. In 1963, he was the first pick of the eminent curator Una E. Johnson to inaugurate the Brooklyn Museum's solo exhibition series on distinguished contributors to the media of drawings and prints in the United States. [2] By then, he had also become a nationally recognized painter. With twenty-eight one-person gallery and museum exhibitions across the country in the first decade of his career, *Time* magazine gave him an illustrated feature article in 1962. [3] Yet today, Jones has been almost entirely forgotten by art historians—by historians of American printmaking, by historians of West Coast art, and even by scholars writing about the art of Los Angeles, where for many years he was championed as a local talent. [4]

White Table, 1957
Etching, soft ground and aquatint, 18"x 18"
Patricia Turnier Collection

The studies that focus on Jones' location and era of highest repute—Los Angeles in the late 1950s and 1960s—tell a remarkably narrow story, committing the same error of progressive narrative as the common objects of their scorn, Clement Greenberg and curators of the Museum of Modern Art. [5] This account almost invariably follows the same outline, beginning with the same creation myth, which took place on March 15, 1957, the day that the *Ferus Gallery* opened its doors to the public. It was there, on La Cienega Boulevard, that founders Walter Hopps and Edward Kienholz purportedly gave birth to the city's first bona-fide avant-garde. The seminal moment occurred just a couple months later with the showdown between Beat artist Wallace Berman and the city's conservative McCarthy-era establishment over the alleged "obscenity" of Berman's exhibition, which provoked a police raid and the artist's arrest. In the early 1960s, particularly after *Artforum* moved its offices from San Francisco to the gallery's second floor, the *Ferus* went on to became a major platform for the streamlined "L.A. Look" that dominates (alongside a few scattered assemblage artists) the city's art history today: L.A. Pop, Finish Fetish minimalism, and the Light and Space movement. These ultra-slick "isms" took New York art trends and transformed them into colorful indigenous varieties that reflected the image of Los Angeles itself as a mecca of popular culture—the world's "Republic of Trivia," as critic Joseph Masheck memorably called it—notorious for its commercial sprawl, the glitzy artificiality of Hollywood and Disneyland, and its lowbrow surf, motorcycle, and hot-rod cultures, the latter made particularly famous by the "kandy-apple" paint jobs of car customizers like Ed "Big Daddy" Roth. [6]

There is no denying the importance of these movements or their influence on subsequent generations. Though scorned at the time, Los Angeles's lowbrow culture ultimately became its greatest asset with the dark allure of film noir and the crime novels of Raymond Chandler, and the kitschy glamour so in keeping with postmodernism's Jeff Koonsian aesthetics of faux and flash. Most recently, Southern California's fusion of high and low has spawned via the Internet an enormously popular underground movement of edgy cartoon-based painting, variously known as Lowbrow Art, the Juxtapoz School, and Pop Surrealism. [7] Yet the fact remains that aside from a handful of recent monographs, the contemporary literature virtually ignores the considerable achievements of many L.A. artists prominent in the 1950s and 1960s. Even the Centre Pompidou's massive publication *Los Angeles 1955-1985: The Birth of an Artistic Capital* (2006), which bills itself as the first "to retrace in such breadth and depth the history of a cultural and artistic scene that has yet to find full

recognition," essentially repeats the same monolithic tale. [8] Among the eighty-five artists represented in that survey, none give a hint of John Paul Jones' contribution or the figurative painting that had so much presence in Southern California after the Second World War.

A good starting point for reconstructing the multifaceted history of Southern California art is Henry Hopkins' survey exhibition of fifty paintings by thirty-seven Los Angeles artists at UCLA's Art Gallery in 1960. Still working on his doctorate, this was Hopkins' first exhibition, and its success launched his long career as one of the few directors of West Coast museums with a deep and subtle understanding of California art. Hopkins' show demonstrated rare insight for such a young man. His thesis was that Los Angeles's special geography necessarily imposed a high degree of pluralism: Quoted in the *Los Angeles Times*, he explained: "Los Angeles painting is known for its diversity. This can be a positive virtue or a fault depending on the critic, but certainly it is a fact, a condition born out the character of the city that sprawls over the geography of Southern California like a gigantic beach towel; artists' studios polka dot its surface from hem to hem. There is no 10th (Street), no North Beach, no single creative heart; there is only a multitudinous series of capillaries, each seeking the 'mainstream' of art as best it can." [9]

Nonetheless, Hopkins' object was to make sense of what he saw and to select the best art he could find. He loosely divided his exhibition into three trends: Abstract Expressionism, the Abstract Classicists—consisting of the geometric painters John McLaughlin, Lorser Feitelson, Frederick Hammersley, and Karl Benjamin—and a group of figurative painters who were bringing "contemporary notions to bear on Renaissance-Cubist tradition," led by Rico Lebrun and including Eugene Berman, William Brice, Hans Burkhardt, John Paul Jones, and Howard Warshaw. [10] This was an unusual curatorial choice for 1960. Most critics agreed with Hopkins' emphasis on diversity, but they gave abstract and figurative artists equal weight. Others considered Abstract Expressionism an import from New York and the Bay Area, giving higher marks to figuration for creative originality. *Los Angeles Times* critic Henry J. Seldis's passion clearly lay in the work of the figurative artists, whose best paintings he described as "vividly experimental and profoundly original" while gaining strength from "an appreciative understanding of the past." [11] Though aware of artists working along these lines elsewhere (notably in the Bay Area), Seldis concentrated on the artists of Los Angeles, calling them "California Imagists." [12]

In the late 1950s, this was not just "local knowledge," to borrow Clifford Geertz' phrase, since contemporary art commentators in New York and other major cities were aware that Los Angeles was a center for a vigorous figurative movement spearheaded in particular by Rico Lebrun, whose large-scale paintings of Nazi death camps were nationally exhibited. And the "New Figuration," Peter Selz's term for the trend in his landmark exhibition *New Images of Man* at the Museum of Modern Art in 1959, extended well beyond Los Angeles, including many artists from European and other American cities as well. In his introduction to this monograph, Selz refers to *New Images of Man* as the context for John Paul Jones. Although Selz did not include him in that earlier exhibition, he acknowledges that he might have, now identifying him as part of a far-flung figurative romantic, expressionist impulse that included Willem de Kooning in New York, Alberto Giacometti and Jean Dubuffet in Paris, Francis Bacon in London, and Nathan Oliveira in San Francisco. *13*

The figurative art that Selz describes was also explored by the critic and poet Selden Rodman in an extensive survey of the subject. *The Insiders: Rejection and Rediscovery of Man in the Arts of Our Time*, published a year after Selz's exhibition catalogue, highlighted Latin American artists as well. Rodman defined the "insider" as "an artist who expresses his concern with the human condition," with an aim toward "communicating on the widest level." *14* Part of his argument was to distinguish the figurative artists favorably from their contemporaries, the Abstract Expressionists, reproaching the latter for being obsessed with stylistic invention.

Yet the spontaneous and remarkably simultaneous development of these trends only shows how deeply both responded to world events. If the imagery of figurative artists was more obviously, as Selz observes in this publication, "fraught with the experience of the War, of Auschwitz and Hiroshima," Abstract Expressionism was equally a response to global trauma. *15* The romantic "Abstract Sublime," the phrase Robert Rosenblum coined to describe the emotionally charged, anti-rationalist, and inward-turning aesthetic of Clyfford Still and Mark Rothko, was shared by a host of figurative artists. *16* While now forgotten by mainstream art history, this widespread phenomenon was well documented in the literature of the time. Solitary figures in moody dreamscapes, mysterious dramas enacting ancient rituals, images of nature's violent forces, and visions of religious revelation were common subjects of the postwar era. *17*

If Rodman erred in opposing abstraction and figuration, he was correct in noting that most figurative artists held a greater respect for the art of the past and were less motivated by a rebellious search for the new. Even during his abstract period, Jones echoed his teacher Mauricio Lasansky's reverence for tradition and his belief that "avant-gardism" was essentially a fabrication of promoters that often led artists astray. While still a student in 1951, Jones wrote for his first one-man exhibition at Iowa Wesleyan College with characteristic subtlety and self-reflection, that no one style or category was any better than another. The only enduring value in art, he said, was "good 'picture making.'" However, even quality and value, he cautioned, were subject to historical relativity and the vagaries of taste. Sounding more like a contemporary postmodernist than a postwar romantic, Jones expressed his awareness of the tenuousity of his own artistic significance. As if to stress this idea, he used only lower-case letters:

> Since 1948 i have been serious about art. during that time i have myself been confronted with many questions, and from them resolved very few answers i cannot answer your questions about art, as I cannot answer mine. in the continual search for a set of values i often find that today's values seem worthless tomorrow and one's strongest convictions may be relegated to a role of unimportance in a relatively short time. 18

In 1954, a few years after writing this statement, Jones was fortunate that Felix Landau invited him to join his gallery. Landau was as independent-minded as Jones and as skeptical about the dictates of fashion. Their similar artistic ideology, which placed primacy above all on personal, instinctive assessment of quality, cemented a relationship that lasted until the gallery closed in 1970. Landau was part of a large contingent of Jewish refugees who fled Europe for Los Angeles during the Second World War and exhibited the modern art that had been banned under the Nazis. Established in 1948, the Felix Landau Gallery was among the first of a string of galleries along La Cienega Boulevard. A native of Vienna, Landau introduced Viennese Expressionism to America, notably Gustav Klimt and Egon Schiele, as well as the Vienna School of Fantastic Realism. Of all the L.A. dealers, Landau had the most eclectic taste. At the height of his success in the mid 1960s, with a satellite in New York, Landau showed many West Coast figurative artists from north and south, representing Jones, Warshaw, and Jack Zajac in Los Angeles while exhibiting Bay Area Figurative painters such as Elmer Bischoff, Richard Diebenkorn, David Park, Nathan Oliveira, James Weeks, Theophilus Brown, and Paul Wonner. But Landau had no figurative bias. In fact, as he told an interviewer, he "never had a concept of dividing art into figurative and nonfigurative

art."[19] He was equally passionate about abstract art, introducing Italian artist Arnoldo Pomodoro to the United States, stirring up a ruckus by giving ceramic sculptor Peter Voulkos his first one-person gallery exhibition in 1959, and representing Finish Fetish artist Tony DeLap in the late 1960s. He remained especially dedicated to the quiet geometric painter John McLaughlin, stubbornly believing in his talent though he recalled selling only a handful of canvases in twenty years. [20]

When Jones joined Landau's gallery he had already established a national career as a printmaker. That same year the *Los Angeles Times* declared that Jones had accrued "an almost staggering list of awards and achievements to his credit," noting that Dore Ashton, writing for *Art Digest*, singled him out as the most talented prizewinner at the Brooklyn Museum's 8th "National Print Show."[21] As a student of Atelier 17-trained Mauricio Lasansky at the University of Iowa, Jones became an early exponent of the experimental intaglio techniques of Stanley William Hayter's famous Parisian workshop, thus playing an important role in the postwar printmaking renaissance in America. With these credentials he was invited to join the art faculty of UCLA in 1953 to head its printmaking program, then one of the few university facilities in the country. Bay Area printmaker Karl Kasten, a classmate of Jones who also studied with Lasansky in the late 1940s and went on to establish UC Berkeley's first printmaking program, described the Lasansky-Hayter credo as a break with the tradition of working with master printers. In order to liberate the creative possibilities of the printmaking process, Kasten said, they produced their prints from start to finish. The central idea was to dispense with preparatory drawings, relying instead on "developing your image on the plate as you went along."[22] Jones was well aware of the revolutionary implications of this approach and its capacity to restore printmaking's status as a creative medium. In teaching notes from his second year at UCLA, he wrote:

Printmaking has long been a minor art form hovering on the periphery of the art world. Here at UCLA . . . we are attempting to create a revival of craftsmanship like that of the Renaissance and are experimenting with new techniques and combinations of techniques to enrich contemporary expression. . . .The etching and engraving techniques have enormous potential vocabulary of expression, the greater part of which is practically unknown. In this class I hope to indicate the directions in which this vocabulary of expression has been used, without pretending to set any kind of limits to their extension in the future. [23]

Yet it is revealing of Jones' preoccupations of the time that while he thoroughly embraced artistic freedom, he also warned against aimless experimentation: "We might call this the age of invention," he told his students. "That this is particularly good or bad, beneficial or harmful, is probably not my place to decide at all. However, there are dangers present that we should consider. Experimentation is only useful with a logical end in view." [24]

The abstract etchings that initially won Jones national acclaim certainly indicated his own Lasansky-inspired pleasure in the rich possibilities available to artists working directly with the plate. Prints such as *Boundary* (1951, p. 43), *Diversion* (1951), and *Suspension* (1953, p. 45) demonstrate his absorption of Lasansky's entire repertoire of innovative intaglio methods—employing inventive variations of etching, engraving, and aquatint—to create tremendous variability of line and texture. Their most astonishing quality, as critics and print curators repeatedly observed at the time, was their superb draftsmanship coupled with their spatial complexity. Composed of tight-knit fields of shifting triangular shafts filled with kinetic action, each print was virtuosic. It is as if he followed to the utmost of his capacity Lasansky's advice that "Real freedom cannot exist without discipline." [25] The painstaking labor, control, and precision that went into works such as the widely acknowledged masterpiece of his geometric phase, *White Table* (1957, p.10), are more akin to seventeenth-century Dutch painting than to midcentury abstraction. On average, Jones produced just three prints a year, sometimes spending as much as fifteen months on a single plate. [26] He was not exaggerating when he explained that his ambition was "to make every square inch compatible with every other square inch so that there would be no question about any square inch." [27] His accomplishment of that seemingly impossible objective is what led the *New York Times* to assert in 1963 that Jones "is one of the best technicians alive today." [28]

Yet one of the most striking aspects of his geometric prints is how drastically they differ from the art of his maturity, the mysterious figurative works of the late 1950s and 1960s. Their painstaking geometry shows more affinity with the austerity of McLaughlin's abstractions than with the Abstract Expressionism of so many of Lasansky's other students, and no apparent influence of Lasansky's own figurative expressive prints, whose style bears a surprising resemblance to Lebrun's feats of theatrical calligraphy. Nevertheless, in many ways the early abstractions reveal a great deal about Jones and the qualities inherent in all of his art. Their sensitivity, subtlety, control, and tenacity were fully in keeping with the intensity of his temperament and personality. Seldis, who practically

worshipped Jones, described him early on, as others would, as somewhat enigmatic: "A slight figure dominated by a pair of piercingly penetrating eyes, Jones, on initial encounter, seems reserved, almost shy. But underneath this calm exterior—as beneath the harmonious blend of his paintings—there lies an encompassing intensity and a very personal mystique, which has lifted this artist above the polemical clamor of art fashions."[29] Those who knew Jones well remember him as brutally self-critical and earnest to a fault, aspects which led to a lifetime of internal conflict that in his maturity became indivisible from his art. A related characteristic, which served his art but incapacitated his political savvy and self-promotional ability, was his utter lack of guile, so extreme it was endearing. Canaday, with a twist of ironic humor, described Jones' self-effacing candor as "engaging." A few hours before the opening reception for his one-person exhibition at the Brooklyn Museum—the kickoff show for a series of ten honoring contemporary printmakers in America, as well as Jones' own New York debut—Canaday stopped by the museum to meet this Californian whose work he had praised in past reviews. The prestige of the event would be heady for any artist, but when the critic asked what Jones thought made him special, he simply replied: "I dunno. It's what I've been thinking about all day. The whole thing's very embarrassing."[30]

Jones' response may have reflected his very genuine self-doubt, for despite his stunning art-world success, there are signs he was growing increasingly dissatisfied with his work. He felt constricted by the narrow art-for-art's sake goals of his geometric abstractions and increasingly concerned with the expressive value of art. In 1962, he described his thinking at the time:

Well, I began to knock off a few prizes. I had some luck at the Brooklyn Museum. Grace Borgenicht (Gallery in New York) saw some prints and took me on. Here's one thing that finally happened: I found out organization doesn't make great art; it's simply one element. There's got to be a richer combination. I'd been working too much in my head, too intellectually. These things became sterile. I can break up space and put it together damn near as good as anybody. It just didn't seem to fulfill anything any more. So I started out using the figure. [31]

In truth, he had been working with the figure all along, but only occasionally, as in his striking self-portrait of 1950 (p. 34). Yet the thrust of his art had been on mastering intaglio, which he pursued, as he would later confess, with no

motivating philosophy to guide him. Canaday seems to have been correct when he remarked after seeing Jones' figurative paintings that his geometric prints appeared to have "served him, after all, only as a proving ground in the techniques of organizing and presenting something that, with greater maturity, he became ready to say."[32]

The etching and aquatint *Return* (1954, p. 56) represents a key transitional work, fusing both his geometric and figurative styles. The print suggests a woman emerging from an ambiguous background of rectilinear planes, and with its unerring sinuous line—emphatically curvaceous—Jones shows that he may have been studying de Kooning's *Women* series of the period. However, this print has none of the New Yorker's aggressive bravado; rather it shows Jones' trademark subtlety. Yet it also demonstrated his newfound capacity for sensuality. In commenting on this work, Dore Ashton noted that, as in his geometric works, the gradations of ink are masterfully controlled, but here Jones demonstrates "a specific gift for 'feeling out' the sensuous possibilities of the metal plate."[33]

The synthesis of figure and geometry makes one of its last appearances in *White Table* (p. 10). It almost seems as if this print served Jones as a kind of cathartic farewell to technique. In this single print Jones pulled out all the stops to show his breathtaking command of intaglio: his pleasure in its seemingly limitless tonal ranges, its textural possibilities, and its spatial complexities, but perhaps above all, his sheer love of the rich viscosity of printer's ink. For the magic of this work is not conjured from the subject of its title but rather from its seductive blackness, the irresistible velvety expanse of ink from which the "white table" emerges.

Jones' transition was gradual. Although he would continue to produce prints of high quality for many years to come—particularly the series of lithographs he created on a Tamarind Fellowship in 1962 (p. 74-75)—he began increasingly to turn his attention to drawing and painting. His production in the late 1950s and 1960s still included a number of important etchings—notably *Annunciation* (1959, p. 57), which, like *Return* (1954) of several years earlier, might be considered transitional in its blend of geometric and figurative elements. In sensibility, however, this print decisively signaled the figurative direction Jones' work would now follow. There are still some hard edges, but the atmosphere has begun to take over. Its mood now expresses a mysterious tone of melancholy: it is not clear who she is, where she is, or what she is doing. She is a woman, certainly, perhaps sitting by a window. But her actions or inactions are unimportant—all that is important here is the engulfing darkness and the quality of

ambiguity itself. On a Guggenheim Fellowship, Jones traveled to Europe for the first time in 1960 and 1961, touring museums in Paris and London to examine the printmakers he had long admired—Rembrandt and Goya, as well as contemporary artists such as Giacometti and Bacon, and in particular the French Symbolists of the nineteenth century. He returned with a renewed commitment to the dark and dreamy figurative paintings and drawings that had preoccupied him with increasing frequency in the 1950s. His exhibition at the Felix Landau Gallery in 1962 showed the fruits of this trip. With a catalogue by Seldis, this exhibition premiered a number of small and delicate lost-wax bronze heads, and it was dominated by a series of very small oil paintings (typically 14 by 10"), mostly anonymous *Black Portraits*, in which ghostly faces emerge from blackish grounds tinged with subtle hints of color. Observers immediately identified these, along with his new series of charcoal nightscapes, with the nineteenth-century Symbolist Odilon Redon's *Noirs*, or *Black Pictures*, a connection Jones enthusiastically endorsed. *34* One of the paintings in this show was in fact a portrait of Redon, with the earlier artist's name scratched into the upper left corner. Jones' schematic, almost childlike homage bears no likeness to the artist, but merely presents two preternaturally large eyes staring directly at the viewer with a single gash for a mouth, twisted into an equivocal smile.

Jones was no doubt attracted to Redon's exquisite mastery of charcoal, a medium which, like intaglio, registers the slightest touch and minute adjustment of tone. Although color would recur periodically throughout his career, primarily in monochrome or duochrome, Jones remained essentially tonalist. Whether working in charcoal, painting, or printmaking, his primary concern would be the art of value relationships. The sumptuous blacks Jones produced with ink he could equally achieve in charcoal, as in the Museum of Modern Art's *Head*, (1960) one of his finest portraits in that medium, with its fragile grace balanced by an inner strength. *35*

Jones' black paintings and drawings represent an embrace of Redon's *Noirs* in their appreciation for black as a vehicle for expressive power, an appreciation Redon eloquently described: "Black is the most essential color. . . One must respect black. Nothing prostitutes it. It does not please the eye and it awakens no sensuality. It is the agent of the mind far more than the most beautiful color of the palette or prism." *36* For Redon, black signified a realm of night, dreams, and the infinite—the unfamiliar terrain of the mind. Jones' work of the late 1950s and 1960s also frequently evoked such associations. But unlike Redon's worlds of fantasy, populated with bizarre creatures

of his own nocturnal and waking dreams, Jones was not interested in creating imaginary figures or scenes—even though many viewers literally interpreted his works as depicting ghosts drifting through haunted landscapes. Jones had certainly come to rely on an intuitive perception of the world to produce art that had much in common with the creative process of the Symbolists. As Seldis explained, Jones now rejected "categorically any separation of outside from inside in human experience," or in Jones' own words: "All outside things come from inside. That is the only way we can conceive them." *37* However, unlike Redon, he depended on "no exotic stimulus" but rather his immediate emotions and surroundings. *38* In an interview with *Time* magazine in 1962, he was quite explicit. He described his act of painting as "a kind of fidgeting to make the figure emerge. I put in, I wipe out, I put back in. . . . I don't know how many figures are standing there waiting. If the face I first find should disappear, there would be many others to take up the emptiness." *39*

If Jones' portrait of Redon brilliantly achieved the aim he set for himself in his personal notes, to keep his art "SIMPLY complex," by capturing in a few swift strokes the Symbolist's conflicting pleasure in violence and beauty that underlay his visionary genius, other portraits intuitively caught a variety of traits and emotions, often with rare compassion. *40* Some portraits show a tenderness that skirts but never crosses the line into sentimentality that would scare off less capable artists. Most notable among these are his portraits of Megan (1972, p. 92), the daughter he loved so deeply that he kept her as often as possible by his side in his studio. Her preciousness to him and his keen sense of her fragility are rendered with such emotion that it is easy to imagine these portraits as premonitions of her death of cancer at the age of twenty, which would lead him to the brink of suicide and cause him to spend his last years in seclusion. *41*

A handful of *Black Portraits* like *Study for Man of Flanders* (1962, p. 49), with open mouths like dark gaping holes, invite immediate comparison to the silent screams of Bacon's popes and the phantoms of Goya's last *Black Paintings.* Some, like Jones' *Petty Swindler, Pimp and Pornographer* (c. mid to late 1960s), might have been inspired by Goya's satirical *Caprichos. 42* But the vast majority of his heads and figures, even his occasional self-portraits, functioned "not as an anatomical entity, but as a finely-wrought symbol," to quote Una S. Johnson. *43* The anonymously untitled lithograph of 1963 (p. 71) is one such self-portrait. Bearing no resemblance whatsoever to the artist, its simple contours, which leave wide, disconnected gaps at both the top and bottom of the head,

suggest the universally elliptical makeup of the individual psyche. Along related lines are the landscapes Jones produced during and after his trip to Europe in the early to mid 1960s, which are striking at first glance for their expanses of emptiness. Works such as *The Unspoken Oarsman* (late 1960's, p. 87) and *Clayfields* (1966, p. 79) appear to present vast vacant skies dominating low, nearly eventless horizons of water or land. But after scrutiny their stretches of blankness become studies in nuance, filled with the subtlest gradations of subdued color and sometimes with flurries of gesture so pale they can be discerned only in strong light. Here again we are reminded of Redon, since nuance and suggestion are at the core of the Symbolist aesthetic. Despite his attraction to the fantastic, Redon spoke of capturing the "obscure world of the indeterminate," and poets of his circle, particularly Mallarmé, emphasized the power of mystery and ambiguity to "charm the imagination." *44*

Still, while we know Jones appreciated the sensibility of Symbolism, it is essential to recognize that after his shift to the figure his approach became increasingly unpremeditated and instinctive. As early as 1963, he acknowledged: "I find it increasingly difficult as time goes on to have theories about my work—I simply try to live in the work as fully as possible." *45* The melancholy and despondency of his art expresses emotive content that, as he insisted himself, necessarily came from within. What are we to make, then, of the isolated figures simultaneously evolving from and dissolving into the shadows or disappearing like wisps of smoke in the air? What did he mean when he told *Time* magazine in 1962 that in his paintings "The figure is woven into the fabric of the surface," giving only the elusive explanation that his "figures are hinged onto this darkness the way people are hinged onto life"? *46*

This sense of uncertainty and ephemerality appeared in his thinking about art before he found a way to express it. While still a student in 1951, he spoke of the shifting sands of meaning and value. Jones' obsession with impermanence, indeed of impending invisibility, is fundamentally different from the Symbolist allure of innuendo. His tendency toward ellipsis and erasure speak to a profound and deep-rooted knowledge of what he later wrote in poetic ruminations was the essential "untidiness" of life and its "refusal to fall into neat, compact shapes," the way "flocks of sparrows never make formations." Jones' sense of randomness and flux is far more akin to the moral incertitude of Nietzsche's godless revelations that formed the prelude to Existentialism, which, after the cataclysmic upheavals of the First and Second World Wars, shattered fixed values into meaningless absurdity.

Jones was a lifelong admirer of the Existentialists Samuel Beckett, Jean-Paul Sartre, and especially Albert Camus, as well as kindred thinkers such as Sören Kierkegaard and Jorges Luis Borges, and he found solace in their writings up until his death. But his profound existentialist view of the world was hardly book-learned. Jones was deeply private and spoke little about his past. In his personal notes he conceded that art is "autobiographical to a large extent" but should never be a "dumping ground" for emotions. *48* Nonetheless, the traumatic events of his life are essential to understanding his art and the philosophy that informed it. Growing up the son of a machinist and trucker "on the wrong side of the tracks" in the small Iowa town of Indianola, he was in elementary school when his father's alcoholism led him to disappear for long periods of time. *49* Jones' parents divorced, but his mother, like his maternal aunt who committed suicide, became mentally ill and unable to care for him (ultimately, she was institutionalized). At the age of eight, an only child, Jones was sent to be raised by his grandparents. *50* His feelings of isolation and instability persisted throughout his life, though his students, friends, and family revered him for his passion and generosity. Capable of deep emotional attachments and by any measure a professional success, his painful early years left him permanently scarred by what his companion Susanne Nestory called "psychological issues of invisibility." *51*

A childhood such as Jones had would be psychologically challenging for anyone, but its trauma paled by comparison to what he experienced during the war as a sergeant with the army infantry in the Battle of Okinawa. *52* Initially, historians viewed this battle, the last of the Pacific Theater, as the deadliest, fiercest, and most gruesome in the Pacific War. Recently, as more information has come to light about the extent of the atrocities, some now characterize it as the single most brutal campaign in United States history with the highest rate of neuropsychiatric disorders of any World War II battle. *53* The number of deaths and casualties, which surpassed those of Hiroshima and Nagasaki put together, are only statistics. What sets this battle apart is the prolonged intensity and barbaric nature of its violence, which enveloped Japanese fortifications on all sides with the most concentrated fire power and explosives ever used in such a restricted area. Okinawa was also where the Japanese launched their most extensive and relentless kamikaze offensive—by some accounts nearly 2,000 suicide missions—destroying U.S. battleships loaded with explosives and causing a firestorm at sea. Moreover, unlike the Battle of Iwo Jima, American forces on Okinawa slaughtered an unprecedented number of civilians in addition to the tens of thousands who were forced by imperial decree to commit suicide before surrendering, generally by holding grenades to their stomachs or jumping off of cliffs.

As a gunner in the 750th Field Artillery Battalion, Jones was a relative latecomer to Okinawa, arriving after Allied troops defeated the largest Japanese fortification in the Battle for Sugar Loaf Hill, forcing a retreat to the southern tip of the island. Though not the "storm of steel," as the Japanese would characterize earlier assaults, Jones' troops took the last stronghold of the Japanese 32nd Army. This final phase was particularly grisly, as it employed for the first time one of the war's most terrifying weapons, the "flamethrower tank," to flush out the Japanese underground command center. Possibly the most uniquely horrifying aspect of the Battle of Okinawa was the destruction of the island's labyrinth of underground tunnels, which, through the end, sheltered much of the civilian population as well as soldiers and officers. By one estimate, these tanks torched miles of tunnels with hoses pumping "liquid fire," a mixture of gasoline and napalm, burning alive unrecorded numbers of women and children in a matter of days. The battle was finally over, but perhaps most psychologically devastating of all was disposing of the corpses, now a sanitary imperative with more than a hundred thousand bodies and limbs decomposing in mud from a monsoon that had passed through during the conflict. The 750th Battalion was responsible for conducting speedy mass cremations; as Jones recalled, he spent three weeks burning corpses. *54*

To quote Walt Whitman's famous words, "The real war will never get into the books." *55* Historian Bill Sloan's account of Okinawa makes an attempt, describing the U.S. deployment in the late spring of 1945: "When thousands of armed and desperate men spend hour after hour, day after day, killing and maiming one another in fighting that drags on for weeks, logic, rational thought—and sanity itself—are frequently among the casualties. Incongruity tends to become standard procedure. The bizarre is increasingly commonplace. The most grotesque sights and sounds disguise themselves as natural aspects of life. Men routinely do and endure things they'd consider intolerable under normal circumstances." *56*

Jones, like most other veterans of Okinawa, generally did not discuss his war experiences with friends and family. Many knew that the sound of gunfire had left him partially deaf, but they had no idea of what he had experienced in the war. In one of the few published oral histories of the battle, Marine Corps veteran E. B. Sledge explained that when it came to specific details of combat, "We didn't talk about such things. They were too horrible and obscene even for hardened veterans." *57* This was the case as well for many artists who had experienced violent combat and, like Jones, initially suppressed it in their art. *58* Frank Lobdell and Walter Kuhlman, for example, came

out of the war painting colorful abstractions influenced by the surrealist period of Picasso and Miró. It would be years before they could express what Kuhlman termed the "shadow side of human nature."[59] And when they did, like Jones, it initially seems to have been unconscious. Kuhlman, who sketched the wounded and the dead in hospitals in the army medical corps, discovered his memories surfacing in a palette of sickly whites tinged with blue and green, conjuring rotting flesh, and slashing forms, evoking surgical knives.[60] Similarly, Lobdell was apparently unaware that his paintings began to suggest bones and tendons. It would take a decade for him to fully express the torment of his recollections serving in the infantry near the Battle of the Bulge.[61] Even then, much like Jones, he was never explicit in depicting the war, but used indirect abstract means and occasionally allegory to express his memories.

In an important sense, then, Jones, who experienced the war first hand, is more closely allied with Abstract Expressionists such as Lobdell, Kuhlman, and Edward Corbett—whose *Black Paintings* of the 1950s are among American art's most powerful visual testimonies of a combat veteran's pain—than with the figurative artists with whom Jones is generally grouped. Burkhardt and Lebrun, who never served in uniform, depicted the atrocities of the war in a manner far more literal than Jones would have countenanced. It is impossible to imagine Jones depicting, as Lebrun and Burkhardt did, the death camps of the Holocaust. The clutter of limbs and bodies in Lebrun's *Study of Dachau Chamber* (1959), while treated with a degree of abstraction, would have been much too direct for Jones. By contrast, the closest Jones came to addressing the war with any specificity was the series of etchings with religious themes that he produced in the late 1950s. Prints such *Pieta* (1957), *People of the Cross* (1958), and *Crucifixion* (1959, p. 64), though Jones did not specify their meaning, can be interpreted as allegories of loss, death, and sacrifice. Obscured in inky blackness, it is difficult to make out their subjects without the titles. Many of Jones' figurative counterparts—Lebrun in particular—painted *Crucifixion* scenes as well, but here, too, Jones' elusive approach is more akin to Lobdell's ambiguity than to the relative literalism of most of his figurative peers.

Yet, even compared with his abstract contemporaries, Jones' anguish is quiet; his paintings are always far quieter than those of Lobdell, who used sludgy impastoed strokes and scratched lines that might have been made by fingernails or claws. Jones' work is certainly quieter than that of the expressionist artists of the New York School, whose gestural slashes and tangles of paint Sam Hunter characterized as "a kind of fever-chart of the

ecstasies and torments" of "isolation."[62] Jones' *Black Portraits* and the religious allegories were his last to cry out to the world in any overt way. Instead, his prevailing theme became solitude—the core motif in the literature and philosophy of Existentialism, as in the agonizing solitude of the people quarantined behind the town gates in Camus's *Plague* or Sartre's notion of the individual-in-the-void at the heart of *Being and Nothingness*. It is typical for veterans returning from war to feel alienated from society due to the impossibility of communicating their experiences, but for Jones, like Sartre, who spent nine months as a prisoner of war in the French army, his own sense of solitude became the impetus for his work. As he wrote in his personal notes, he identified with "a man so aware of his absolute aloneness that the only way to survive was to convince himself he had chosen it out of obligation to a greater mission."[63]

All of his figurative works, then—whether of men, women, or children—ultimately should be understood as self-portraits, expressing his intense feelings of solitude. One of the earliest of these solitary figures is the nearly obliterated *Bride* (1955), which, given the usual connotation of blissful union, is particularly heart-rending. Many, like *Figure under Arch* (1964), stand erect, as if to assert valiant invincibility in face of the surrounding darkness. Others, notably *Woman in the Wind* (1963), appear on the verge of being blown away. Jones' *Red Woman* (1958, p. 54) is also threatened by outer forces; she appears to be slipping into an abyss and, in fact, part of her body has already disappeared beyond the borders of the etching. This work and numerous others—such as *Landscape Woman* (1961, p. 72), whose central figure has nearly dissolved—are reminiscent of Oliveira's lone figures, which appear to be melting into murky atmospheres.[64] They also bring to mind Giacometti's attenuated bodies, emblematic of the individual struggling to withstand the self-negating forces of society.

Often Jones' figures seem not so much to be dissolving as sealed into a vacuum that renders them immobile. They are always still, whether standing, sitting, lying or assembled at a dining table. Whether by themselves or in groups, they are inert. There is a disquieting lack of communication, which adds to the pervasive sense of isolation. Beginning around 1964, Jones painted a number of canvases in subdued hue—mauve, rose, and lavender—populated by beings that stand motionless or float off into hazy monochrome backgrounds. *Encounter* (1964) hardly depicts the subject of its title, for the figures seem disengaged from one another. Another painting from this series, *Sea Watch* (1964), looks like it might have been inspired by Gustave

Doré's rendition of Dante's *Divine Comedy*. The robed, incorporeal figures seem trapped and adrift in a perpetual state of purgatory.

The quality of ethereality is central to all of these works. They communicate the artist's acute sense of the transience of life—conveying paradoxically both its preciousness and insignificance at the same time. This is the case not only for his figure works but also for the landscapes such as his oil painting *The Great Cathedral* (n.d.), a subject that most artists would render as a grand structure. Here, however, we have only a speck of a building, a mere punctuation on the horizon line, as if to suggest the ephemerality of man's most ambitious efforts. The theme of transience in Jones' work takes various forms. Often it is expressed through non-forms: empty pockets and lacunae in which pigment is nonexistent. In *Walking Woman* (1961), the figure appears to be striding directly into a gaping void that opens up inexplicably in the center of the print. Jones' charcoals and pastels take this subtractive approach further than his prints and paintings, sometimes making more extensive use of an eraser than of his drawing instruments. Perhaps this is most disturbingly exemplified by his drawing of 1960 called *Woman,* in which the bust of a young lady has been reduced to the edge of nothingness.

Smoky atmospheres abound in Jones' work, perhaps calling forth the memories of Okinawa embedded in his mind. It is tempting to interpret the painting *Sea Fire* (1964), both by its dusky haze and its title, as a return to his experiences on that island. Others, such as the enigmatic painting *Hatmaker's House* (1958, p. 48), are choked with smoky blackness and the suggestion of fiery embers. However, in later years, Jones turns Leonardo's smoky technique of *sfumato* into works of great poetry. As Redon did before him so beautifully in his charcoal *Noirs,* Jones' light and shade blend so gradually as to be imperceptible, rendering forms at times so vaporous that they appear on the verge of vanishing. This approach continued through the 1970s, for example in his *Leda and the Swan* series (1974, p. 101), and into the 1980s in lithographs such as *Paradise Gate: Maine Gate* (1980, p. 132). Clearly, these works follow a tradition that goes at least back to the seventeenth-century Dutch memento mori still lifes, reminding us of life's transience. In his obsession with the fleetingness of life, they surely stand among the most deeply felt works of this genre in the twentieth century.

To the end, Jones created art addressing life's fragility. Though he gradually left the figure behind, returning to abstract painting in the late 1970s and producing a series of highly refined geometric sculptures, it remained an important theme. In the last work of art he produced before he died (p. 29), he expressed this idea with such simplicity and poetry that it seems to sum up the essence of the man. It is composed of just two slender aluminum rods that hang from the ceiling, so delicate and fine that one could easily miss them. It is fragile and elliptical—like his self-portrait of earlier years—allowing the interpenetration of inner and outer space. The sculpture is reminiscent of one of Edward Corbett's last paintings, in which the square, a symbol of order, clarity, and the absolute, reappears in an imprecise, self-negating form. 65 Like Corbett, Jones' beliefs were tested by a lifetime of wrenching pain. But in the end he was never able to discard his desire for beauty and poetry. A few words he wrote in private notes after moving to seclusion in the Oregon countryside sum up the ideals he maintained over a lifetime: 66

Art: a single gesture packed with meaning; a crucial instant frozen in time, simple and beautiful.

Susan Landauer is the former Katie and Drew Gibson Chief Curator at the San Jose Museum of Art. She has written extensively about American Art.

Gate #5, 1998
Aluminum with springs and rings, 48"x 48"x ½"
John Paul Jones Estate

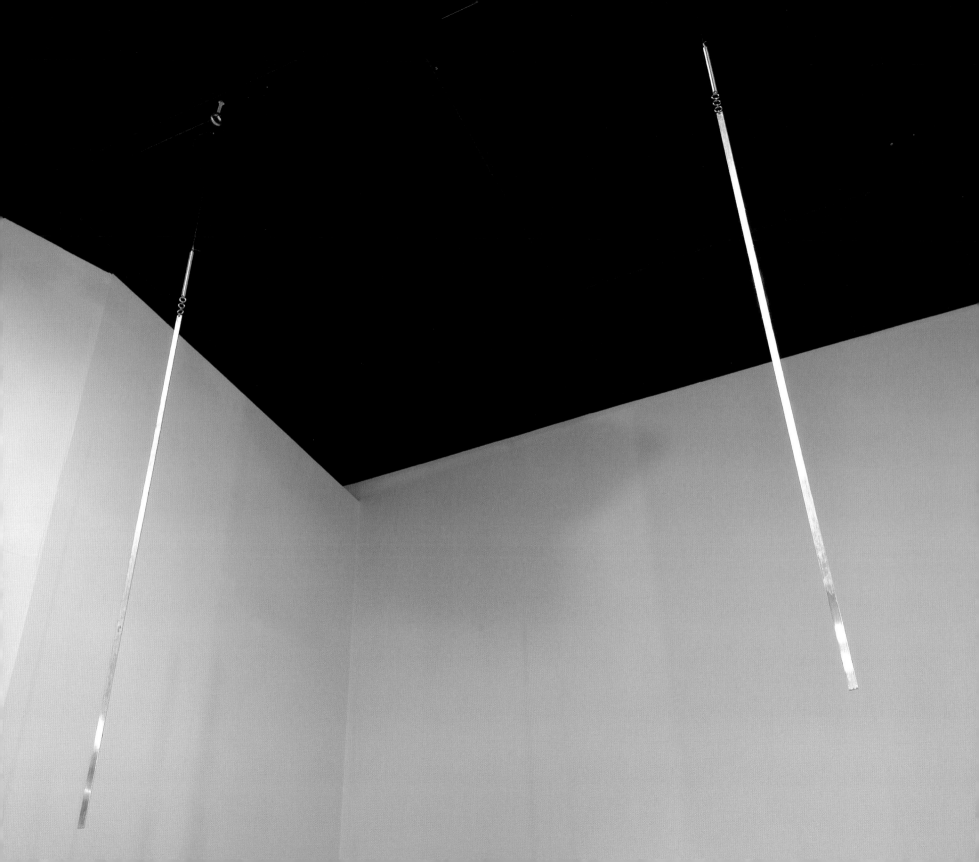

I would like to thank my husband Carl as well as Michael Duncan, Paul J. Karlstrom, Karl Kasten, Jeffrey Landau, Phyllis J. Lutjeans, Susanne Nestory, and Peter Selz for reading my manuscript and making many important observations and suggestions.

The following abbreviation is used throughout the notes: AAA for Archives of American Art, Smithsonian Institution, Washington, D.C.

1. John Canaday, "John Paul Jones: The American Artist Shown in Brooklyn," *New York Times*, 9 June 1963. In this review of Jones' solo exhibition at the Brooklyn Museum, Canaday further stated that "Mr. Jones' work is not easy to write about no matter how much you like it," also quoting curator Una E. Johnson as admitting that "When you get around to trying to put it down on paper, you find how impossible it is. He's just good, that's all."

2. See Una E. Johnson, *John Paul Jones: Prints and Drawings, 1948-1963* (Brooklyn: Brooklyn Museum, 1963).

3. Bob Jennings, "Haunted House," *Time*, 7 December 1962.

4. Toward the end of his teaching career, Jones had a handful of small solo exhibitions with catalogues, notably *John Paul Jones*, catalogue with commentary by Rudy H. Turk (Tempe, Arizona: Arizona State University Art Museum, 1987); *John Paul Jones: A Survey Retrospective 1950-1983*, catalogue with essay by Susan C. Larsen (Los Angeles: Los Angeles Municipal Art Gallery, 1984); and *John Paul Jones: Dreams and Lies in the Gatekeeper's House*, catalogue with essay by Melinda Wortz (Irvine, Calif.: Fine Arts Gallery, University of California, 1984).

5. The Museum of Modern Art came under attack in the 1980s for its exclusionary, progressive narrative of the history of modern art dating back to the nineteenth century. Alfred Barr, its most influential and early formative curatorial visionary, may have contributed something to this with his schematic diagrams or family trees of artists' and their movements' developments. However, it is important to recognize, as Peter Selz has observed, that "Barr was totally opposed to Greenberg's linear approach." E-mail to the author, 29 May 2009.

6. Joseph Masheck, "California Color," *Artforum* 9 (January 1971): 72, quoted in Cécile Whiting, *Pop L.A.: Art and the City in the 1960s* (Berkeley: University of California Press, 2006), 3.

7. See Kirsten Anderson, ed., *Pop Surrealism: The Rise of Underground Art* (San Francisco: Last Gasp, 2004) and Matt Dukes Jordan, *Weirdo Deluxe: The Wild World of Pop Surrealism and Lowbrow Art* (San Francisco: Chronicle Books). The loose confederation of artists these books describe include Gary Baseman, Tim Biskup, Camille Rose Garcia, Mark Ryden, Robert Williams, and Todd Schorr. The Laguna Art Museum and the San Jose Museum of Art in California are among the very few to exhibit these artists. See the latter's publications with Last Gasp on Camille Rose Garcia and Todd Schorr.

8. Catherine Grenier, *Los Angeles 1955-1985: Birth of an Art Capital* (Paris: Divers Interforum in association with Centre Pompidou, 2006), cover copy. A partial list includes Lars Nittve and Helle Crenzien, *Sunshine and Noir: Art in L.A., 1960-1997* (Humelbaek, Denmark: Louisiana Museum of Modern Art, 1997); Stephanie Barron, Sheri Bernstein, Ilene Susan Fort, *Made in California: Art, Image, and Identity, 1900-2000* (Los Angeles: Los Angeles County Museum of Art in association with the University of California Press, 2000); Whiting, *Pop L.A.*. One survey that makes passing reference but fails to give substance to John Paul Jones and artists outside of the usual Los Angeles Pop/Finish Fetish emphasis is Nancy Dustin Wall Moure, *California Art: 450 Years of Painting and Other Media* (Los Angeles: Dustin Publications, 1998).

9. Henry Hopkins, quoted in Henry J. Seldis, "Student Selects Show's Works," *Los Angeles Times*, 27 March 1960. Hopkins would go on to organize *John Paul Jones: Painting and Sculpture, 1955-65* at the Los Angeles County Museum of Art in 1965. This was reportedly the first major retrospective the museum gave to a Los Angeles artist.

10. Hopkins was clearly impressed by the exhibition *Four Abstract Classicists*, held at the Los Angeles County Museum of Art the previous year, which was conceived by Peter Selz for the Gladys K. Montgomery Art Center in Pomona and, after Selz took the position of chief curator of Painting and Sculpture Exhibitions at the Museum of Modern Art, subsequently organized at his suggestion by critic Jules Langsner. See Peter Selz, "Abstract Classicism in Retrospect," *Art Ltd*, October 2007.

11. Henry J. Seldis, "UCLA Shows California Art," *Los Angeles Times*, undated clipping, John Paul Jones Papers, AAA.

12. Seldis himself organized an exhibition on the "California Imagists" at the Los Angeles Municipal Art Gallery, Barnsdall Park, in June of 1961. Neither Seldis nor Hopkins included the figurative painters such as Millard Sheets, Albert Stuart, Phil Dike, and a host of watercolorists loosely called the "California Watercolor School." Although these artists had come to prominence in Los Angeles in the 1930s and 1940s, they were still active and part of the art scene in Southern California during the 1950s.

13. In an e-mail to the author, Selz wrote: "I might have, but I didn't" include Jones in *New Images of Man*. E-mail to the author, 29 May 2009.

14. Selden Rodman, *The Insiders: Rejection and Rediscovery of Man in the Arts of Our Time* (Louisiana State University Press, 1960), 4-5. Rodman included about fifty artists but concentrated on Jose Clemente Orozco, James Kearns, Leonard Baskin, Rico Lebrun, Aubrey Schwartz, Jose Luis Cuevas, Peter Paone, Elbert Weinberg, Jack Zajac, and Octave Landuyt. The jacket copy described the book as a "brilliant attack on abstract expressionism."

15. Peter Selz, introduction to this monograph. In *New Images of Man*, Selz wrote of the postwar figurative artists he selected for the Museum of Modern Art's publication: "They are perhaps aware of the mechanized barbarism of a time which, notwithstanding Buchenwald and Hiroshima, is engaged in the preparation of even greater violence in which the globe is to be the target." Selz, *New Images of Man* (New York: Museum of Modern Art, 1959), 12.

16. Robert Rosenblum, "The Abstract Sublime" (1961), republished in *On Modern Art: Selected Essays by Robert Rosenblum* (New York: Abrams, 1999).

17. Susan Landauer, "Clyfford Still and Abstract Expressionism in San Francisco," in Thomas Kellein, ed., *Clyfford Still 1904-1980: The Buffalo and San Francisco Collections* (Munich: Prestel-Verlag, 1992), 92-93. This "neo-romanticism" might be a continuation or revival of developments in the 1930s, as Michael Duncan has discussed in his writings on Eugene Berman and Pavel Tchelitchew. See also Bram Dijkstra, *American Expressionism: Art and Social Change 1920 -1950* (New York: Abrams, in association with the Columbus Museum of Art, 2003).

18. John Paul Jones, in brochure for *Paintings, Prints, Mobiles*, Iowa Wesleyan College, 1951, John Paul Jones Papers, AAA.

19. Felix Landau, quoted in "Los Angeles Art Community: Group Portrait: Felix Landau," interviewed by Merle Solway Schipper, Oral History Program, University of California, Los Angeles, 1977, 34.

20. Landau, "Los Angeles Art Community," 45. Landau classed McLaughlin as being among his four favorite artists along with John Paul Jones, Paul Wonner, and Jack Zajac. "I tried very hard to get him (Jones) shows in the early years like Betty Parsons. . . . And there was just absolutely no interest at all for many, many years." (p. 39).

21. Alice Everett, "Bay Area Art News," *Evening Outlook*, 20 November 1954, in John Paul Jones Papers, AAA.

22. Karl Kasten, quoted in Susan Landauer, *Breaking Type: The Art of Karl Kasten* (San Francisco: San Francisco Center for the Book, 1999), 15.

23. Teaching notes from "Methods and Materials, Graphic Arts 125B," 1954, John Paul Jones Papers, AAA.

24. Ibid.

25. Henry J. Seldis, "Lasansky: License and Liberty Are Different," *Los Angeles Times*, 4 June 1961.

26. Frederick S.Wight, "Three Los Angeles Artists," *Art in America* 50 (spring, 1962): 88.

27. Wight, "Three Los Angeles Artists," 89.

28. John Canaday, "John Paul Jones: The American Artist Shown in Brooklyn," *New York Times*, 9 June 1963.

29. Henry J. Seldis, "Jones Reveals Poetic Personality," *Los Angeles Times*, 30 November 1965. Wight also emphasized Jones' intensity: "The look of John Paul Jones is quite special, mostly due to his intense scrutiny of the person to whom he talks. He has deep-set eyes that grow wild with communication, and they dilate until you are practically in his head. He is a Greco, or brother to Kokoschka in Self-portrait with Hand on Breast. He is thin, narrow, and black-and-white." Wight, "Three Los Angeles Artists," 88.

30. Jones, quoted in Canaday, "The American Artist Shown in Brooklyn."

31. Jones, quoted in Wight, "Three Los Angeles Artists," 89.

32. Canaday, "The American Artist Shown in Brooklyn."

33. Dore Ashton, "Prints, Brooklyn's 8th Annual," *Art Digest* (May 1954), clipping from John Paul Jones, AAA.

34. Jones is quoted as saying, "Why Should I mind being like Redon? Redon's Wonderful!" in Wight, "Three Los Angeles Artists," 88.

35. Una E. Johnson singled this drawing out in her catalogue essay for Jones' survey at the Brooklyn Museum, stating it was "a profile of exquisite sensitivity. Its fragile grace and subtle tonalities emphasize the inner strength of the individual." (Johnson, John Paul Jones, 17).

36. Odilon Redon, quoted in the *Museum of Modern Art Bulletin* 19 (winter 1952), in Edward Corbett Papers, AAA.

37. Seldis, "Jones Reveals Poetic Personality."

38. *John Paul Jones* (Los Angeles: Felix Landau Gallery, 1967), n.p.

39. Jones, quoted in Jennings, "Haunted House."

40. Jones, John Paul Jones Papers, AAA.

41. Susanne Nestory, conversation with the author, 4 April 2009. After reading the manuscript for this publication, Nestory reflected that Jones' existentialism may have occurred in boyhood. "When I was with him, he frequently recalled having just been left with his grandparents and one day playing outside, bouncing a ball against the house. 'I was eight years old and I understood that I was alone; that whatever I did in life I would have to do alone.'" (E-mail to the author, 2 June 2009.)

42. Artwork reproduced in *New York Times Book Review*, 8 October 1967.

43. Johnson, *John Paul Jones*, 14.

44. Stéphane Mallarmé, quoted in Edmund Wilson, *Axel's Castle: A Study in the Imaginative Literature of 1870-1930* (New York: Norton, 1931), 20. The full quote reads: "The Parnassians, for their part, take the thing just as it is and put it before us—and consequently they are deficient in mystery; they deprive the mind of the delicious joy of believing it is creating. To name an object is to do away with the three-quarters of the enjoyment of the poem which is derived from the satisfaction of guessing little by little: to suggest it, to evoke it—that is what charms the imagination."

45. Johnson, *John Paul Jones*, 16.

46. Jennings, "Haunted House."

47. Susanne Nestory, conversation with the author, 4 April 2009.

48. John Paul Jones Papers, AAA.

49. Quoting Susanne Nestory, conversation with the author, 4 April 2009.

50.-51. Ibid.

52. Jones' discharge papers identify him as a decorated sergeant and rifle marksman in Lineman Field 641, Battery C, of the 750th Field Artillery Battalion (which served in the XXIV Artillery under Brigadier General Josef R. Sheetz). After three years in the Army, 15 months overseas in the Hawaiian Islands and Okinawa, he was discharged in March of 1946. John Paul Jones Papers, AAA.

53. Bill Sloan, *The Ultimate Battle: Okinawa 1945 –The Last Epic Struggle of World War II* (New York: Simon and Schuster, 2007), 5-7.

54. Susanne Nestory, conversation with the author, 4 April 2009. After reading the manuscript for this publication Nestory concurred that the war was pivotal: "I feel strongly that WWII and Okinawa were integral to the development of his personal vision and philosophy as you have stated with such insight. He often lamented late in life how tired he was of fighting for his existence. I remember all too well how he revisited the war in hallucinations during the last days of his life. He cried out in anguish, 'I can't do it! I can't shoot people! I can't do it, I can't!'" E-mail to the author, 2 June 2009.

55. Whitman was speaking of the Civil War. Paul Fussell, the literary and cultural historian who has written the most psychologically penetrating account of World War II to date, concluded by quoting Whitman. See Paul Fussell, *Wartime: Understanding and Behavior in the Second World War* (London and New York: Oxford University Press, 1989).

56. Sloan, *The Ultimate Battle*, 135.

57. E. B. Sledge, *With the Old Breed: At Peleliu and Okinawa* (New York: Random Press, 1981), 260.

58. See Susan Landauer, "Painting Under the Shadow: California Modernism and the Second World War," in Paul J. Karlstrom, ed., *On the Edge of America: California Modernist Art*, 1900-1950 (Berkeley: University of California Press, 1996), 41-67.

59. Walter Kuhlman, quoted in Susan Landauer, *The San Francisco School of Abstract Expressionism* (Berkeley: University of California Press in association with Laguna Art Museum, Laguna Beach, Calif., 1996), 108.

60. Ibid.

61. Landauer, *San Francisco School*, 239 n. 69.

62. Sam Hunter and John Jacobus, *American Art of the 20th Century: Painting, Sculpture, Architecture* (New York: Abrams, 1973), 203. Hunter was writing about Jackson Pollock in this instance, but he makes similar observations on other painters elsewhere.

63. John Paul Jones Papers, AAA. In his notes, Jones appears to make this statement about "Noguchi," presumably Isamu Noguchi, but this characterization does not fit the sculptor.

64. According to Tom Dowling, Jones' student and friend of many years, Oliveira and Jones "felt a connection" when they saw each other's work years later, and "they were surprised by their affinities." Dowling, conversation with the author, 4 April 2009.

65. The painting is reproduced on page 34 of Susan Landauer, *Edward Corbett: A Retrospective* (Richmond, Calif.: Richmond Art Center, 1990).

66. John Paul Jones Papers, AAA.

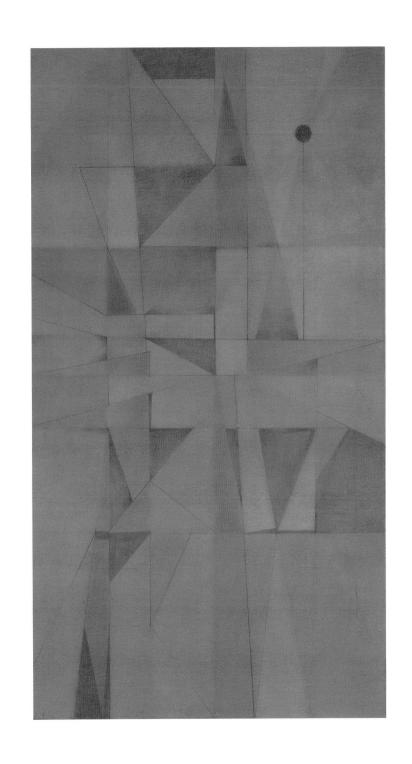

Green Landscape, late 1940s
Oil on linen, 20" x 36"
Noble and Hudson Collection

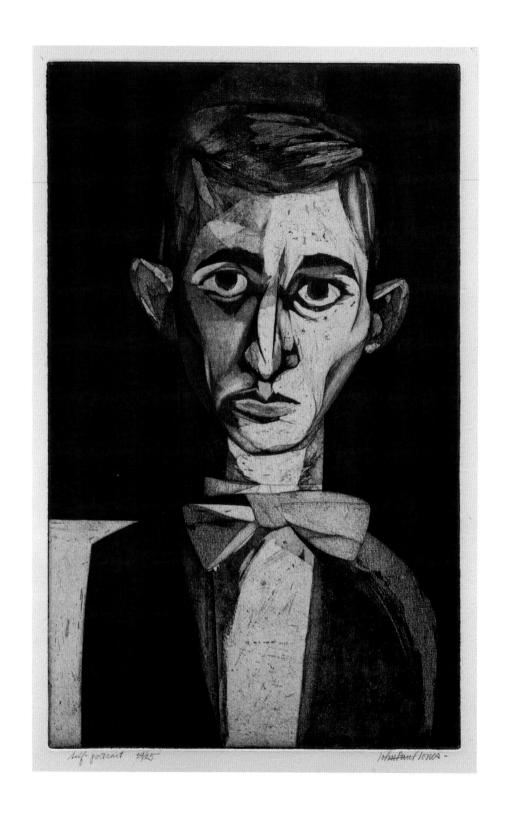

self-portrait 3/25 John Paul Jones -

Self-Portrait, 1950
Etching, soft ground and aquatint, 16"x 10"
John Paul Jones Estate

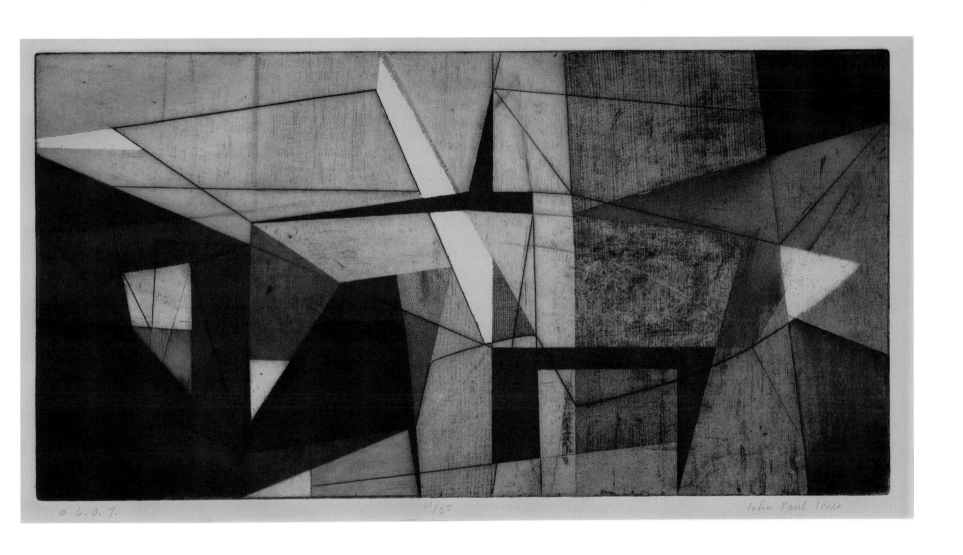

6.0.7., 1949
Etching and aquatint, 9¹/₈" x 18"
John Paul Jones Estate

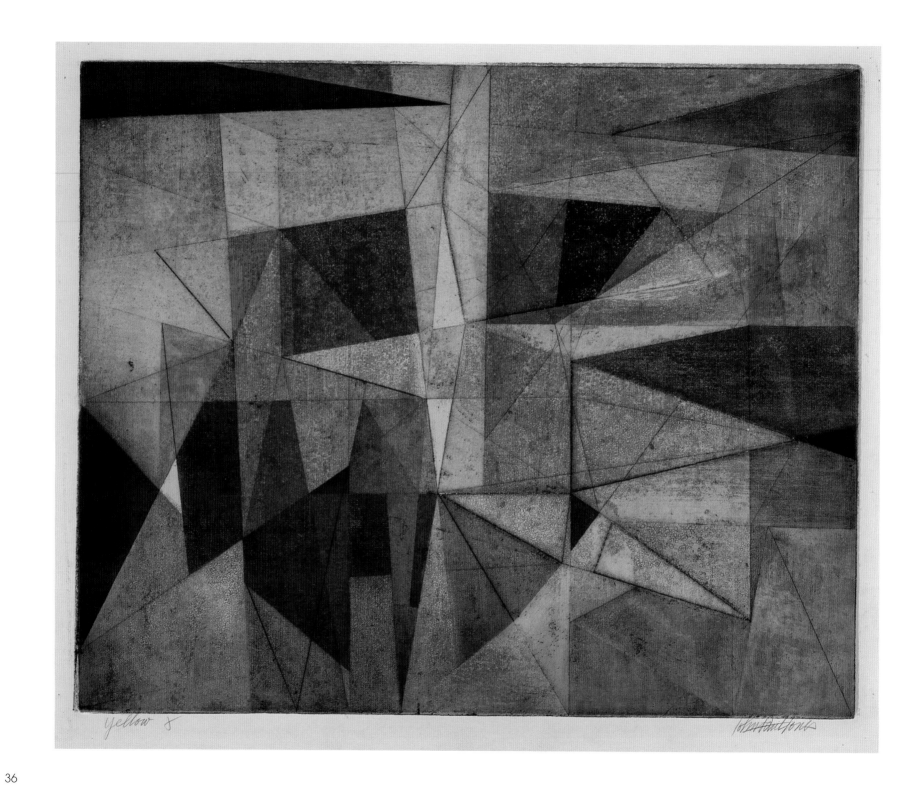

Yellow 8 John Paul Jones

the great artist makes the human race look like a better idea.

J.J.

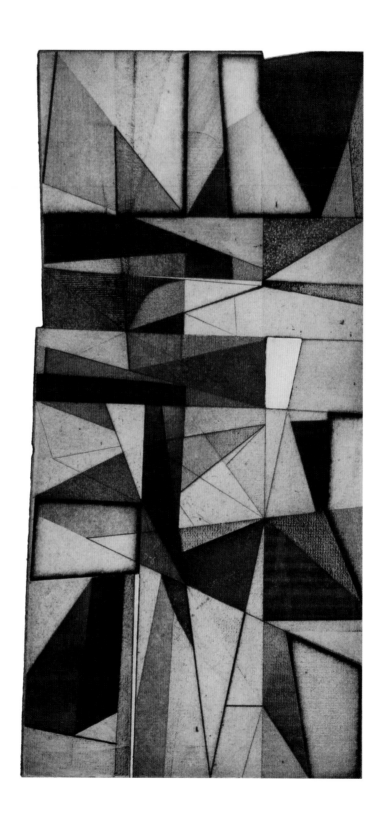

Monument 8, 1954
Monoprint, 13⅞"x 6¾"
John Paul Jones Estate

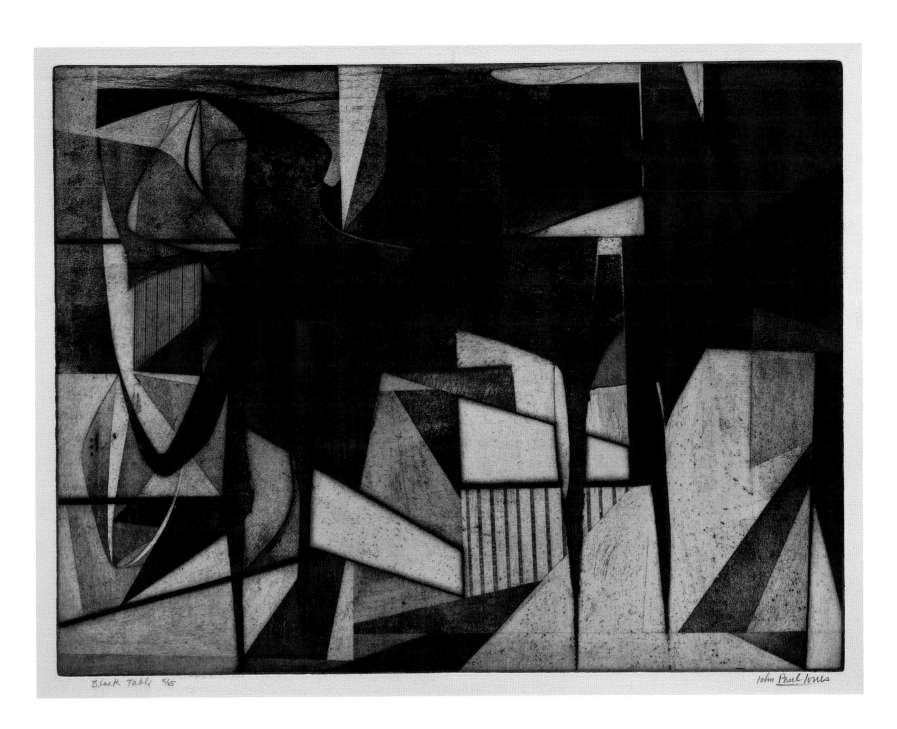

Black Table, 1953
Etching and aquatint, 17⅞"x 23⅞"
John Paul Jones Estate

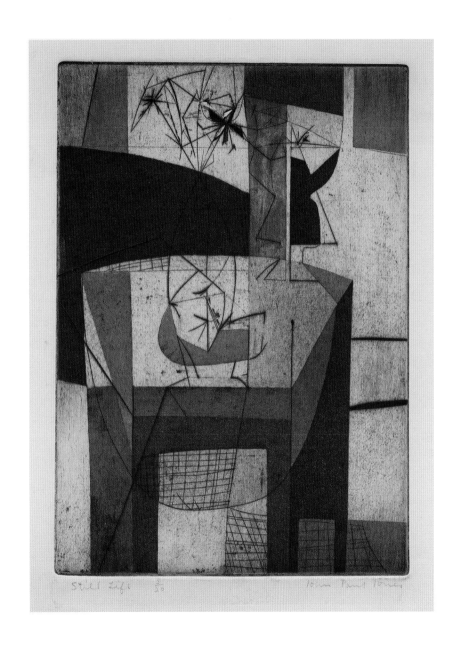

▶ **Still Life**, 1948
Etching and aquatint, 11"x 7¾" (ed.25)
John Paul Jones Estate

◀ Detail of **Still Life**, 1948

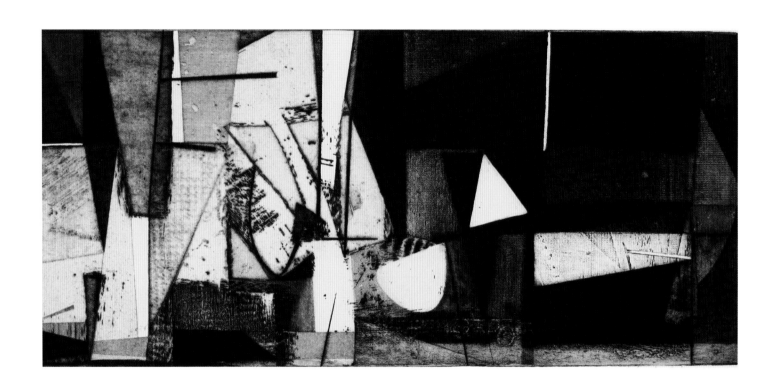

White Landscape, 1952
Monoprint, 7½" x 16⅛"
John Paul Jones Estate

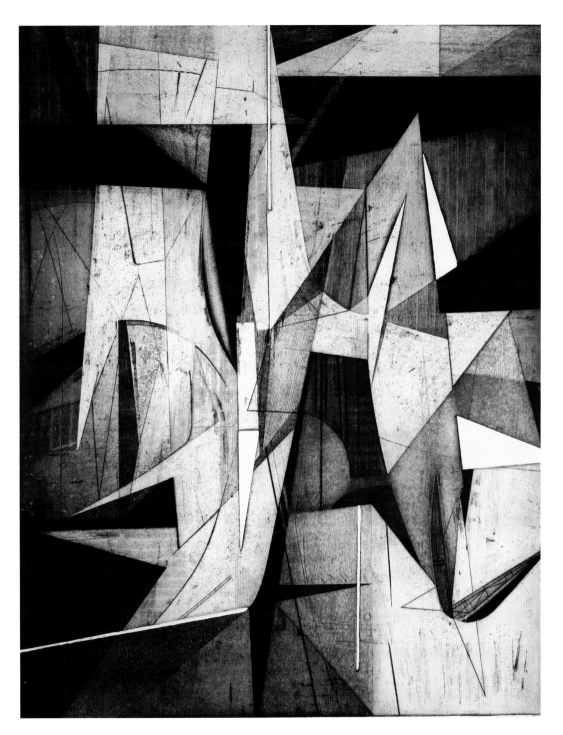

Boundary, 1951
Etching, soft-ground, aquatint and engraving, 28"x 22"
John Paul Jones Estate

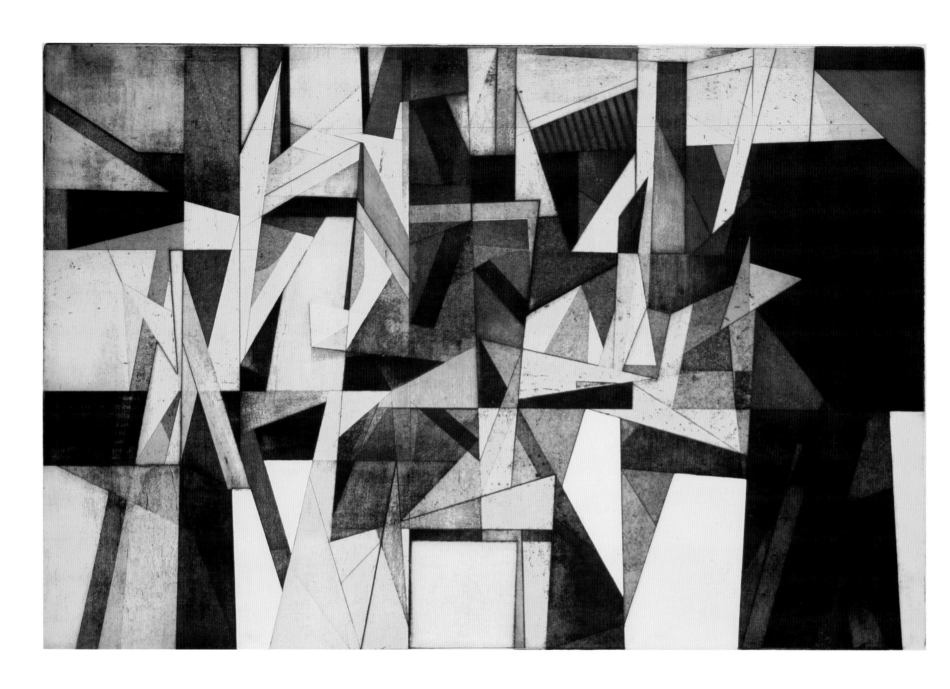

Untitled, 1955
Etching, soft-ground,
aquatint and dry point, 23⅞" x 35¾"
John Paul Jones Estate

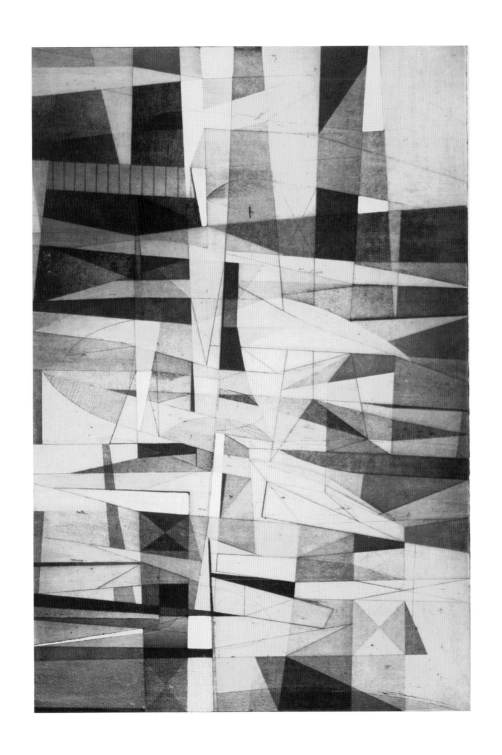

Suspension, 1953
Etching, engraving,
aquatint, and soft-ground, 21½" x 15"
John Paul Jones Estate

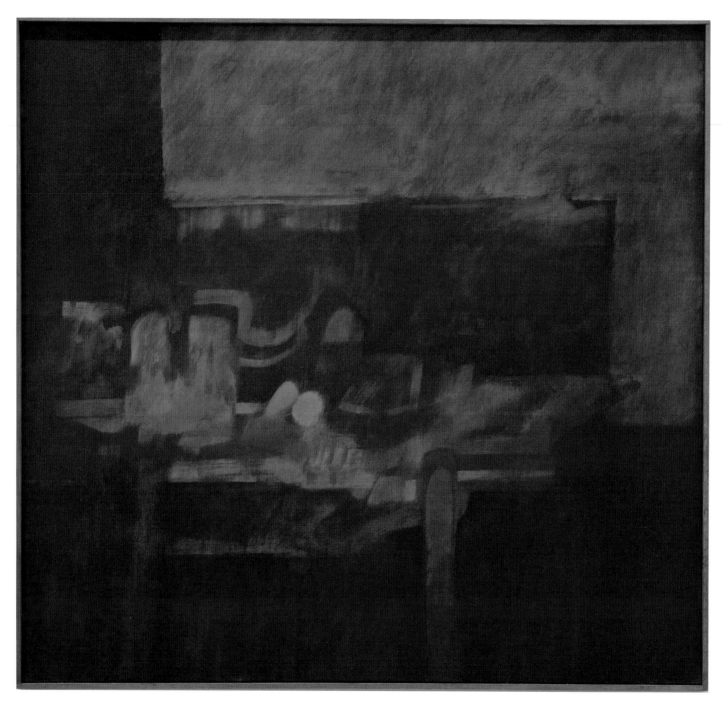

Table Painting, late 1940s or early 1950s
Oil on canvas, 36"x 34"
Noble and Hudson Collection

Untitled, 1959
Charcoal and pastel, 4½"x 3¾"
Noble and Hudson Collection

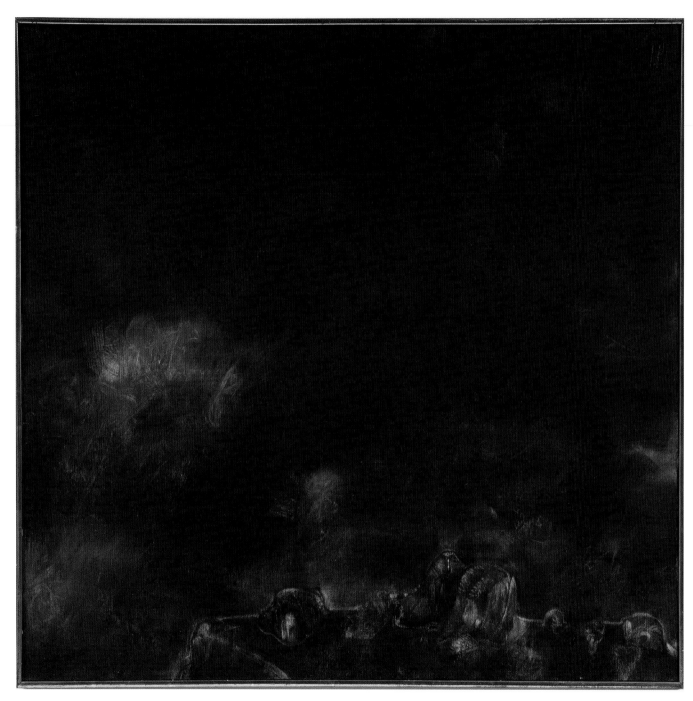

Hatmaker's House, c. 1958
Oil on canvas, 25½"x 26½"
Jones Paul Jones Estate

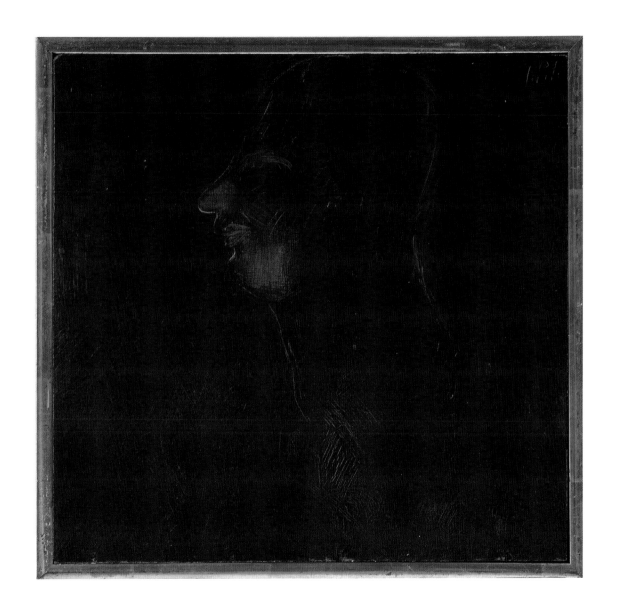

▶ **Study for Man of Flanders,** 1962
 Oil on masonite, 11½"x 12"
 Dowling Family Collection

▼ *Following two pages*:
 Title Unknown, mid-1960s
 Oil on canvas, 33"x 21"
 Alicia and David Price Collection

49

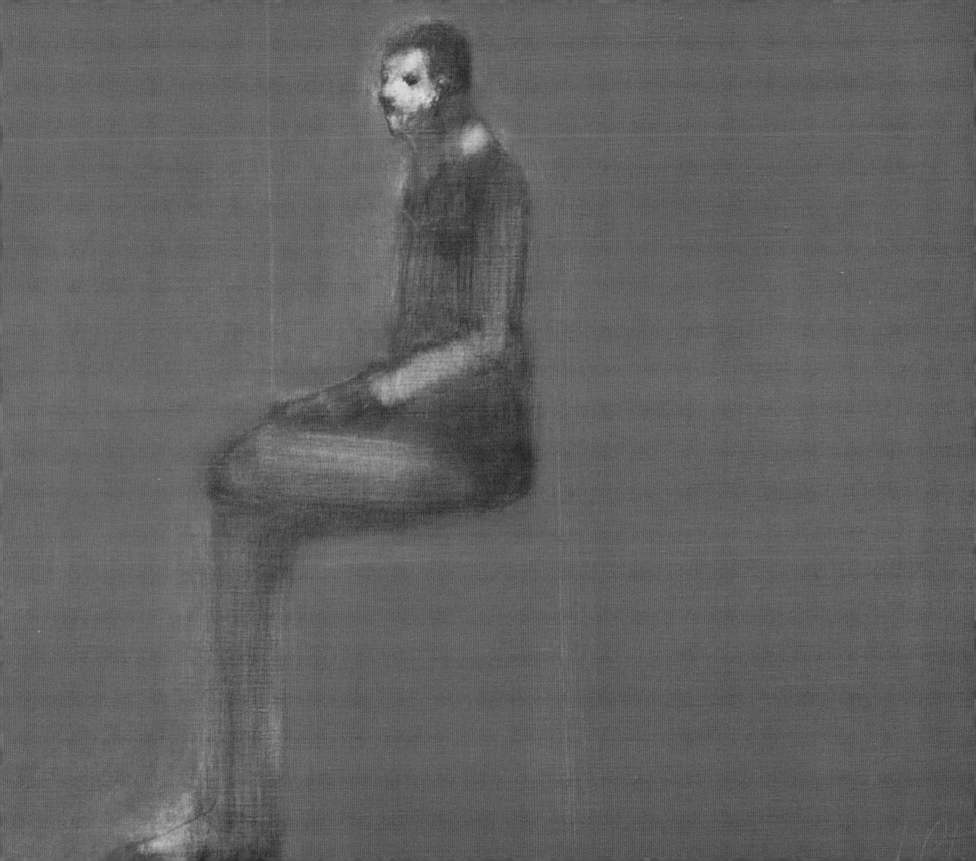

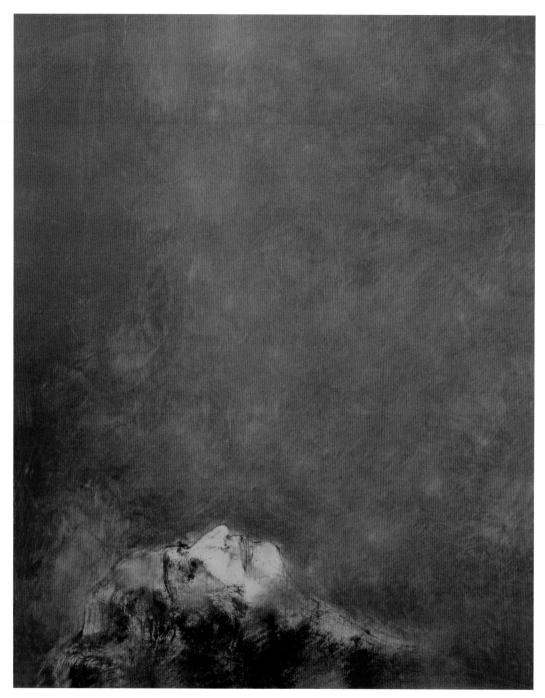

Waiting Woman, 1963
Oil on paper on board, 23"x 18¼"
Rae Lynn and Bret Price Collection

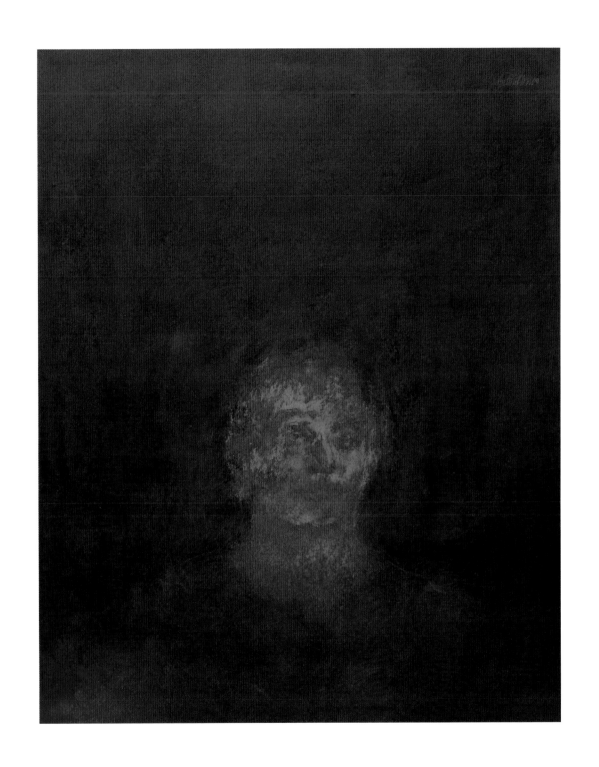

October's Lady, 1963
Oil on paper, 23¾"x 18"
Rae Lynn and Bret Price Collection

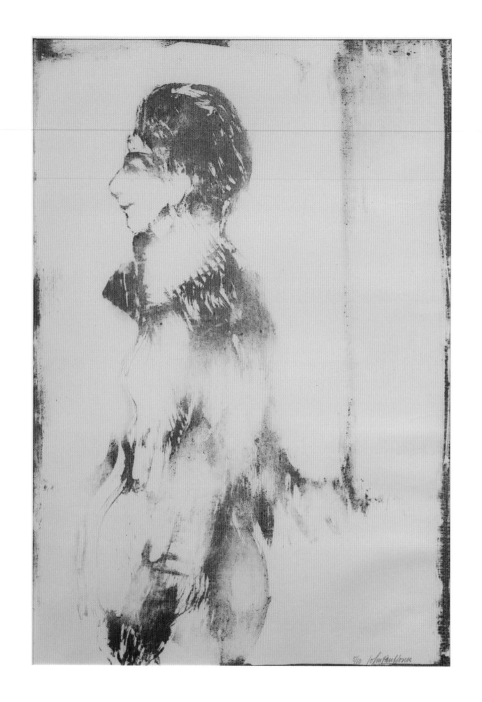

Red Profile, 1961
Lithograph in red ink, 21½"x 15½"
John Paul Jones Estate

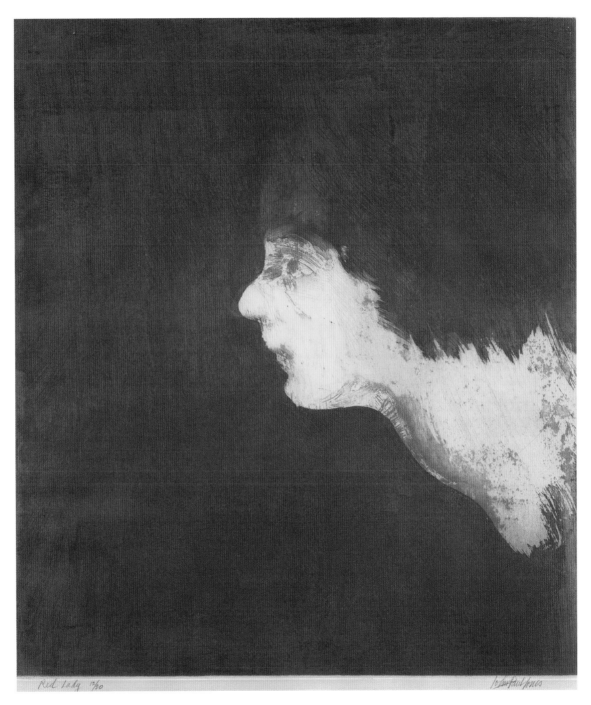

Red Lady, 1961
Etching and aquatint in red ink, 19½"x 17"
John Paul Jones Estate

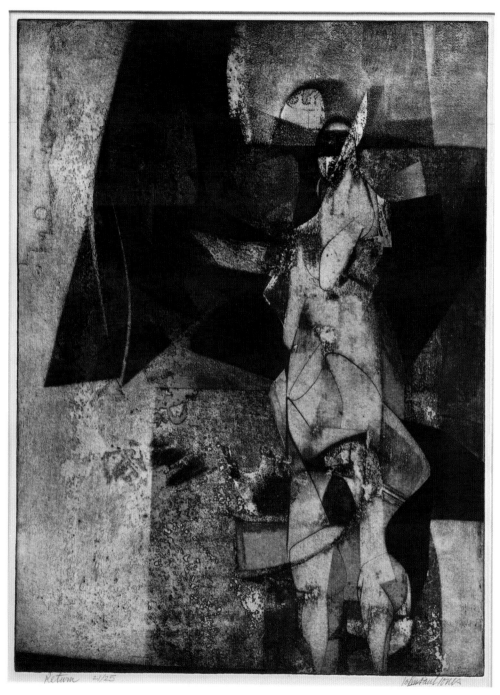

Return, 1954
Etching and aquatint, 23⅞"x 17⅞"
John Paul Jones Estate

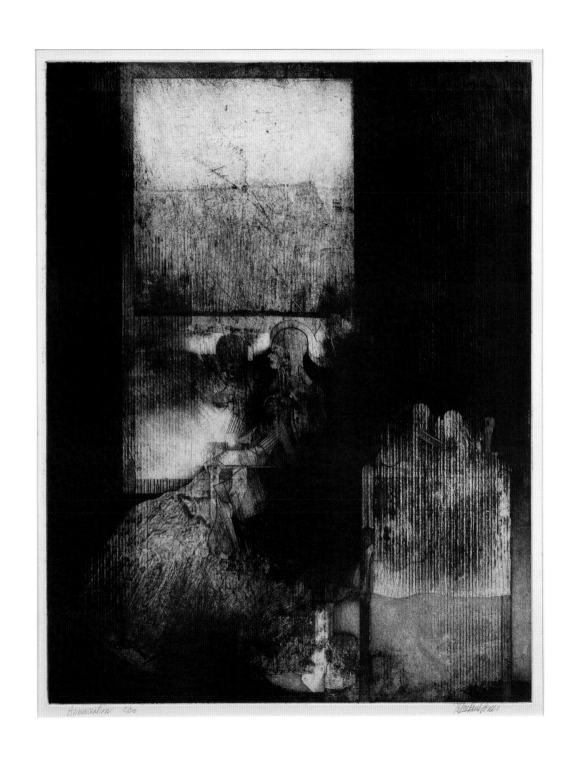

Annunciation, 1959
Etching and soft ground, 28″ x 25″
John Paul Jones Estate

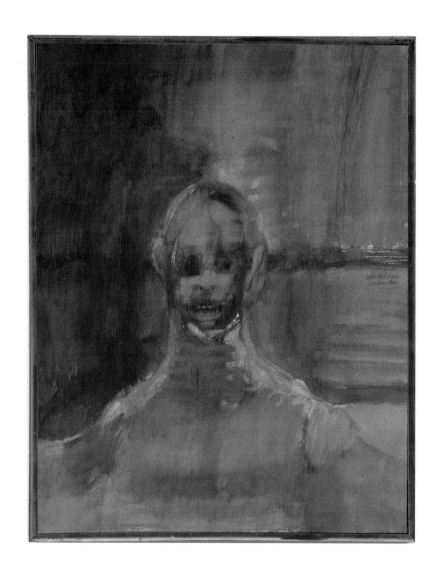

Spectre, 1960
Oil on paper, mounted on masonite, 23" x 18"
Dowling Family Collection

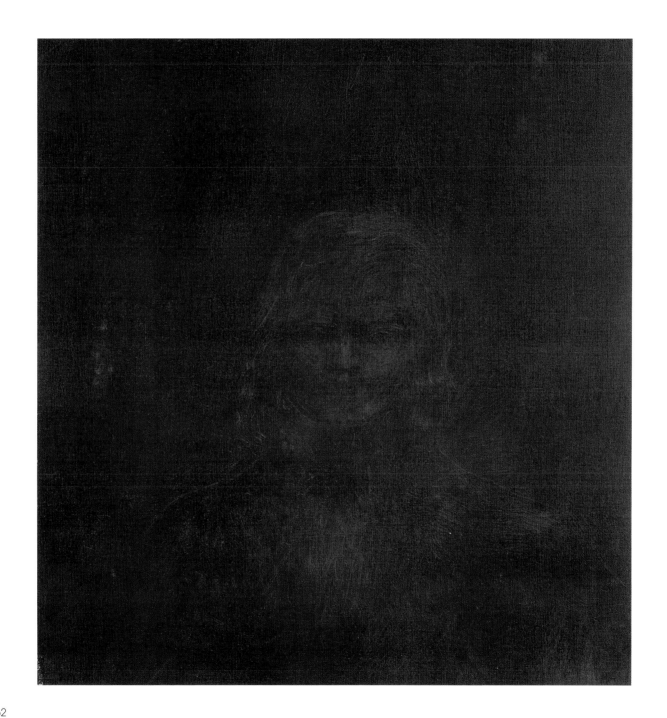

Portrait of a Writer, 1962
Oil on linen, 22½"x 19"
John Paul Jones Estate

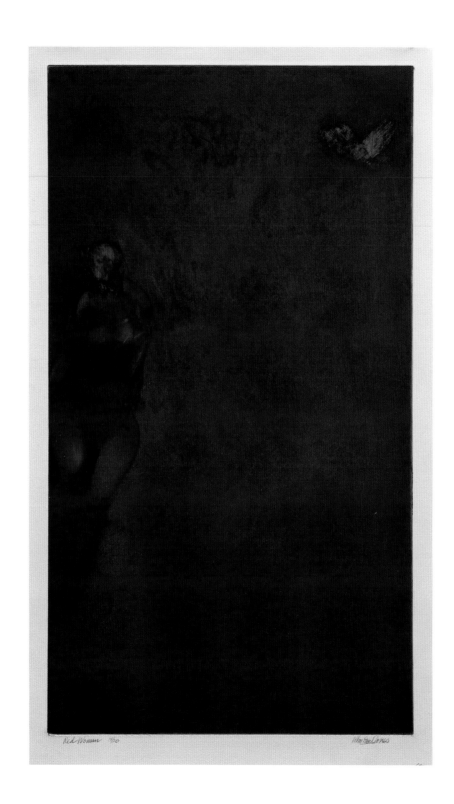

Red Woman, 1958
Etching and aquatint,
31¾"X 18"

John Paul Jones Estate

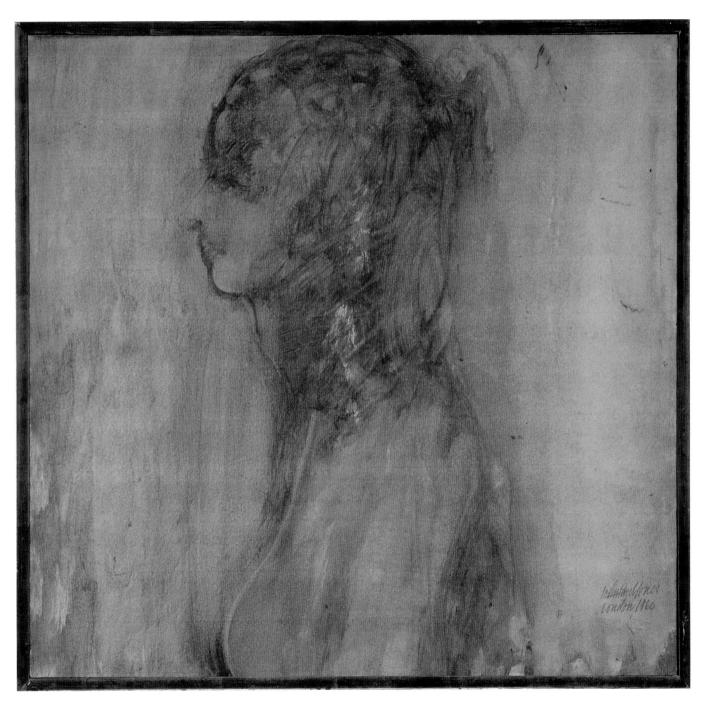

Profile/London, 1960
Oil on paper, mounted on masonite, 17¼"x 18¼"
Dowling Family Collection

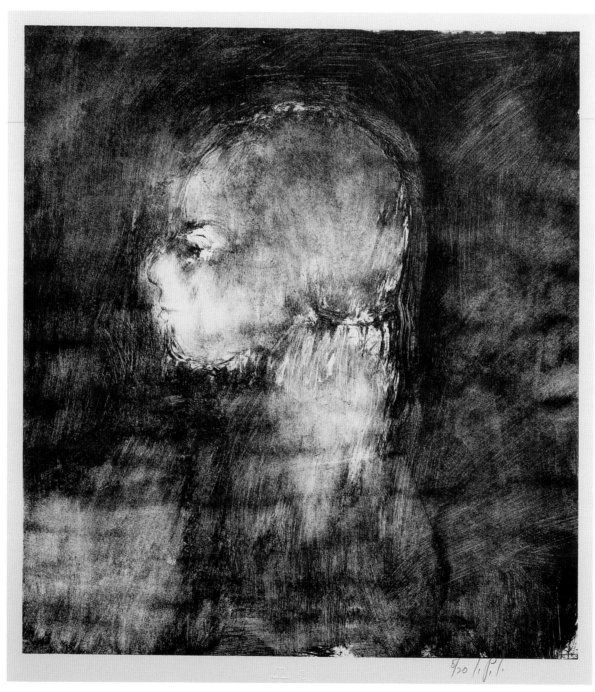

Girl with Hair Tied, 1963
Lithograph, 16"x 14⅝"
John Paul Jones Estate

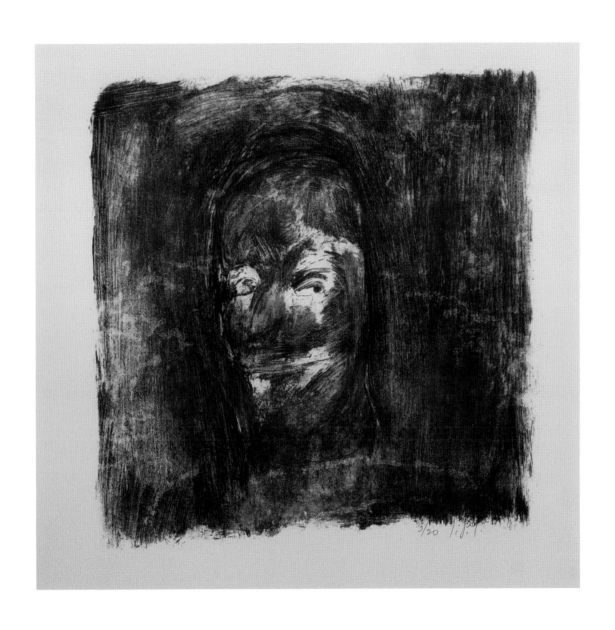

Knight of a Different Color (Brown Knight) 1963
Color lithograph, 13"x 13"
John Paul Jones Estate

63

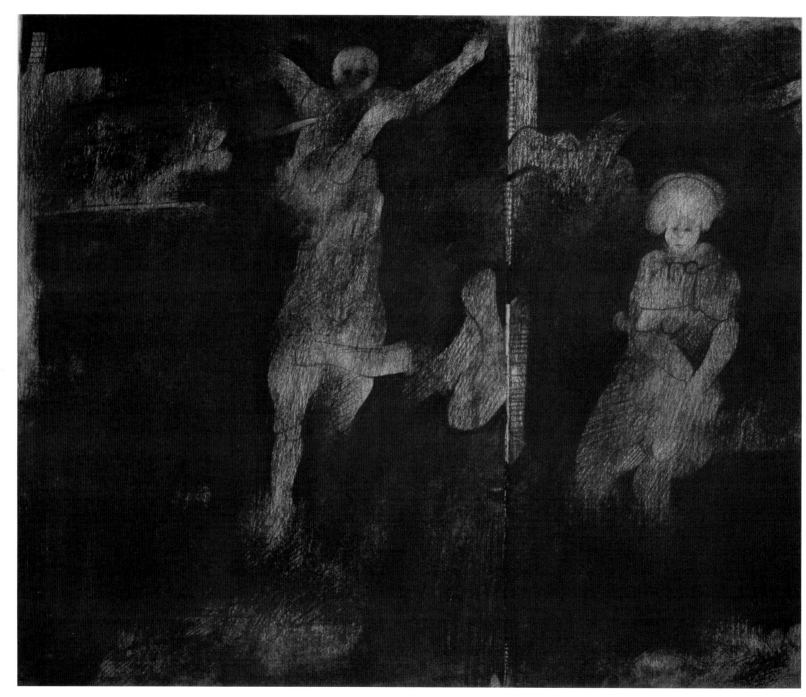

Crucifixion, 1959
Charcoal on paper, 30" x 36"
John Paul Jones Estate

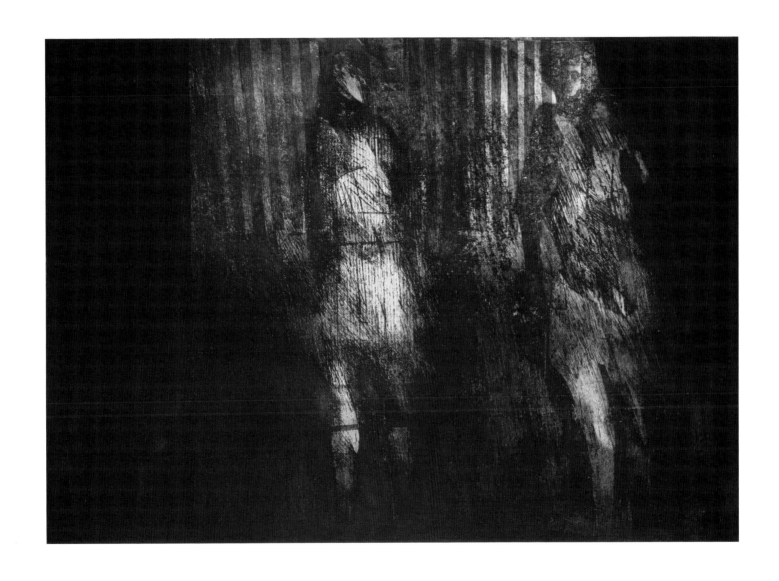

Double Portrait, 1957
Etching, soft-ground and aquatint, 23¾″ x 33″
John Paul Jones Estate

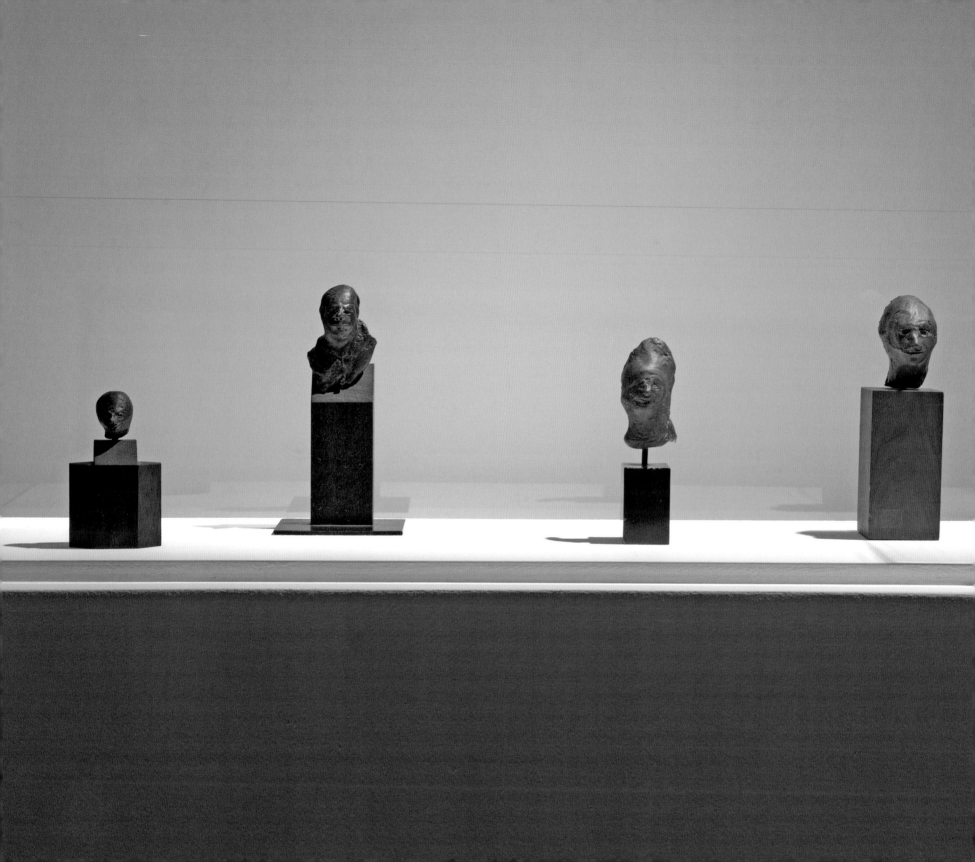

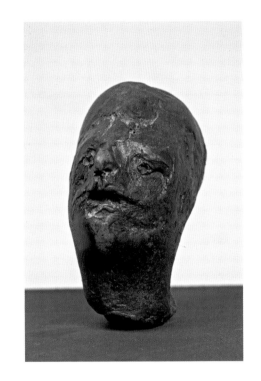

◀ **The Flemish Master**, 1962
Bronze, 1¼" h
Noble and Hudson Collection

Woman from Vondel Park, 1962
Bronze, 3⅛" h
Noble and Hudson Collection

The Knight's Mistress, 1962
Bronze, 3" h
Landau Family Collection

Elegante, 1962
Bronze, 2½" h
Landau Family Collection

▶ **Title Unknown**, 1962
Bronze, 2" h
Noble and Hudson Collection

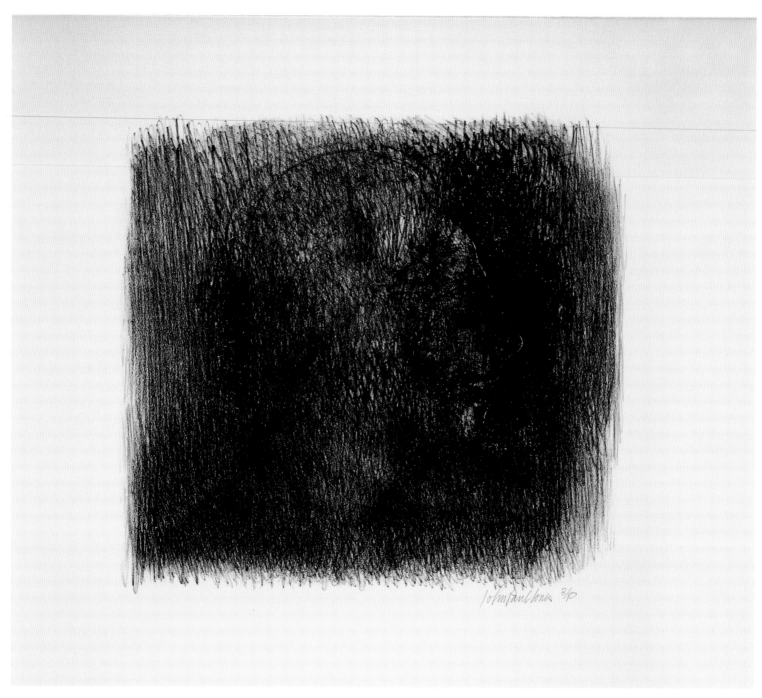

Untitled, 1962
Lithograph, 12"x 13"
John Paul Jones Estate

68

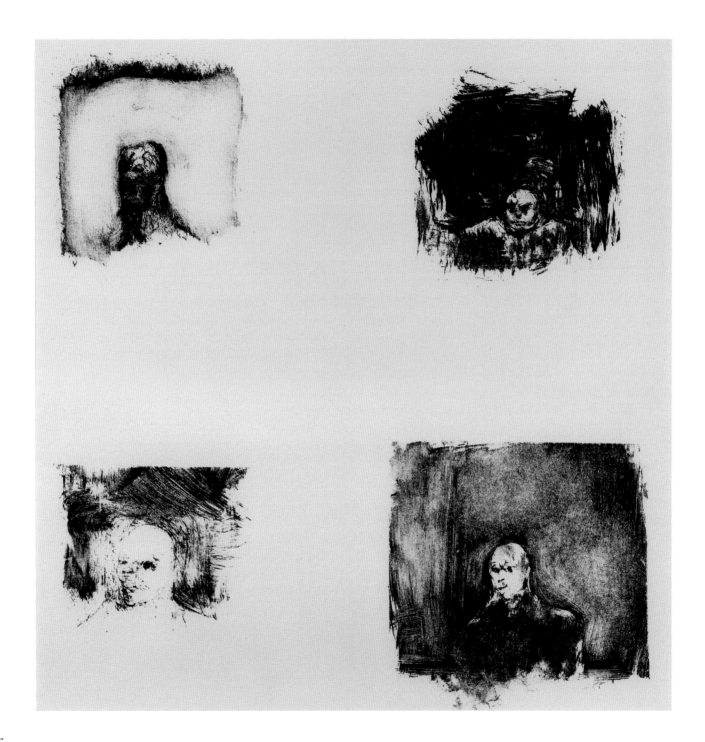

Four Heads, 1963
Lithograph, 20½" x 16½"
John Paul Jones Estate

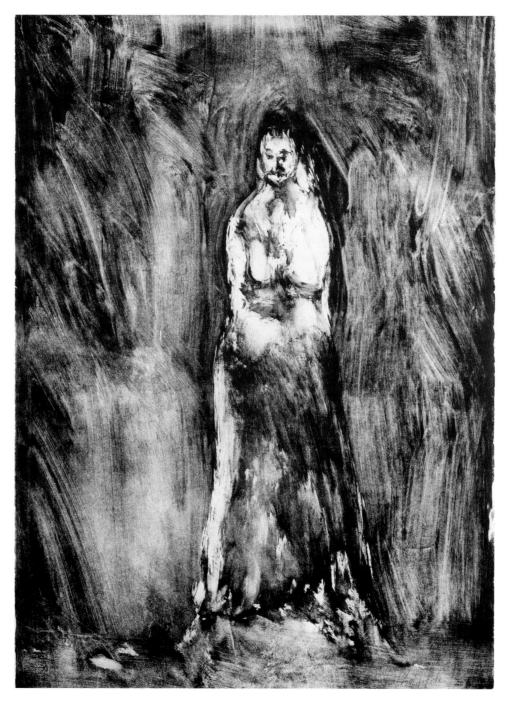

Girl for Goya, 1963
Lithograph, 30"x 22"
Chapman University Collection

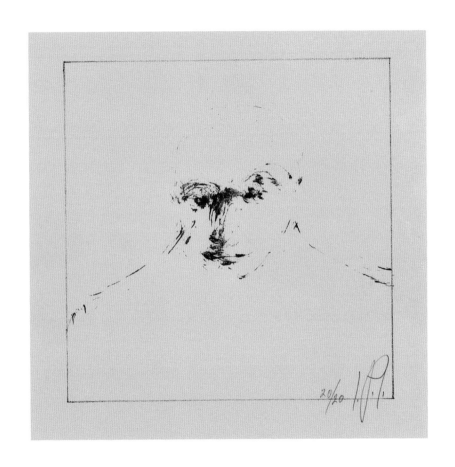

Untitled, 1963
Lithograph, 7½" x 6"
Keith and Maggi Owens Collection

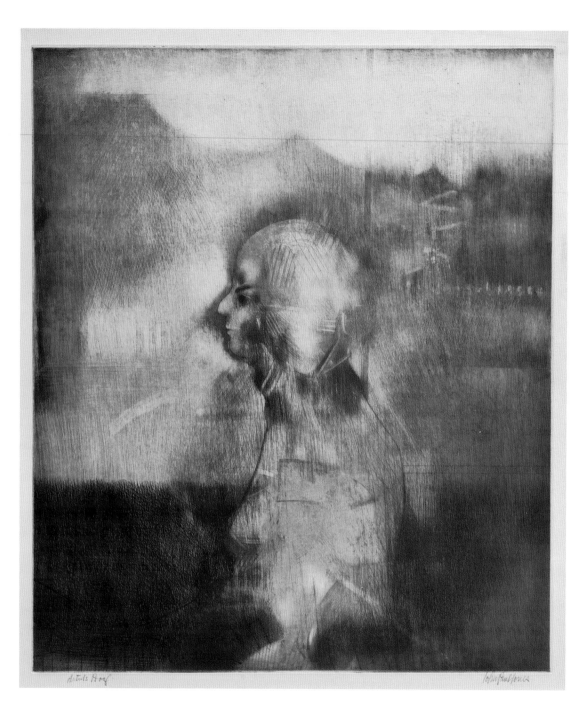

Landscape Woman, 1961
Etching, 21½"x 18¾"
John Paul Jones Estate

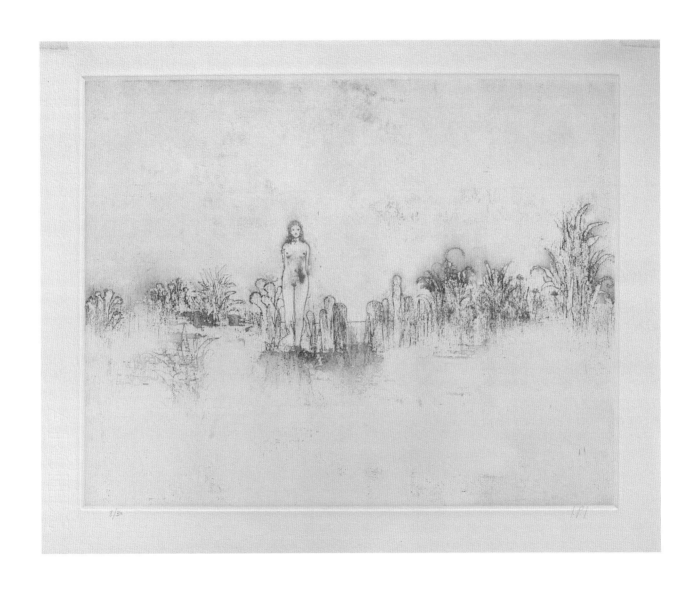

Rose Desert, 1968
Etching, 15"x 18¾"
Laguna Art Museum Collection

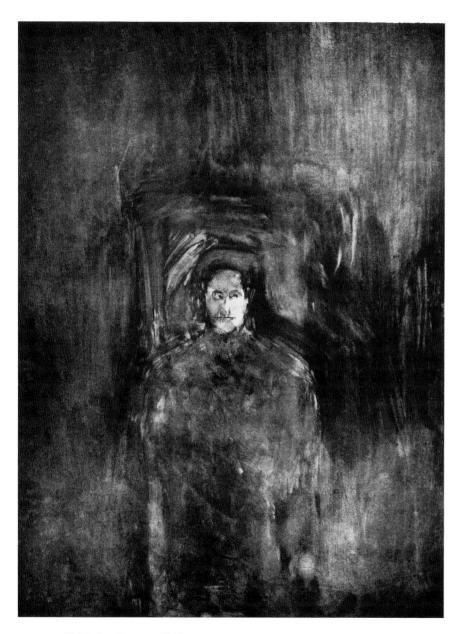

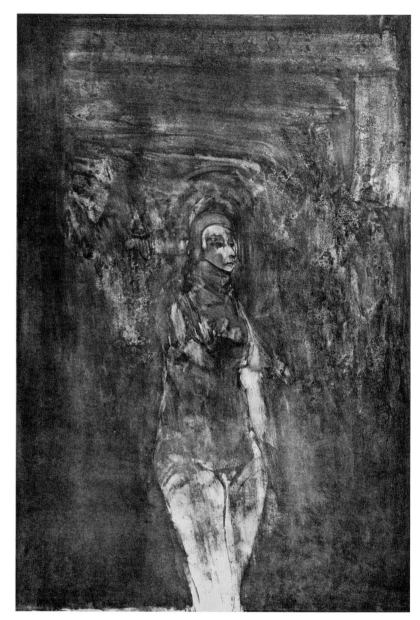

Welsh Goalkeeper, 1963
Lithograph, 25"x 19"
Cal State Fullerton Collection

Girl with Fat Legs, 1963
Lithograph, 27⅞"x 19"
74 Cal State Fullerton Collection

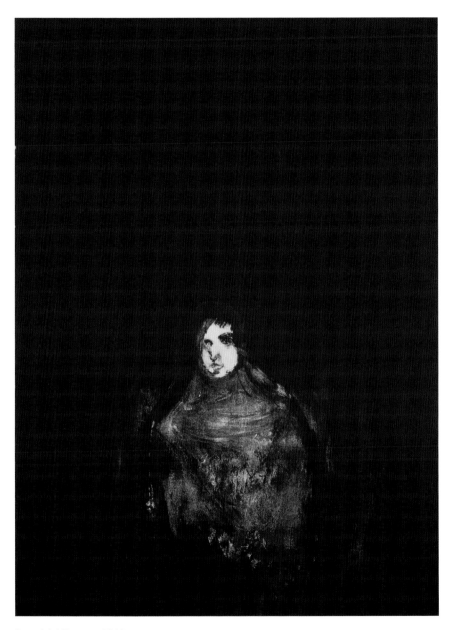

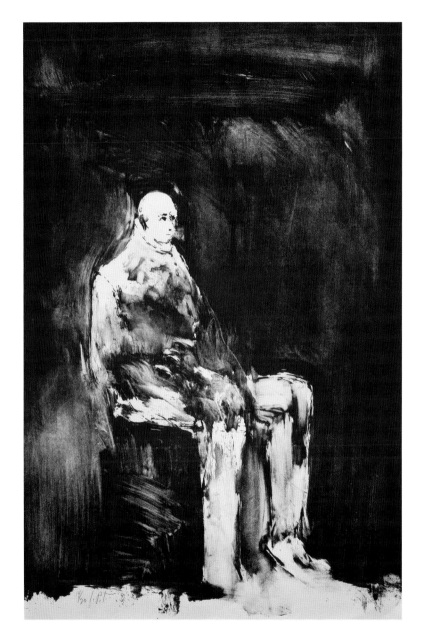

Spanish Woman, 1963
Lithograph, 26"x 19"
Cal State Fullerton Collection

Bovitch in Egypt, 1963
Lithograph, 33"x 23"
Fullerton College Collection

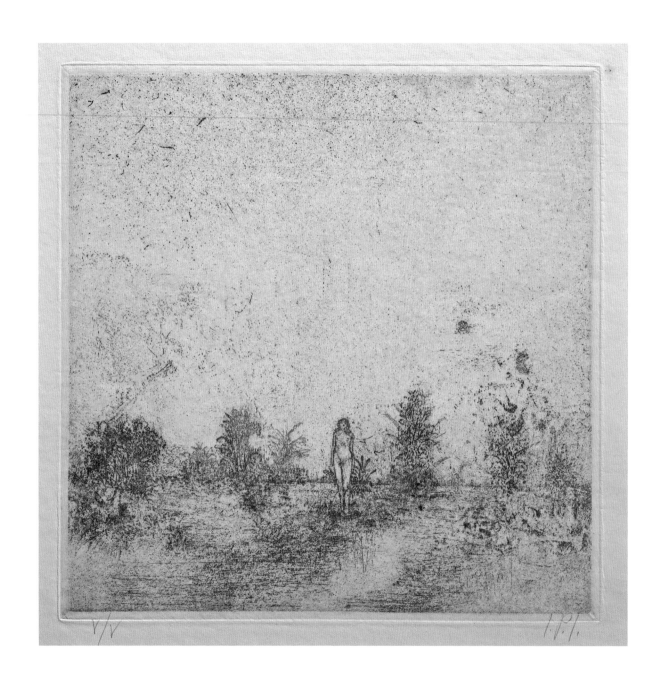

Grove Woman, 1968
Color etching, 8¾" x 8¾"
Laguna Art Museum Collection

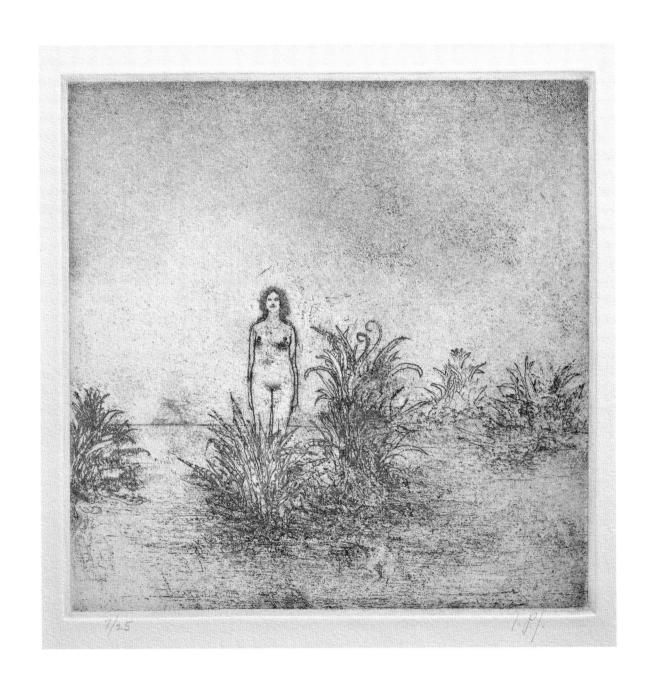

Sealine, 1968
Etching, 8¾"x 8¾"
John Paul Jones Estate

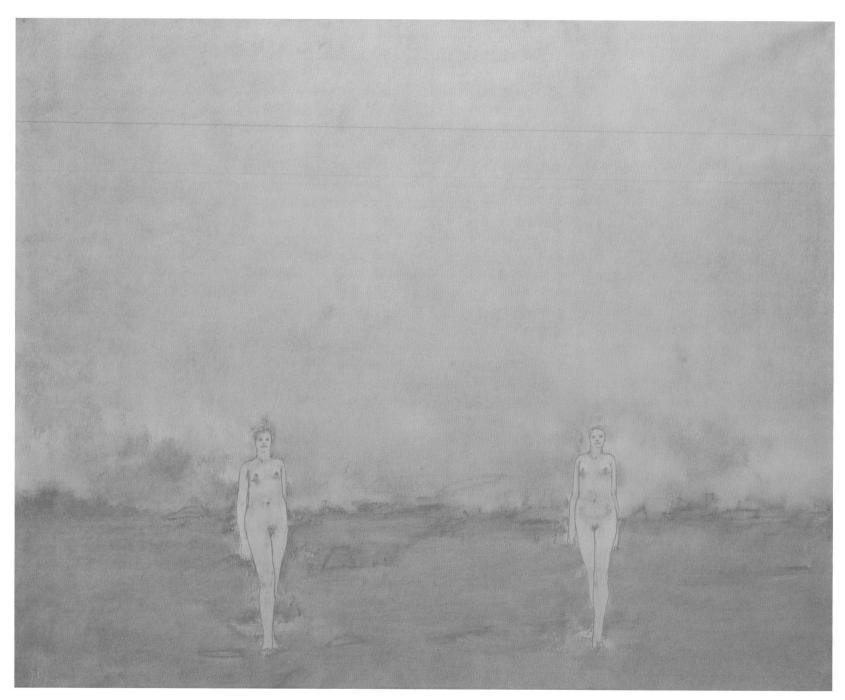

Sisters, 1968
Oil on canvas, 38″ x 48″
Fullerton College Collection

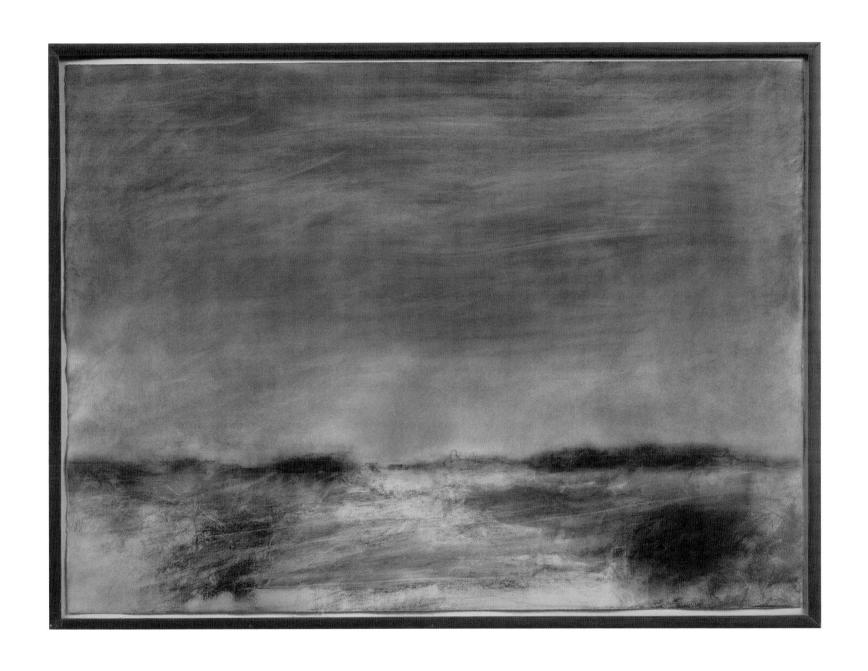

Clay Fields, *1966*
Pastel and charcoal on paper, 30"x 42"
Noble and Hudson Collection

Mid-Career Works

Interview with June Wayne

Mike McGee

Artist, designer, lithographer, and educator June Wayne was a founding director of the Tamarind Lithography Workshop, which opened in Los Angeles in 1960. In 1970 the workshop became affiliated with and moved to the University of New Mexico, Albuquerque, where it continues to educate fine art lithographers and offer fellowships to artists. John Paul Jones was awarded fellowships at Tamarind in 1962 and 1980. This interview took place at June Wayne's studio on Tamarind Street in Los Angeles on March 19, 2009.

MM: How did you meet John Paul Jones.

JW: I don't remember. Surely just hanging out with artists—at openings, museums, possibly Landau's or UCLA. We swam in the same waters. I rarely knew, personally, the artists invited to Tamarind but I knew their work. An invitation to Tamarind could result from my sense that an artist had something special to offer the medium. We could serve twelve artists a year for two months each. Their arrivals were staggered, so on the first of each month an artist would finish a residency and a new one arrive. In this way, the group could give the new artist a lot of attention when it was needed most.

MM: You invited people?

JW: Yes. We did not accept applications but rather would consider what we had already produced and then looked for aesthetics that were missing.

MM: John Paul was a teacher, famous for that. Did you encounter that in any way?

JW: I knew he was a teacher but I never held it against him.

MM: So how was that different, as an experience for Tamarind, to have someone who intimately knew about the medium, as opposed to someone who didn't? Did it bring up specific changes?

JW: As I recall, Jones did not know as much about litho as he did intaglio. In any case, you never know everything about anything. If you brought in a good artist, you would get something new nearly every time, and in this way we added many new techniques to litho as experiments or even accidents by artists responding to an unfamiliar métier.

MM: Did you have other artists who were thoroughly trained as printmakers with whom you collaborated?

JW: Yes, but remember that within the print groups there were dozens of techniques, some utterly different from others. Most of the artists we worked with had never made prints before, although some, like John Paul, were expert at one or two kinds.

MM: So how did Tamarind respond differently to someone with or without knowledge of the medium?

JW: Being an autodidact myself, I did not necessarily value the amount of normal training of an artist. Most of the artists we worked with had no previous experience with printmaking, and even fewer with litho. In a way, that made it easier because there weren't as many bad habits to unlearn. Also, remember the times: Prints were not "in" in the art world. It was a time when the museums were building new and huge galleries—all white walls and not enough big paintings to put in them. The revival of prints coincided with the founding of Tamarind, not with the huge fields of paintings needed to cover those empty museum walls.

MM: Did that bring up specific challenges for Tamarind?

JW: Yes, indeed, but, again, you never know everything about anything. If you brought in someone who was good already, you could learn a hell of a lot that could be very stimulating even though it came from some other technique. It was boring to work with someone who didn't know what a #2 crayon could do. Everything depended on the sensibility of the artist, and John Paul had a unique sensibility. His work was exquisite, disciplined—international modern but also romantic. The way he could lay down a wash was downright romantic.

MM: Is there anything in particular you remember about him?

JW: I never visited his home. I didn't know his family. He was quiet, compact, nothing extra pasted on him. But remember that the relationship between men and women was different in those years. Women didn't count as artists, so one was either having an affair with a male artist or one was a casual acquaintance, but almost never a colleague. I was certainly not a girlfriend and was thought to be a bit pushy by the "real" artists, who were men. The only artist who wasn't sexist was Lorser Feitelson.

MM: So you remember John's shows at Landau and LACMA?

JW: Yes, and I loved them.

MM: Later in his life he dramatically changed his artistic style and medium and began doing sculptures that were very minimalist and handcrafted with wood…how do you see that connecting to his other bodies of work?

JW: It shares essential characteristics. The economy, the line—the surfaces were so beautiful and so subtle. It was almost like poetry. I just loved his work.

MM: Is there anything else you remember about John Paul?

JW: I often wondered how…where it came from, the exquisite romanticism of his lithos. They were really romantic. I didn't know him well. I didn't know his stories. I didn't know his injuries. But it appealed to me, the fragility, a kind of edge to his works of art.

MM: Not very popular these days.

JW: Oh, screw it!

MM: (Laughs)

JW: "Popular" is always brief anyway.

MM: How do you think Jones' training as a printmaker affected his art in other media?

JW: Printmakers are developers. The difference between printers and artists is that printers enjoy reps (repetitions), they enjoy getting it right. They work until they get it right. And they know when they get it right. An artist is an artist. It doesn't matter very much what medium. They bring the results into it. Artists are what they are.

I understand what it took for John Paul to make one of those smoky textures or draw that line or make those exquisite objects. I don't know what he went home to. It didn't matter. The way he would pick up a tool is familiar to me. I'm part of the tribe. It's happened to me. I have this dual vision where I'm suffering, I'm mad, trying to get myself out of quicksand. Every artist does. The artist recognizes the artist.

And in that sense, John Paul and his work were so meaningful to me. I so appreciated the line that he didn't draw and then to go from that to these immensely romantic gouache pictures, and I would look at him, and think to myself—he was slim and put together like one of his drawings.

I really appreciated him because he was new to (lithography). He intuited it without reference to intaglio. He saw it for its own potential. And did it beautifully. I considered him a great success. We sent out into the world a batch of his lithos that are just so good.

MM: Do any of his works stand out to you?

JW: There was one of a woman's face. It's not a large print. It's all in gouache. You'd think that there's some kind of costume. I don't know what it was. It was so nice that he didn't get literal. I have images in my head about turning that into an identity . . . but it seems almost impossible to do so.

4/20 J.P.J.

Ming Stills, early 1970s
Etching, 10¼" x 14¾"
John Paul Jones Estate

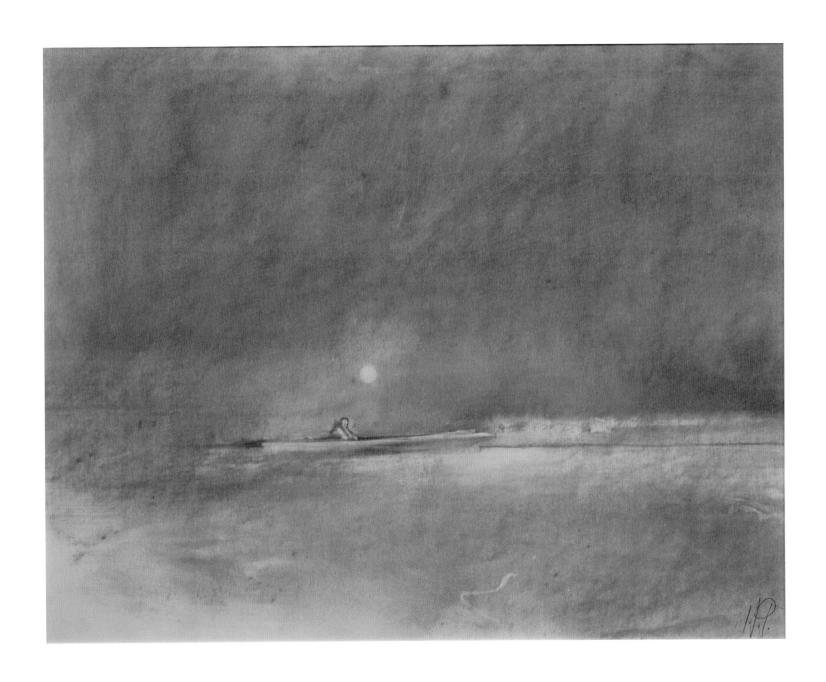

The Unspoken Oarsman, late 1960s
Charcoal on clay-coated paper, 21½"x 20½"
John Paul Jones Estate

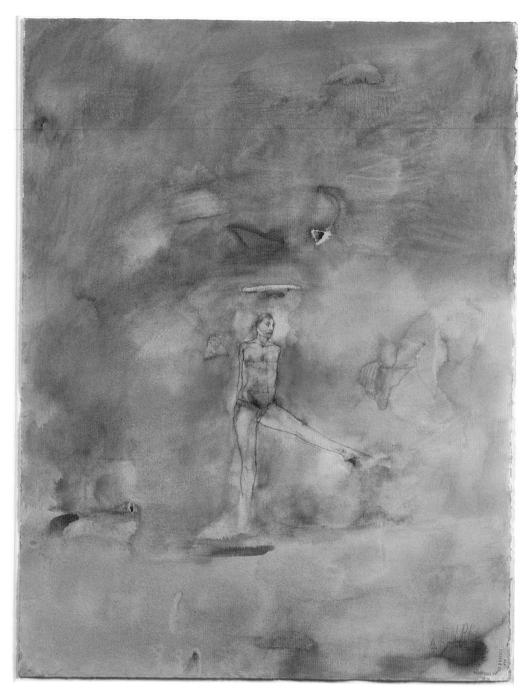

One Step, 1970
Watercolor, 26" x 20¼"
Landau Family Collection

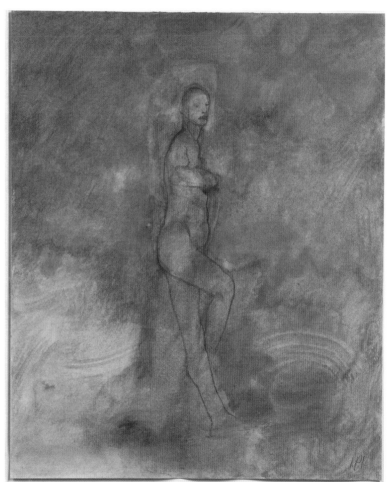

Runner, 1970
Watercolor, 26"x 20¼"
Keith and Maggi Owens Collection

Still Woman, 1970
Watercolor, 18"x 15"
Fullerton College Collection

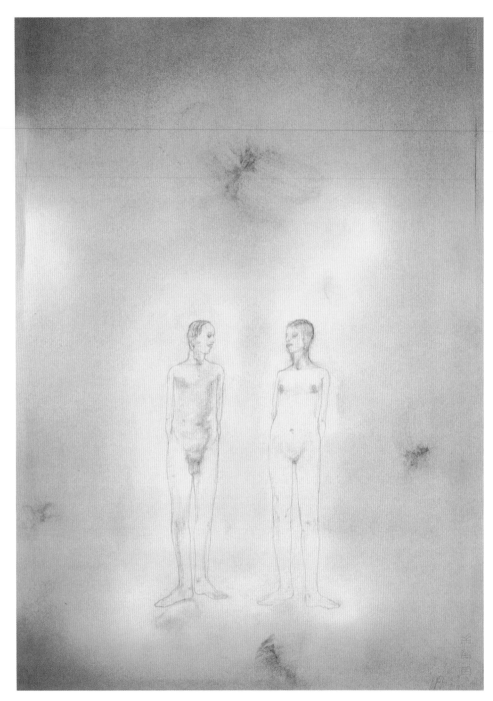

No Double, 1970
Charcoal and pastel on paper, 41½″ x 29¾″
John Paul Jones Estate

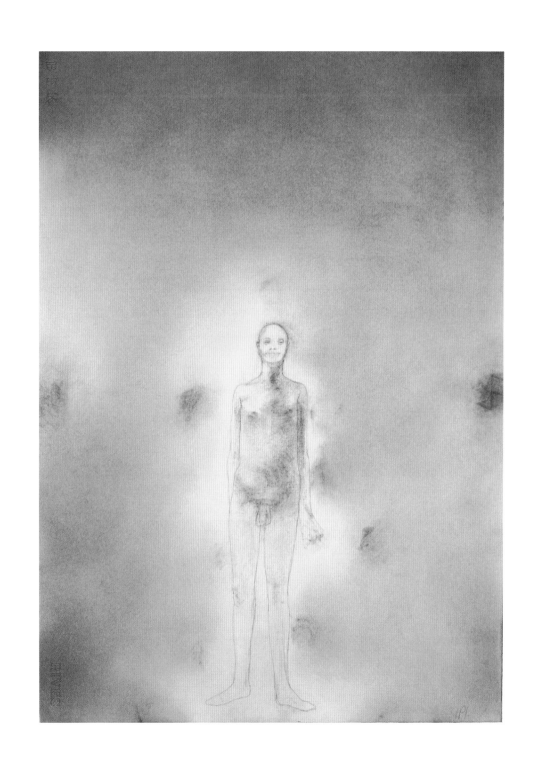

Near Green, 1970
Charcoal and pastel on paper, 41½" x 29¾"
John Paul Jones Estate

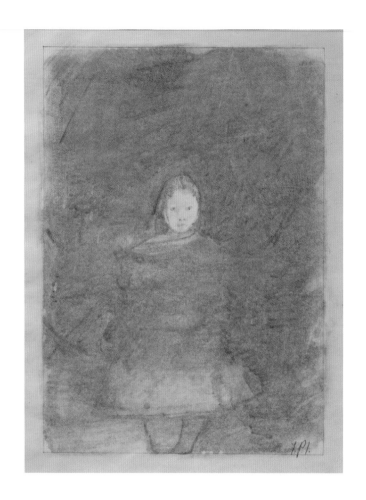

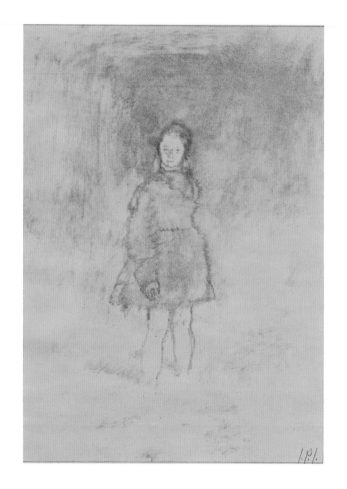

Untitled (Portrait of Megan) (both images), 1972
Graphite and charcoal on clay-coated paper, 7"x 5" each
Noble and Hudson Collection

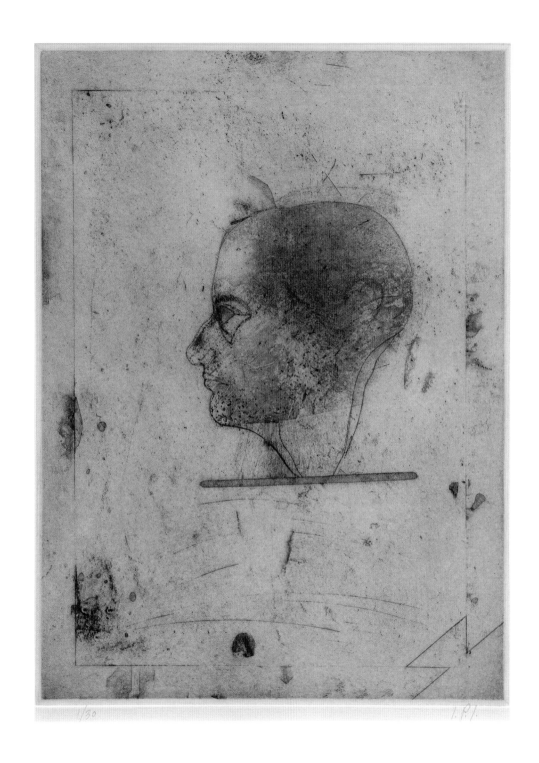

Blue Line Man, 1971
Color intaglio, 16"x 12"
John Paul Jones Estate

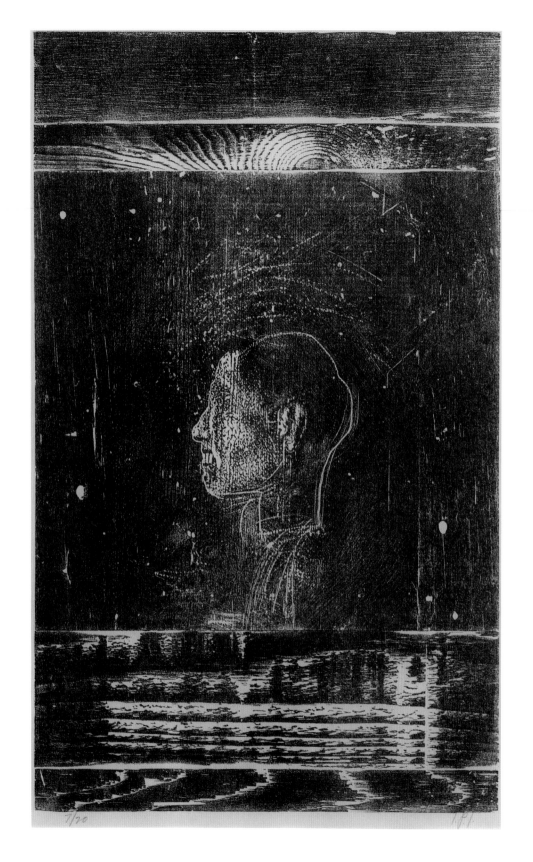

7/20

Chartroom Man (profile), 1971
Woodcut, 17⅛″ x 10⅝″
Fullerton College Collection

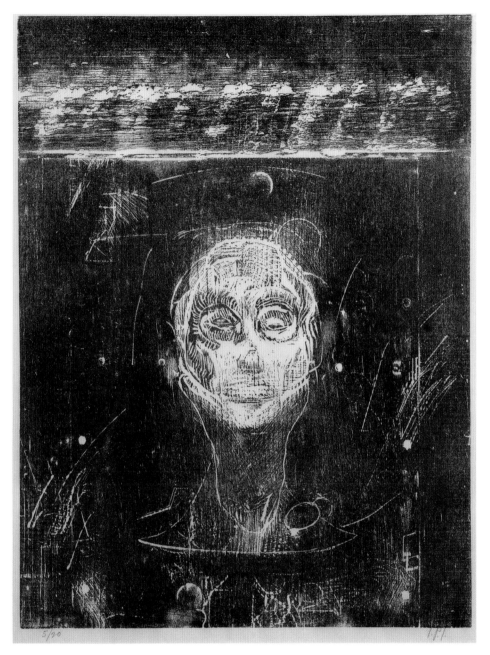

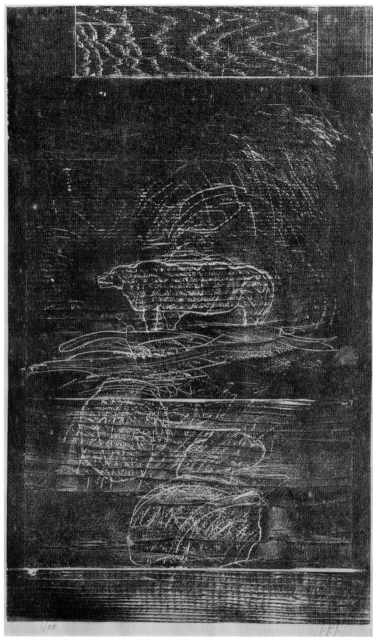

Chartroom Man, 1971
Woodcut, 24"x 18"
Fullerton College Collection

Dog Hill Blues #6, 1971
Woodcut, 17¾"x 10⁵/₈"
Noble and Hudson Collection

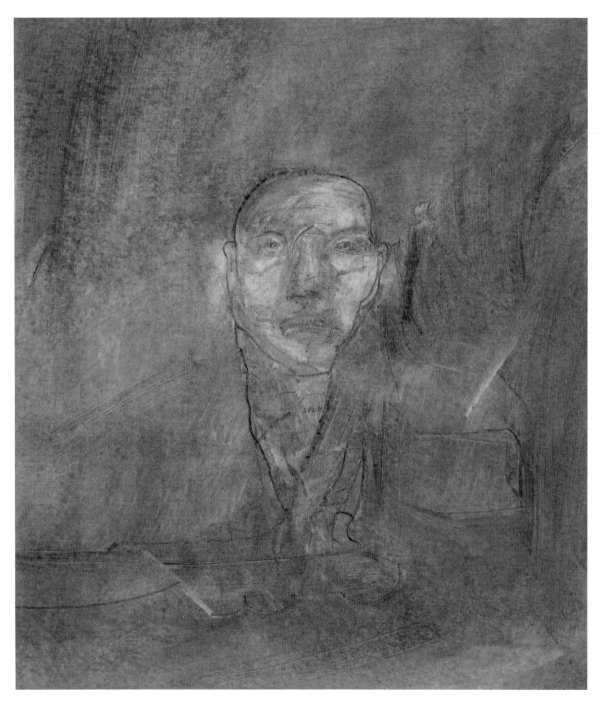

Everyman, 1973
Charcoal on clay-coated paper, 12½" x 11"
John Paul Jones Estate

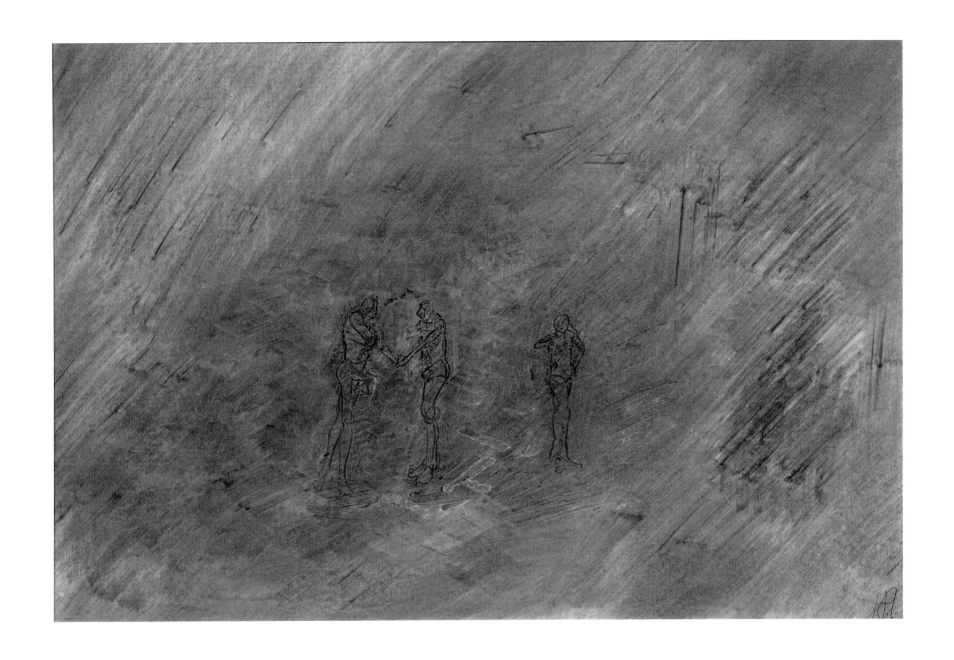

Ivory Lovers #5, 1974
Charcoal on clay-coated paper, 18⅝" x 22¾"
John Paul Jones Estate

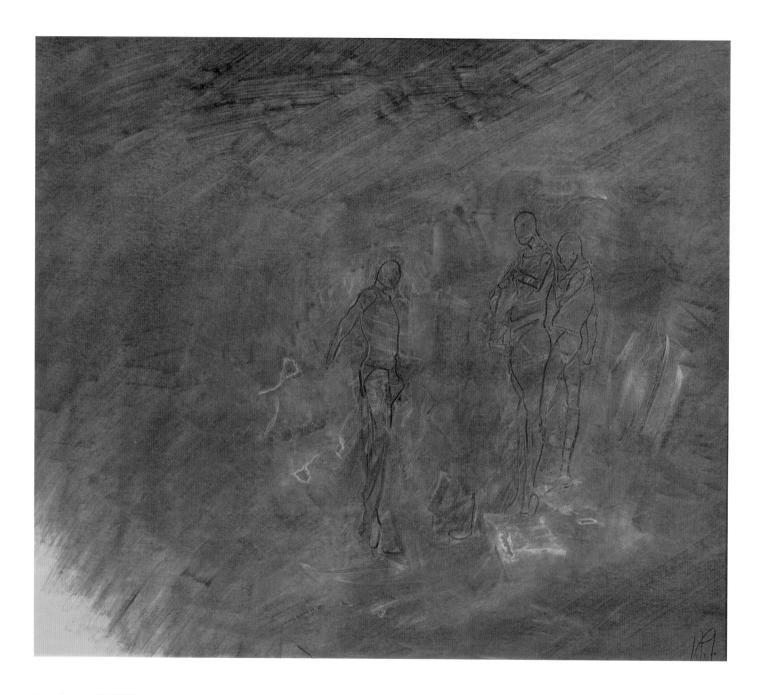

Ivory Lovers #7, 1974
Charcoal on clay-coated paper, 14¾"x17"
John Paul Jones Estate

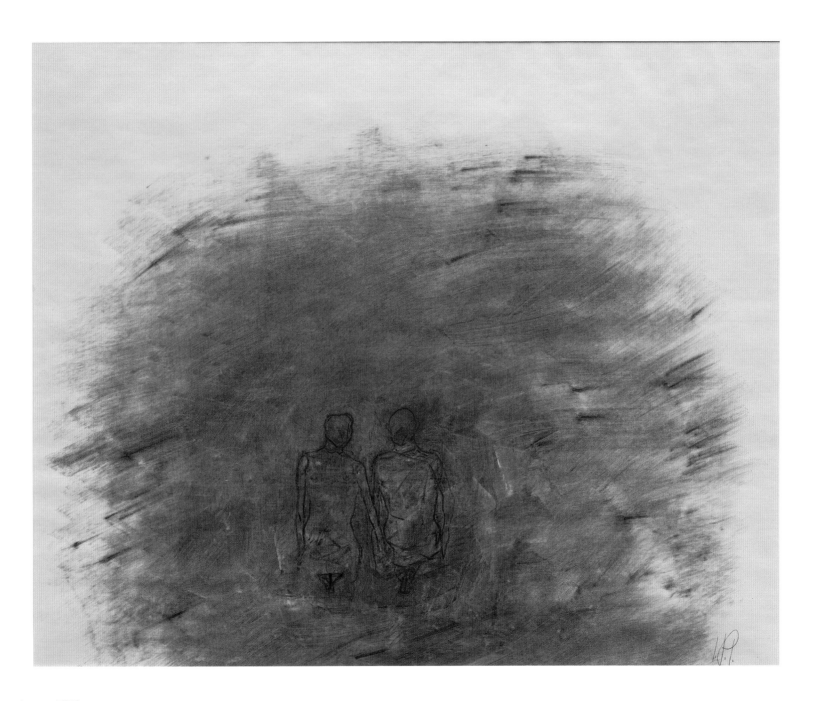

Ivory Lovers, 1974
Charcoal on clay-coated paper, 14½" x 18"
Chapman University Collection

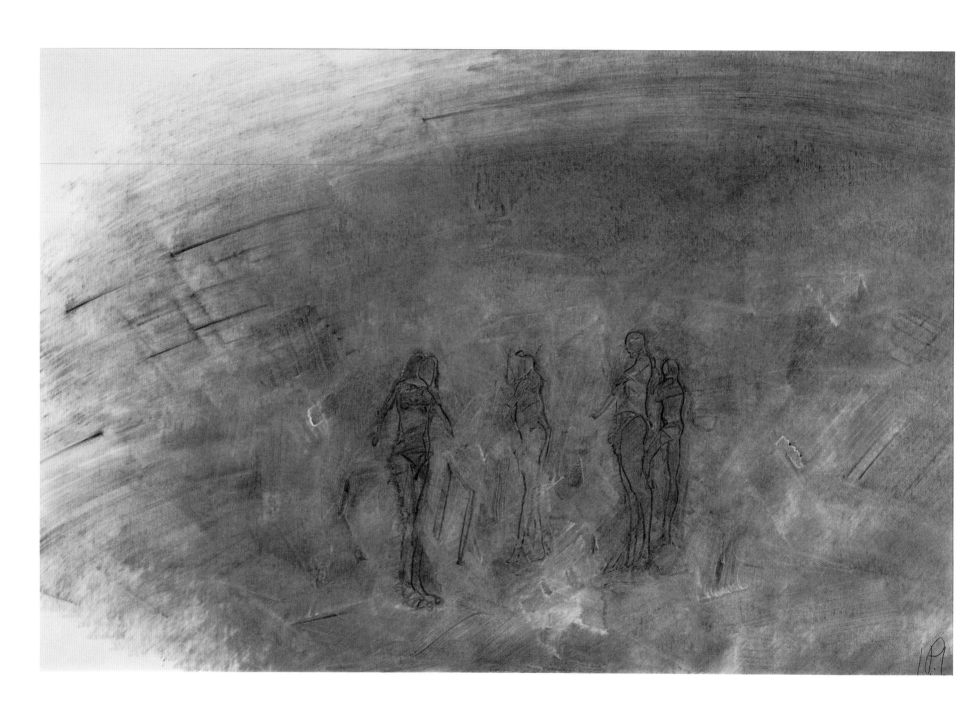

Ivory Lovers #6, 1974
Charcoal on clay-coated paper, 18⅝" x 22¾"
John Paul Jones Estate

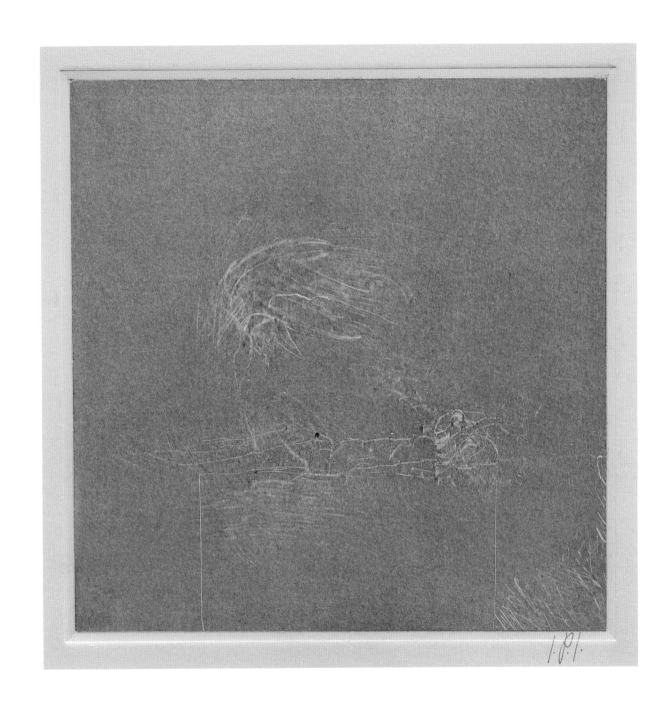

Leda and the Swan (from series), 1974
Monotype, 10"x 10"
John Paul Jones Estate

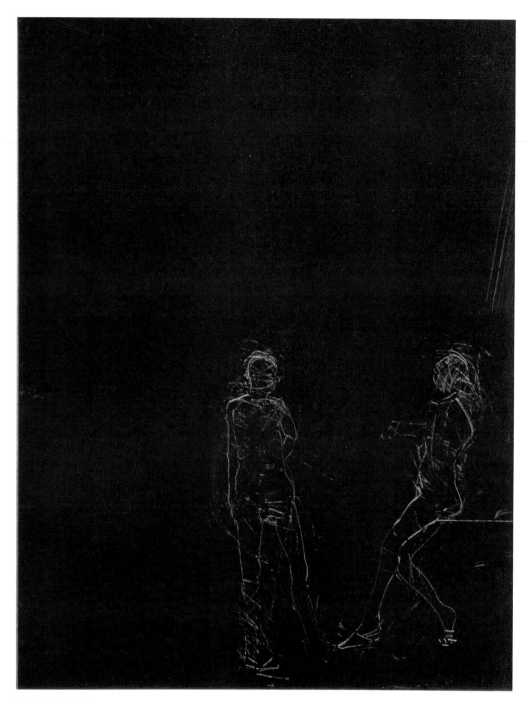

Untitled 1, 1970
Monotype, 22¼" x 17¼"
John Paul Jones Estate

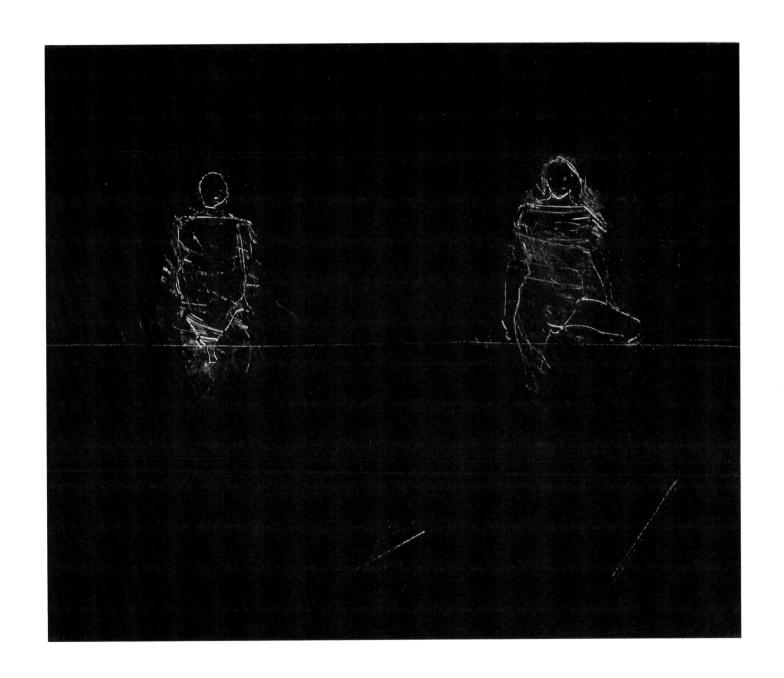

2 on a Line, 1974
Monotype, 15"x 20"
John Paul Jones Estate

Paradise Gate IV (Nancy's Gate), 1977-81
Graphite on paper, 16"x 19½"
Noble and Hudson Collection

Paradise Gate II, late 1970s
Graphite on paper, 16"x 24"
Fullerton College Collection

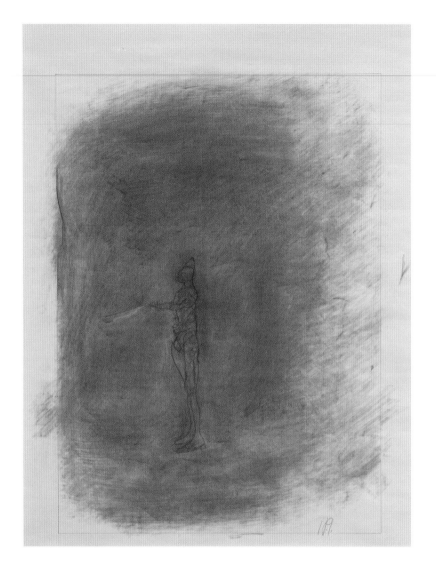

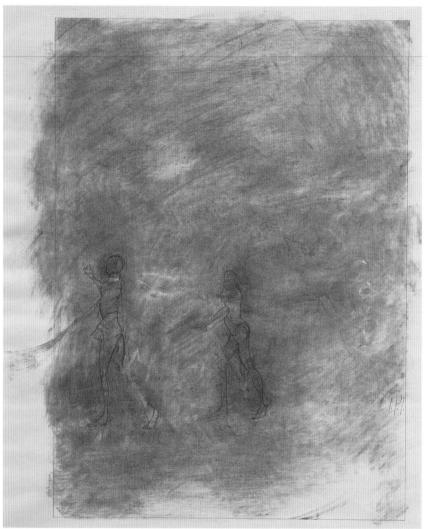

Artist and Model 3, ca. 1973
Charcoal on clay-coated paper, 17½"x 12"
Fullerton College Collection

Artist and Model 2, ca. 1973
Charcoal on clay-coated paper, 17½"x 12"
Fullerton College Collection

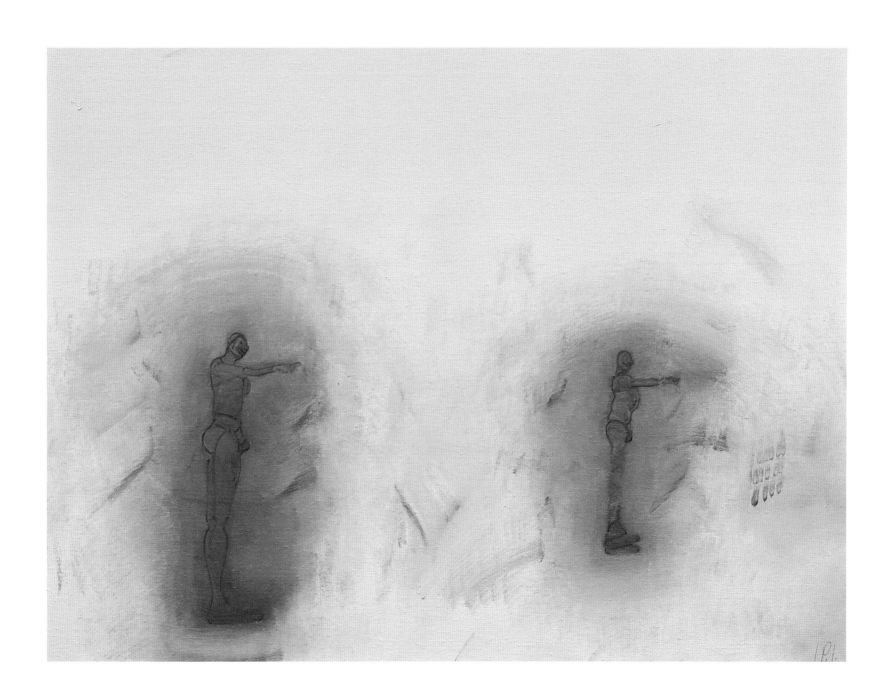

The Artist at Work, 1973
Oil on canvas, 30"x 36"
Laguna Art Museum Collection

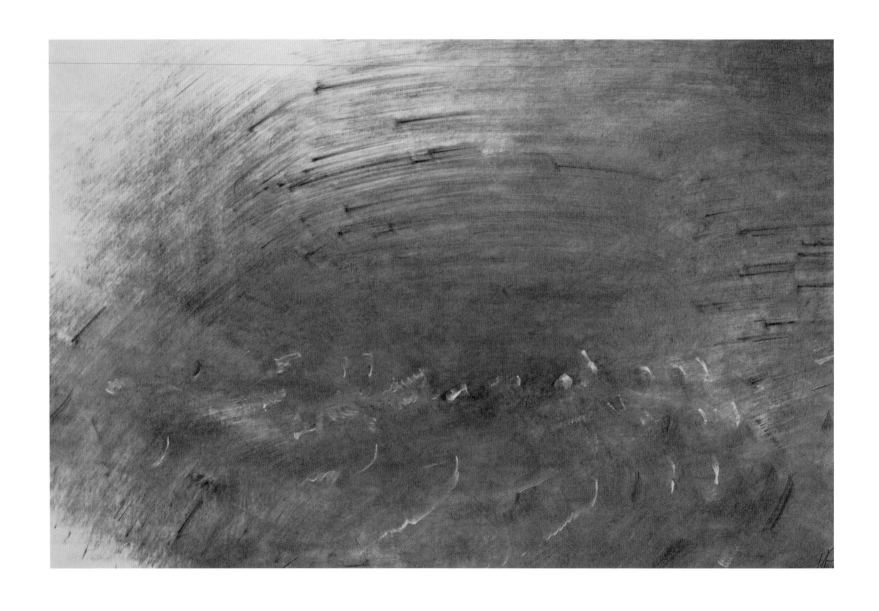

Ivory Winds 1, 1974
Charcoal on clay-coated paper, 15"x 22"
Fullerton College Collection

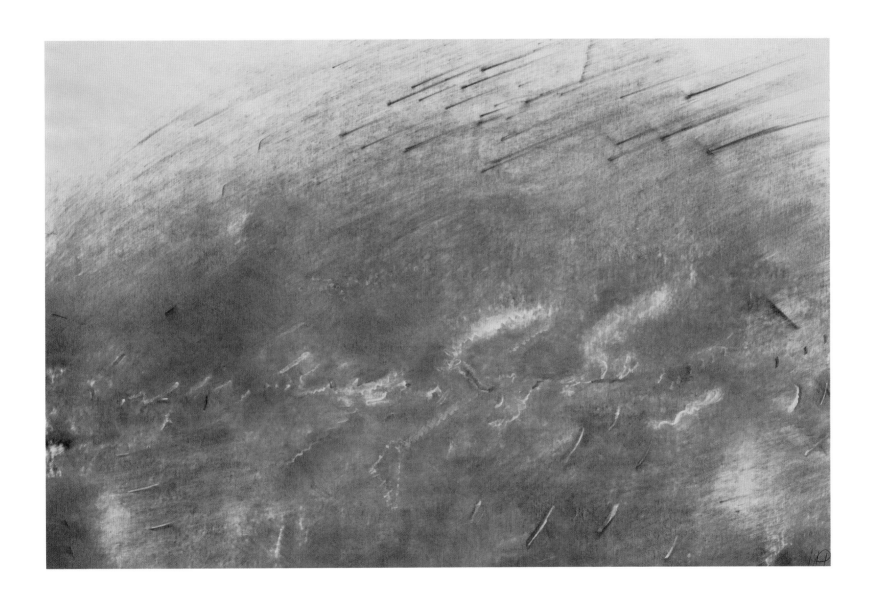

Ivory Winds 2, 1974
Charcoal on clay-coated paper, 15"x 22"
Fullerton College Collection

Paradise Gates14, Pre-sculpture series, 1978
Graphite on paper, 26¼" x 38¼"
John Paul Jones Estate

110

Colossal 25, Pre-sculpture series, 1978
Graphite on paper, 26¼" x 38¼"
John Paul Jones Estate

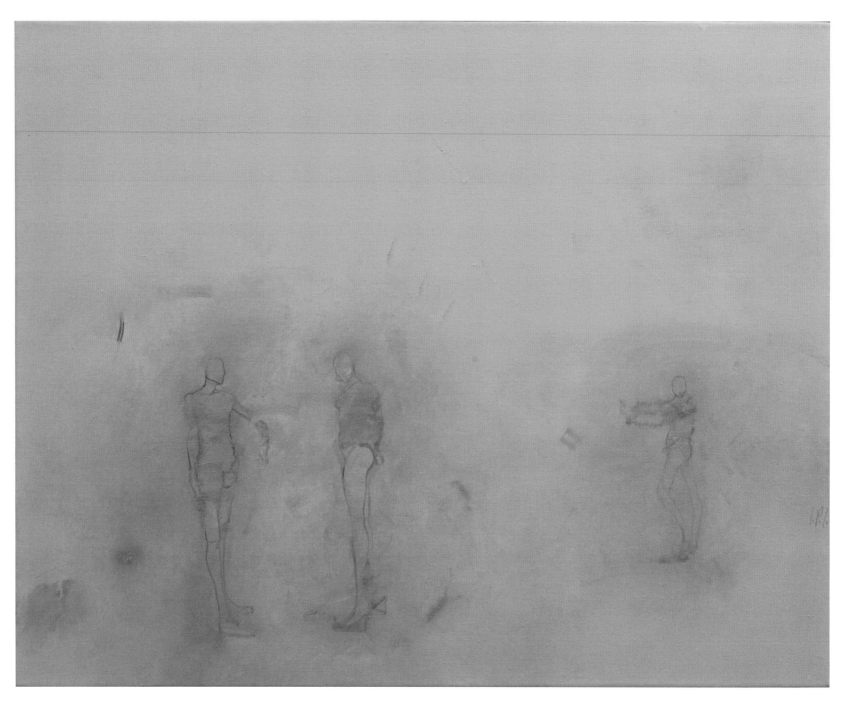

Lovers and Dancers, 1972
Oil on canvas, 38"x 29¾"
Noble and Hudson Collection

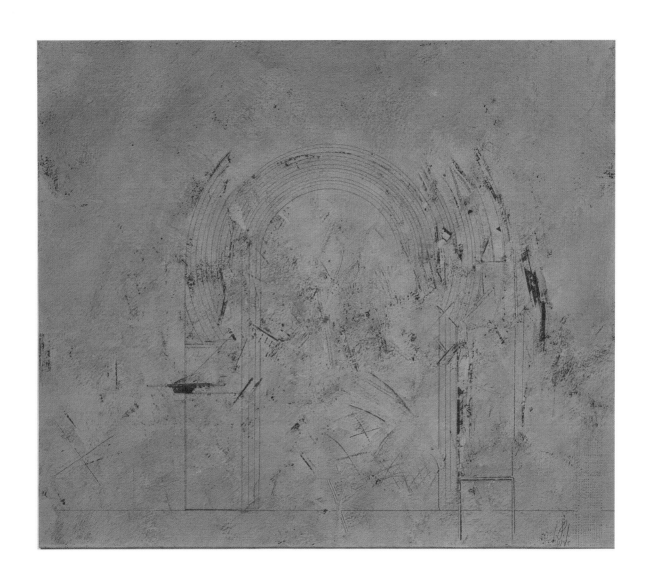

Welsh Gates 2, 1985
Acrylic on paper, 23"x 26"
John Paul Jones Estate

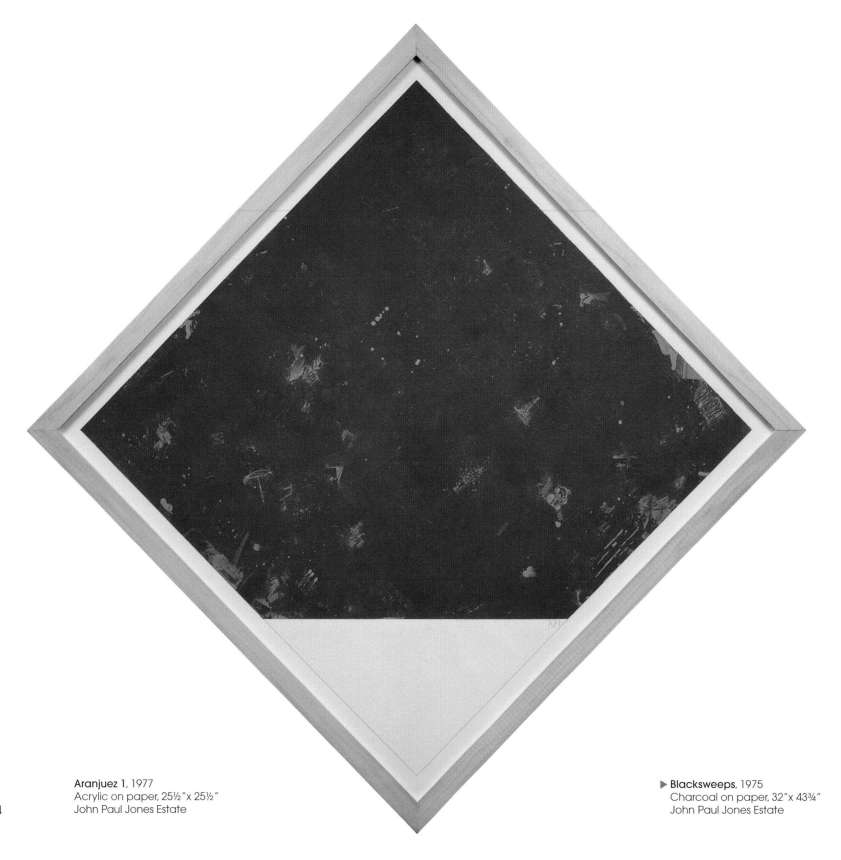

Aranjuez 1, 1977
Acrylic on paper, 25½″x 25½″
John Paul Jones Estate

114

▶ Blacksweeps, 1975
Charcoal on paper, 32″x 43¾″
John Paul Jones Estate

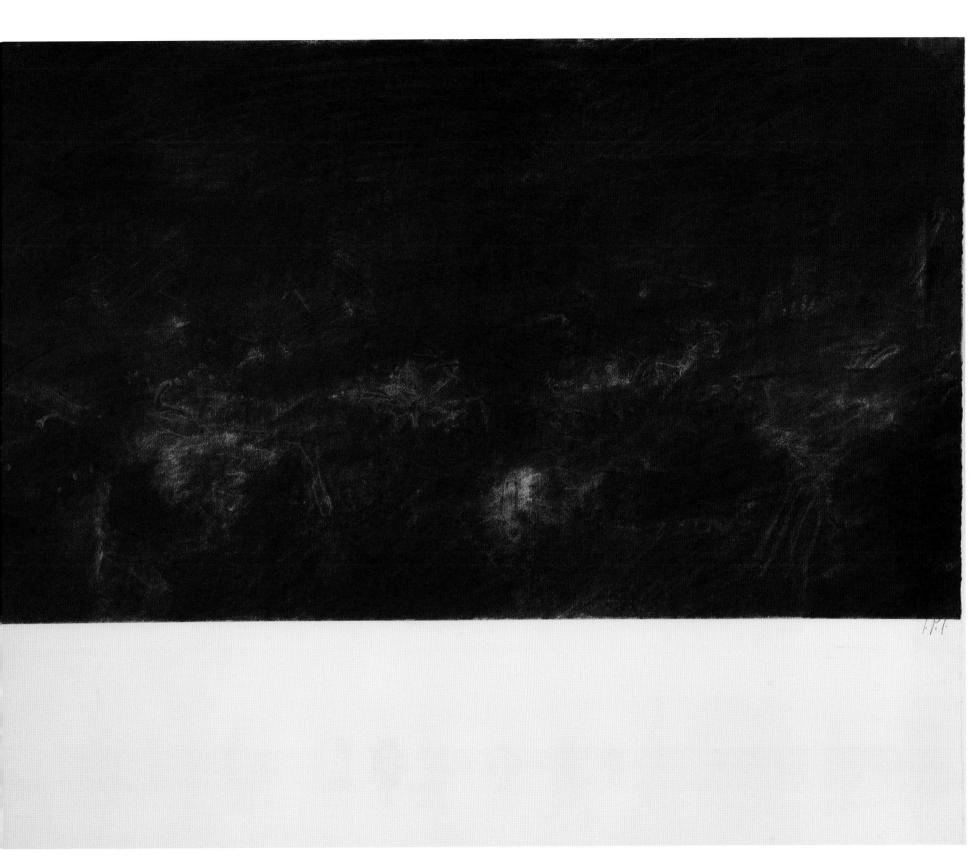

Late Works

John Paul Jones — A Life Lived Forward

Mike McGee

When I pursued my MFA at the University of California Irvine, John Paul Jones was on my graduate committee. I attended UCI from 1978 to 1980, the exact period when Jones began to create his first wood sculptures. [1]

At one point I asked Jones why he had made such a radical change in his work. Why had he moved from figurative drawings, paintings, and prints to abstract prints, paintings, drawings, and wood-and-metal sculptures? After an awkward moment of pause, he told me it was "Because it was the most difficult thing to do." We both laughed. Jones was always quick to laugh. He had a quick wit. His humor was often self-effacing and almost always about absurdities. His response to my question was typical of the kind of cryptic answers he so often gave to direct questions.

I often think back to his response because I feel it was uncharacteristically revealing—the Jones I knew was a very private man. I am convinced that he endeavored this stylistic sea change in large part because it set him on a difficult and problematic path. But like so many other aspects of his career, reasons for this stylistic change are complex and nuanced.

Jones had pursued his 1940s and '50s cubist and figurative work at the exact moment when Abstract Expressionism emerged and flourished. Jackson Pollock was twelve years older than Jones and was dead years before Jones had his first solo museum exhibition. And Jones' geometric abstract works in the '80s and '90s would have been more in tune with minimalism and other prevailing contemporary art themes in the '60s and '70s.

New York Times art critic John Canaday, who wrote several positive reviews of Jones' exhibitions, wrote a review of Jones' first major museum survey, his 1963 exhibition organized by Una E. Johnson at the Brooklyn Museum. Commenting about Jones' shift from abstract to figurative imagery between 1957 and 1958, Canaday wrote:

" . . . it makes him a member of an avant-garde that never thought of itself as being ahead of or behind any movement, or even a part of any movement, an absence of self-consciousness that is virtually a contradiction of the term avant-garde as we have come to know it."*2*

To my knowledge Jones never considered his work avant-garde—in all his notes and letters the term never appears. He often counseled his students not to be too "clever" or rely on "novelty"; for Jones art was best presented in a "straightforward" fashion.*3* His Midwest roots no doubt contributed to his caution about novelty, and Jones, who was first introduced to cubism in 1946, went from being an art history neophyte that year to teaching the subject in 1951, when he accepted a faculty appointment at the University of Oklahoma. Before receiving this offer he had planned to move to New York; one can only speculate how living in New York might have influenced his art.*4*

Less interested in creating works that were ahead of their time, Jones wanted to create works that were timeless.*5* Early in his career he claimed to suffer from what he termed "masterpiece-itis."*6* He would struggle his whole life to understand the exact criteria that defined a successful artwork and how to achieve that success. He often wrote notes to himself, usually on 8 ½ x 11 sheets of yellow-lined paper. These notes were about life and art, about making successful art. One of his notes reads, "the art of Art is **mysterious**, its (tenets) **ephemeral**, its heart **passion** (emotion) . . ."*7*

One of the reasons Jones' students found him so endearing—aside from his sense of humor—is because of his obsession with the process of making art and his conviction that process could lead to something significant and true. As he wrote, the goal is to achieve "art whose beauty is indistinguishable from truth and wisdom . . . a work saturated in its own fulfilled tendencies."*8* But this was not an easy task. He lamented how elusive and laborious a process this was for him, particularly early in his career.

For Jones, the process had a lot to do with intensity and engagement. An artist had to be involved both emotionally and intellectually—art had to be fueled by passion, but it needed structure. Although he believed art was by nature autobiographical, each work of art had a life or a spirit of its own, and the artist had to discover the essence of each work. This required keen awareness; to make this leap of discovery, each new work

required a progressive expansion of the artist's consciousness. As Jones phrased it, the artist had to be "there," completely immersed in the work.

What resulted from Jones' process were artworks that reflected the mystery he sought to better understand. His meaning of his images was never explicit, always elusive. The critic who may have understood Jones best and who wrote some of the most insightful reviews of his work, *Los Angeles Times* critic Henry Seldis, wrote, "Even at the beginning of his career, Jones was essentially concerned with ambiguities and mysteries of life."[9] In another review, Seldis wrote, "The essence of the appearance which Jones defines seems to exist on the very edge of consciousness."[10]

Jones devoted his life to chasing and honing his process.[11] It was a journey that would lead him through a multilayered labyrinth of personal, cultural, and aesthetic issues. He would grapple with his Midwest upbringing and his Welsh heritage, Europe's rich cultural legacy and a relatively young, fresh American can-do pragmatism, utopian ideals and unflinching realities, the rational and the emotional, and the figurative and abstraction. Before his first trip to Europe in 1960, his titles consisted of words such as "Table," " Woman," "Lady" and "Landscape." After Europe, new words emerged, such as "Nobleman," "Dukes," "Knights," and "Duchesses." There are also nods to art history with references to Donatello, Alberto Giacometti, Auguste Rodin, Odilon Redon, Piero della Francesca, and other European icons. Jones' most overt post-Europe references to artists are his reverent quotes, both visual and literary, from romanticists Francisco Goya and J.M.W. Turner. The richly expressive gestural marks and nuanced details in his prints echo Goya; *Spanish Woman* (1963, p. 75), and *Girl for Goya* (1963, p. 70), are overt homage. Many of Jones' landscapes, particularly *Ivory Lovers #7* and *Ivory Lovers* (both 1974, p. 98-99), with their atmospheric skies made up of wispy, twisting pastel and charcoal smudges of ochre and brown tones, could, at a glance, be mistaken for works by Turner.

Such references are one of the reasons many observers, including June Wayne in her interview for this publication, see Jones as a romantic. In addition to his handling of materials, Wayne cites a sense of deep-seated longing in his images, particularly in the faces from the 1960s. His images of the female figure take longing to the point of obsession, particularly with his *Grove Woman* (1968, p. 76), and Venus series of prints. Throughout his life Jones wrote poems; romantic love was a common theme.[12]

It is understandable that many aspects of romanticism appealed to Jones. His efforts to immerse himself in a work of art bring to mind the essence of romanticism: the hero's struggle, the power of transcendence, and the value of aesthetic experience. Individualism and the capacity to use intuition and the awe and goodness of nature to overcome the ills of a corrupt and dispassionate society are tenets of romanticism with which Jones' undoubtedly indentified.

His quest for clues to the meaning of life and his pursuit of artistic meaning were unceasing. In addition to persistently writing notes—thoughts and insights of his own or quotes from sources that caught his attention—he kept copies of articles he found interesting, often underlining key passages and sometimes writing comments in the margins. *13* An avid reader, Jones was always looking for bits and pieces that would shed light on the puzzle of life. But he never assumed the pieces would come together to form a didactic answer. He had a disdain for dogma and was not an ideologue. If there was a philosophical framework besides romanticism that had a profound influence on him it was existentialism.

He found Albert Camus absorbing and had read Søren Kierkegaard, Jean-Paul Sartre, Friedrich Nietzsche, Martin Heidegger, and other writers essential to existentialism. *14* Jones' curiosity about human existence, reality, and truth made existentialist thought a ripe source for ideas and contemplation. For existentialists, subjective human experience holds primacy over rational constructs of reality. In an otherwise absurd and meaningless world, individual existence is the only undeniably valid truth. In Sartre's *Being and Nothingness* (1943)—a book Jones had read—the author suggests, among other things, that sex is theoretically the joining of the corporal and consciousness into a harmonic state of wholeness; however, this unification is nullified by the temporal nature of the act. In essence, Jones was attempting to capture a harmonic event and preserve it in his art. Sartre's title here is a nod to Heidegger's earlier influential treatise, *Being and Time* (1927); in this treatise, Heidegger uses the word *Dasein* as a term to define human existence; literally translated from German the word means "being-there." The simplicity and directness of existentialism appealed to Jones, and the idea of being alone trying to make sense of an absurd universe was compelling.

The grande dame of the Los Angeles art scene in the '70s and '80s, Josine Ianco-Starrels—who organized two major Jones exhibitions, including his 1984 survey at the Los Angeles Municipal Art Gallery—once described the

faces in his work as "haunted."*15* In her essay for this publication, Susan Landauer concisely outlines the personal and psychological tribulations Jones encountered in his early life, punctuated by his World War II military service in Okinawa.*16* He undeniably witnessed horrific scenes in the war, and it is likely that the images of cremating bodies after this ferocious battle remained in Jones' memory. Once you know this, it is impossible to look at his work without seeing charred faces, expressions of agony, and twisted, tormented bodies. While this is true of some of Jones' images made in the late 1950s and early in 1960, it is especially evident in the prints, paintings, and drawings he executed from 1962 forward. His 1962 series of small bronze heads are also emotionally charged: the textured surfaces read like tortured skin and the faces seem more like portraits of psyches than physical likenesses.

Jones had done figurative work before the late 1950s, but this early work lacked the emotion his figures and portraits conveyed after the late 1950s. Many who have written about his work, and Jones himself, point to his 1954 intaglio *Return* (1954, p. 56) as a turning point. Noted art critic and historian Dore Ashton wrote, "*Return* represents a synthesis of his two early styles, geometric and figurative. From a somber ambiguous background of rectilinear planes, a semi-abstract rounded figure emerges."*17*

For several years after *Return*, Jones continued to wrestle with abstraction and the figure. The Grunwald Center for Graphic Arts at the UCLA Hammer Museum has the largest institutional John Paul Jones print collection. There are very few extant sets of stage proofs for his editioned prints. The Grunwald owns a set of six stage proofs for the intaglio print *Presentation* (1955). With these stage proofs it becomes clear how Jones struggled with revisions and why it took him so many months to complete these early prints. In the early stages of *Presentation* human figures are clearly visible, visual cousins to his lone figure in *Return* but more clearly defined silhouettes and head-on views rather than profiles. As the print progress in stages, black and textured geometric shapes increasingly conceal the figures. In the final stages, the figure is completely buried; no visual trace remains.

This tension between the human figure and abstraction is a constant throughout Jones' oeuvre. Even his late, ostensibly abstract sculptures are about the relationship between form and the human body. Other than his brief foray with lost-wax technique in his bronze heads in 1962, he did not work in sculpture again until the late 1970s. After the '60s he did flirt with complete abstraction in the *Ming Stills* (1970, p. 86) and *Leda and the Swan* (1974, p. 101), but abstract fields of rich textures and marks always loomed in the backgrounds of his figurative works. In

his *Ivory Winds 1 and 2* (1974, p. 108-109), and *Black Sweeps* (1975, p. 115), the background consumes the picture plane and no figures are to be found. Throughout the '70s he continued to depict the figure in works such as *Ivory Lovers* (1974, p. 99), *Artist and Model 2 and 3* (1973, p. 106), and *The Artist at Work* (1973, p. 107).

In a way, Jones' move toward abstraction in the late 1970s was a return to his roots. He had studied to be an architectural engineer when he first entered college. The architectural structures and geometric shapes that occupied him in his later works are descendants of the geometric shapes that once buried his human figures in *Presentation* and his other works from that era.

When Jones made his shift from abstraction to figuration in the late 1950s, he had said it was because he thought his early abstract works came from a place that was too "intellectual." He wanted to explore more emotional aspects of his work. At first glance, his sculpture, paintings, and drawings of the '80s and '90s seem very structured and cool. But there is emotion in this late work, beyond the minimal elegance, just beyond initial impressions.

From a distance, Jones' late abstract paintings read as geometric shapes, mostly monochromatic squares and circles. But when you look closely at paintings such as the triptych *Capricios* (1996, p. 166-167), you see that the surfaces are rich with subtle detail. Many of the paintings look like sections of exterior walls cut out in squares, framed, and mounted in the gallery: the slight impasto and open patches that reveal undersurfaces tell of paint painted upon paint, each layer suggesting a weathered history. And there are pencil marks, thin, expressive marks that bring to mind a subdued graffiti, an expressiveness contradicted by occasional ruled lines that form geometric structures such as grids.

Some of the sculptures, too, have pencil marks on them; bits of expression can be seen in small portions of intentionally evident saw marks and dabs of color in works such as *Royal Blade* (1987, p. 155). The sculptures are about craftsmanship: reverently selected sugar pine, jelutong, basswood, metal, and hardware held together by an inventive dance of dado cuts, dowels, notches and miter, mortise and tenon, butt and finger joints. Some of the sculptures, such as *Comb Table 9* (1981, p. 171), are held together solely by the joints—no nails, screws, or glue. Hanging from the ceiling, mounted on a wall, or freestanding in the middle of the floor, these sculptures are undeniably architectural, but they are also totemic. Each work has a distinct presence, as if it is a record of some

ritual, an artifact or tool for a ceremony, a tribute to hallowed knowledge, or a portal to some coveted place. All of the late sculptures are plays on symmetry and repetition. They hang in space and create rhythms, like music. The *Tower* Series (1988, p. 160 and 170), perhaps the most architectural and totemic of the sculptures, are, despite their verticality, some of the most volumetric.

Overall, the sculptures, including the towers, tell us just as much about the space they don't occupy as they tell us about the space they do occupy: they are about the spaces in between. The thin wood lines formed by *Catwalk* (1983, p. 156) capture more negative space than the sculpture physically occupies. The gap between the narrow aluminum tubes is less than the thickness of the tubes' diameters that hang from their wood and metal armature in *Paradise Gate* (1981, p. 137). Much of the negative space around the sculptures is activated by shadows. In many cases, as with *Paradise Gate*, the darkness of the shadow creates shapes that dominate the eye. The mind knows we are supposed to pay attention to the object, but the crisp outline and the near-black values of the shadows compete for our attention. To varying degrees, the shadows are an integral part of all the sculptures—at some point Plato's Cave had to have crossed Jones' mind. It is tempting to declare the sculpture, painting, and drawing from the '80s and '90s to be more pure of form than Jones' early works and call it a day. This would be a mistake. The complexity, passion, mystery, irrationality, and struggle are all present, but more focused and, as a result, more intense.

Jones could have continued to investigate his images of the figure for the rest of his life and would probably have arrived at some additional incremental insights. But it is hard to imagine any other course he could have taken that would have constituted such a dynamic aesthetic leap, so pointedly put his early work into perspective, and brought him closer to his goal of understanding what makes a work of art successful. There are similarities and connections between his early and late work, yet the differences amount to a stylistic transmutation.

Such a change seems likely to be motivated by more than just esthetics; the timing of this stylistic shift also coincides with crucial events in his life. In 1976-77 Jones spent his sabbatical in Europe, returning once again to Spain and Wales; he went through a separation from his second wife, Chadlyn, that culminated in their divorce in 1980; and by the late 1970s it was becoming increasingly clear that his career would not reach the pinnacle it had seemed, in the 1960s, destined to achieve.

By 1960 Jones' work had been included in more than a dozen solo exhibitions at galleries and at museums such as the Oakland Museum, Santa Barbara Museum of Art, Pasadena Museum of Art, and Los Angeles County Museum of Art (this exhibition was actually a two-person exhibition with the French engraver and sculptor Henri-Georges Adams). A one-person exhibition in 1963 surveyed his work from 1948 to 1963, and in 1965 Henry Hopkins, one of the driving forces behind the early Los Angeles art scene, organized a 1955-65 painting and sculpture exhibition for Jones at Los Angeles County Museum of Art.

Early in his career Jones won dozens of awards and prizes, and critics in Los Angeles and New York lauded him. He received a Guggenheim Grant in 1960 and a Tamarind Fellowship in 1962. His work was reviewed by every major national art magazine. He received a glowing review in *Time* magazine in 1962.[18] His career was going so well that in 1963 he resigned from his professorship at UCLA to devote himself full time to making art.[19]

Jones' work was also included in exhibitions and publications that put him in lofty company: a survey of modern artists in America selected from the Museum of Modern Art collection and exhibited at the Tate Museum (1956); an international traveling exhibition of American prints organized by the Brooklyn Museum of Art (1959-62); an exhibition titled *American Painters from A to Z* presented at the American Cultural Center in Paris; a survey of "Directions" in American sculpture and painting at the Chicago Art Institute (1963); and a 1955-65 survey for American drawing at the Whitney (1965). He was also featured in the 1964 two-book series *Drawing of the Masters: 20th Century Drawing*. Reviewing the entire list of artists who participated with Jones in the above projects one quickly realizes that Jones was one of the very few of these artists who, by the late 1970s, had not achieved "blue chip" status.[20]

By the late '70s most of Jones' champions had left the stage. Felix Landau, the celebrated dealer who probably did more to advance Jones' career than any other individual, closed his Los Angeles and New York galleries and retired to Paris in 1971. Una E. Johnson became curator emeritus at the Brooklyn Museum in 1973. In 1977 John Canaday stepped down as art critic for the *New York Times. Los Angeles Times* critic Henry Seldis died in 1978. Although Jones maintained a strong regional following, he would never again have a group of supporters with as much art world clout. His international reputation waned.

The combination of these events had to have weighed on Jones. His sabbatical in 1976-77 gave him time to think. Kierkegaard, reflecting on his nineteenth-century life in a letter to a friend, wrote, ". . . the thing is to find a truth which is true for me, to find the idea for which I can live and die."[21] It is easy to surmise that at this point in his career Jones might have been more interested in finding a truth for himself than a truth for the world, especially the art world.[22]

The most distinguishable seed for Jones' venture into his late sculpture and abstraction was sowed during his sabbatical as he pondered over the idea of "gates." He created a series of graphite and pencil drawings of gates that were for specific people in his life, such as *Paradise Gate IV (Nancy's Gate)* (1977-81, p. 104) for Nancy Noble, his longtime friend and patron. In the '60s his focus on the figure had crystallized with the edition of prints he did during his 1962 Tamarind Fellowship. During his second Tamarind Fellowship, in 1980, he produced three Paradise Gates lithographs: *Maine Gate, California Gate*, and *Japan Gate* (1980, p. 132-133). This series of prints would lead to the architectural and abstract works that would occupy him for the next two decades.

During his first trip to Europe, he lived at 7 Lancaster Gate in London. Gates are entrances. They can keep people out, and they usually keep something of value secure. If you find the right gate and can get inside, you will likely discover something desirable, perhaps even miraculous. In her essay for Jones' exhibition at UC Irvine in 1984, Melinda Wortz wrote: "For this Irvine exhibition Jones has installed some of the 'gates': in such a way that we must walk under or through them as we would with a 'real' gate. But these delicately delineated, ethereal structures are clearly meant to refer to something else—perhaps the Platonic ideal behind the particular form, or the spirit that vivifies matter. His gates are in fact 'gateless' gates, or as John Paul puts it, 'Dreams and Lies in the Gatekeeper's House.' We recognize the dreams and lies to which these mysterious abstractions refer as universal to the human condition, our own as well as the artist's—our dreams of paradise and bliss, and the lies we invent to delude ourselves in the pursuit of our dreams. However much we may love the earth, as Jones suggests in his reverence for materials, and however perfectly we may proceed, we remain finite and limited beings for whom the Absolute lies continually just beyond reach: at the top of the stairs, through the next gate, or over the next bridge."[23]

It doesn't take a great leap of imagination to envision Jones' life as a passage through a series of gates. His change from figurative work to abstract in the late 1970s, like his earlier shift from abstract to figurative work in

the late 1950s, corresponded to changes and challenges in his personal life.*24* In the late 1980s he would go through another series of personal changes and challenges, culminating in his retirement from UCI and his relocating from Southern California to Ashland, Oregon, in 1990.*25* Jones had always had a reputation for being reclusive. His move to Oregon enhanced that reputation.

The house on the land he bought was not finished, and he spent a lot of time completing the buildout. He sold much of his art to Nancy Noble and Dennis Hudson before leaving Southern California, but he took a significant portion of his oeuvre with him to Ashland. In his house he displayed only one sculpture that he had made before the move, *Untitled* (1988, p. 129), a single vertical thin strip of wood mounted to the wall with flat-planed and routed surfaces.*26* Physically it is not a complex object, viewed from the left one sees only flat planes that form obtuse angles; yet viewed from the right one sees a series of convex curves that form vertical lines the length of the sculpture.

Jones did not stop making sculpture while he lived in Ashland. He made a series of sculptures in the 1990s. Some of them he installed in his house, but most he placed outdoors on his land. He created dozens of outdoor sculptures and formed an outdoor installation: a gracefully arranged garden of lean towers and thinly defined rectangles and squares, all made of linear planes of wood and metal, nestled amidst the brush, trees, and hills. (p. 184-188)

Jones was prolific during the early 1990s. The triptych *Capricios* is part of series of twenty-six similar sized painting on canvas completed in the mid-1990s; he also completed 100 acrylic painting on paper during that period. He did hundreds of drawings in pencil and graphite but occasionally used a color pencil, sparingly, in a few select spots. The drawings were done in series with titles that often referenced them as flag patterns and maps. They consist of abstract geometric shapes that alternately float on the surface of the picture plane or are obscured by the smudged pencil and graphite marks that form the background. Jones made marks on the backs of the drawings—they were ratings. The drawings he thought best are the ones that are minimal to the point of being amorphous—as if they hover between existence and nonexistence.

At some point in 1997 Jones stopped making art; after July he remained in his house. He spent much of his time reading—literary magazines, books by a variety of writers including the existential writers mentioned above, and one of his favorite authors, the Argentine, Jorge Luis Borges; listening to music—jazz, from big bands to Thelonious Monk, and particularly female vocalists; and watching films by some of his favorite directors–Ingmar Bergman, Robert Bresson, Jean Renoir, François Truffaut, and Orson Welles. Toward the end of winter, in early 1998, suffering from emphysema, mostly confined to his bed, he got a burst of inspiration and asked Susanne Nestory, his companion during the years he lived in Ashland, to go to the hardware store and buy him some supplies. He made one final group of sculptures. These works were made of split rings, small extension springs, wooden dowels, and aluminum tubes and strips. Six of these works consisted of two vertical assemblies; the other four were intended to hang as single, individual assemblies. With the two-part works his intention was that the two vertical pieces be hung from the ceiling at a distance from one another equal to the length of the verticals, thus forming a square in space. These two-part works are titled "Gates." *Gate #5* (1998, p.27) is one of the simplest and most elegant of these last sculptures. It consists of a tension spring, three split rings, and a long narrow strip of aluminum. As far as I know, Jones never titled a sculpture as his Paradise Gate. Perhaps *Gate #5* is his gate.

After completing the *Paradise Gate* lithographs he made at Tamarind in 1980, Jones made only a few prints, and he stopped making prints altogether in 1986. But between 1991 and 1992—as he was completing construction on his Ashland home—he created a series of woodcuts: it is probably more accurate to call these works "inked impressions from wood scraps." While he once toiled and fretted for months to create a successful print, here he would find images on the surfaces of random, palm-size lumber remnants, scratch in a few marks or not, ink the wood, and apply paper—no over-thinking, no agonizing, just pure instantaneous acts of faith in his capacity to see. He made notes and marks on the prints: titles such as *Sky Full of Moons* (1991-92, p 182), *Ice Palace (Gates)* (1991-92, p 182), and *Moondancer with Hat* (1991-92, p 183); notations such as "cut off" or "matt here"; an "X" for those he thought were good prints, a circled "X" for very good prints. He printed them on raggedly cut sheets of tracing paper, which have a coloration similar to and a feel evocative of human skin. He intended these to be proofs and set the project aside, but never went back to or decided how to create "final" images for the series.

Printmakers are notorious for carefully handling their prints to the point of obsession, even proofs. Yet Jones used masking tape to firmly attach each of these delicate pieces of paper to a wall in his house. It was as if the master printmaker didn't care that these images might someday be framed and presented publicly. He was more urgently interested in the juxtaposition of the prints on the wall than in any future function or value these images might have.

The beauty of these prints stunned me when I first saw them. They are so simple, yet each one seems to contain a universe of complexity. As I studied them I realized that it had taken Jones a lifetime to create these images. I imagined Jones somewhere—perhaps sitting and musing with his cat, Claude—laughing at the irony that at the end of his career he was able to achieve such beauty with so little effort. Perhaps, for Jones, Paradise is a place where every little artistic effort produces a masterpiece. But knowing him as I did, I would guess Paradise for him is a place where he would relive the journey and the struggle toward the masterpiece, toward perfection, over and over.

Mike McGee is the Cal State Fullerton Art Gallery Director. He organized the exhibition *John Paul Jones: A Retrospective.*

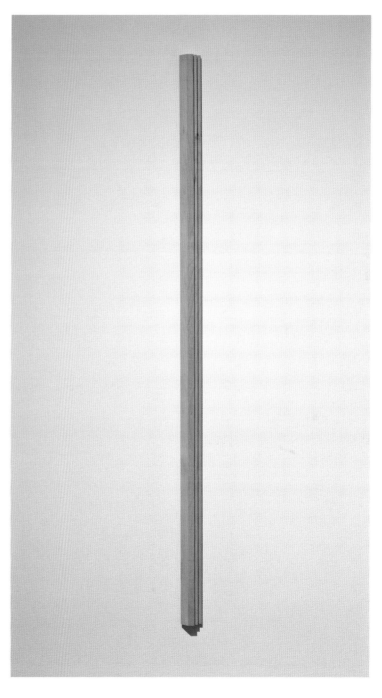

Untitled, 1988
Pine, 51½"x 2¼"x 1"
John Paul Jones Estate

1. Jones was a professor at UCI from 1969 to 1990. As a graduate student I would meet with Jones regularly for one-on-one discussions. We discussed art, philosophy, and life. Many of my observations about him and his art are influenced by those discussions.

2. John Canaday "John Paul Jones: The American Artist Shown in Brooklyn," *New York Times*, 9 June 1963.

3. These quotes are based on a conversation I had with Jones. These words are also found in a fall 1986 lesson plan Jones wrote for his graphics class. See John Paul Jones Papers, Archives of American Art, Smithsonian Institution, Washington, D.C.

4. See Henry Hopkins, *John Paul Jones: Painting and Sculpture 1955-65* (Los Angeles: Los Angeles County Art Museum, 1965).

5. In her essay for the Jones' drawing exhibition at La Jolla Museum, Josine Ianco-Starrels wrote, "John Paul Jones is from another era. He has ignored or intentionally avoided the paces and rhythms of modern culture. He made it his life long quest to approach his live and art at a pace and with an intensity that is foreign to our time." *John Paul Jones Drawings* (La Jolla, CA: La Jolla Art Museum, 1970).

6. Jones, as quoted by Henry Hopkins in his essay for the exhibition catalog *John Paul Jones: Painting and Sculpture 1955-65*.

7. John Paul Jones Papers, Archives of American Art.

8. Ibid.

9. Henry J. Seldis, "Jones Reveals Poetic Personality," *Los Angeles Times*, 30 November 1965.

10. Henry J. Seldis, "Art Emerges From Lightness," *Los Angeles Times*, 11 December 1967.

11. Henry J. Seldis, "La Jolla Art Museum Offers Drawings of John Paul Jones," *Los Angeles Times*, 4 January 1971. Seldis writes, "(Jones') art is concerned with process rather than progress although certain technical and conceptual improvements can be noted regularly."

12. A number of Jones' poems are found in his papers at the Archives of American Art.

13. There are a several such annotated articles in the Archives of American Art.

14. Existentialism was one of the topics Jones and I discussed when I was his student.

15. Josine Ianco-Starrels, *John Paul Jones Drawings*.

16. Susan Landauer, "From Essence to Quintessence: The Figurative Art of John Paul Jones," in this publication.

17. Dore Ashton, "Brooklyn's 8th Annual," *Art Digest*, April 1954.

18. Jones intended all his towers to be maquettes for large-scale outdoor sculptures. Conversations with collector Dennis Hudson and with Susanne Nestory, Jones' companion in his Ashland years.

19. Bob Jennings, "Haunted House," *Time*, 7 December 1962.

20. Jones would subsequently take an appointment at University of California Irvine in 1969 to found the printmaking department there.

21. The list of artists included Joseph Albers, Roy Lichtenstein, Robert Indiana, Richard Diebenkorn, Ad Reinhart, Adolf Gottlieb, William de Kooning, Hans Hofmann, Frank Stella, Morris Graves, Robert Rauschenberg, Robert Motherwell, Robert Indiana, Lee Bontecou, Joseph Albers, Sam Francis, Larry Rivers, Mark Tobey, and Jasper Johns.

22. Søren Kierkegaard, *The Essential Kierkegaard*, edited by Howard and Edna Hong. Princeton, 2000. This quote is from a letter (dated August 31, 1835) Kierkegaard wrote his friend, Danish zoologist and paleontologist Peter Wilhelm Lund. In broader context, the letter reads: "What I really lack is to be clear in my mind what I am to do, not what I am to know, except in so far as a certain knowledge must precede every action. The thing is to understand myself, to see what God really wishes me to do: the thing is to find a truth which is true for me, to find the idea for which I can live and die . . . I certainly do not deny that I still recognize an imperative of knowledge and that through it one can work upon men, but it must be taken up into my life, and that is what I now recognize as the most important thing."

23. In an undated note Jones wrote, "I was going to be a maestro and give all that stuff brings . . . so how come I end up the beneficiary?" John Paul Jones Papers, Archives of American Art.

24. Melinda Wortz, exhibition brochure, University of California Irvine, March 1984.

25. Jones made his first trip to Europe during the 1960-61 academic year. He received his Tamarind Fellowship in 1962—both his 1962 and 1980 Tamarind workshops demarked substantial changes in Jones' esthetic direction. He traveled to Europe again in 1963. He divorced his first wife, Charlotte Enger Jones in 1963.

26. In 1987 he was divorced from his third wife, Peggy Ann Jones; that same year, his daughter, Megan Hart Jones, died.

27. Susanne Nestory told the writer about this sculpture during a series of conversations in 2009.

John
Paul
Jones
a retrospective

Paradise Gate: Maine Gate, 1980
Lithograph, 22"x 30"
Fullerton College Collection

Paradise Gates: California Gate, 1980
Lithograph, 24"x 32½"
Dowling Family Collection

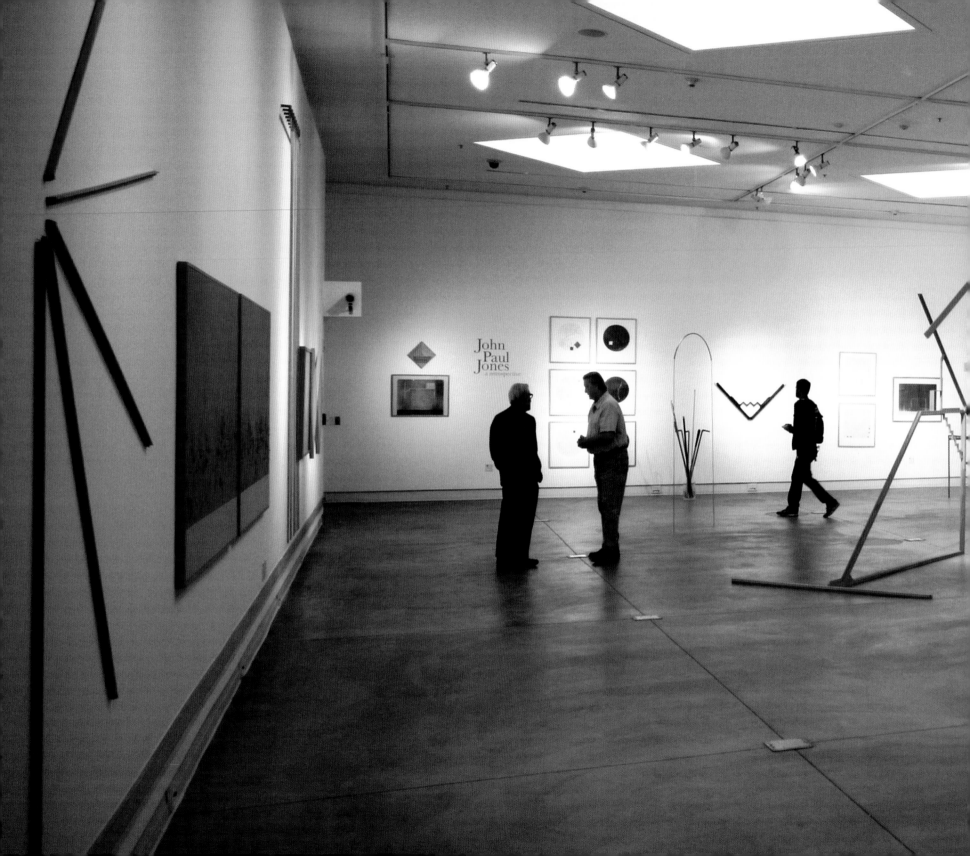

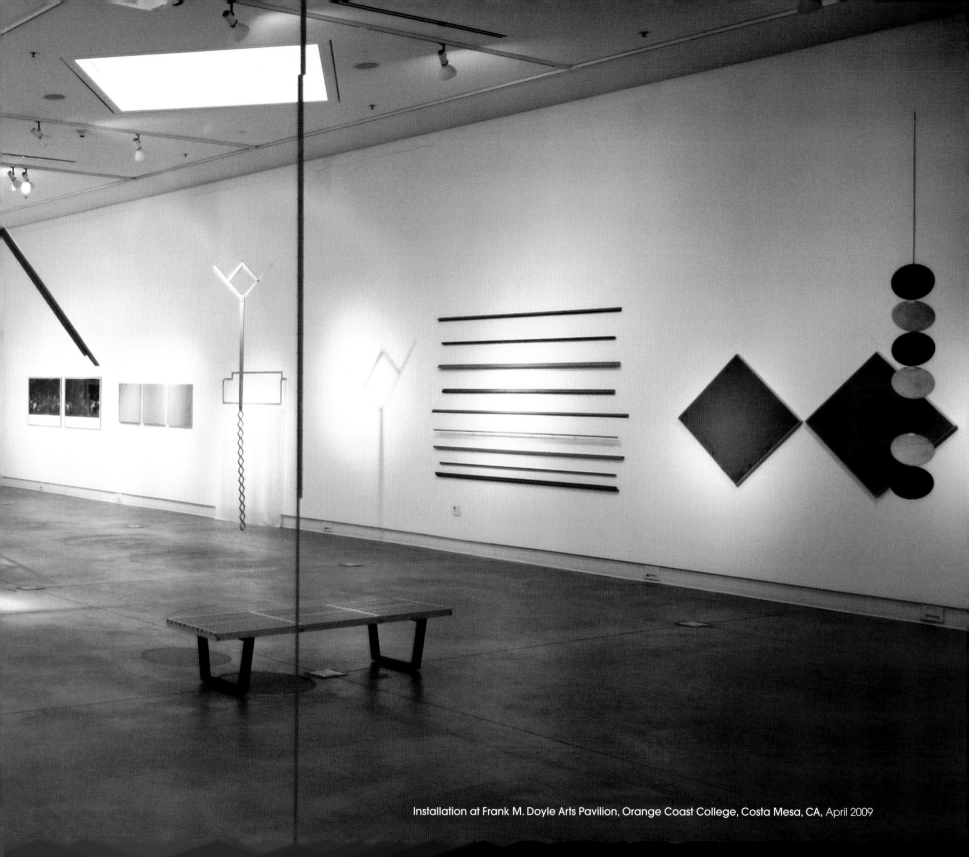

Installation at Frank M. Doyle Arts Pavilion, Orange Coast College, Costa Mesa, CA, April 2009

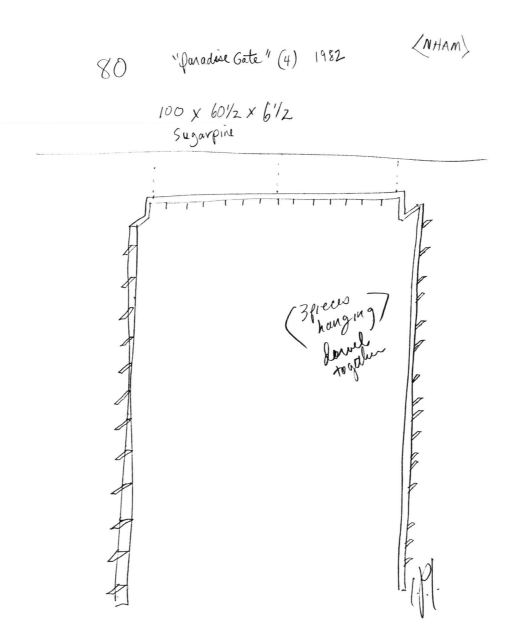

80 "Paradise Gate" (4) 1982 ⟨NHAM⟩

100 x 60½ x 6½
Sugarpine

(3 pieces hanging) dowel together

John Paul Jones installation sketch for
Paradise Gate (4), 1982
Hudson and Noble Collection

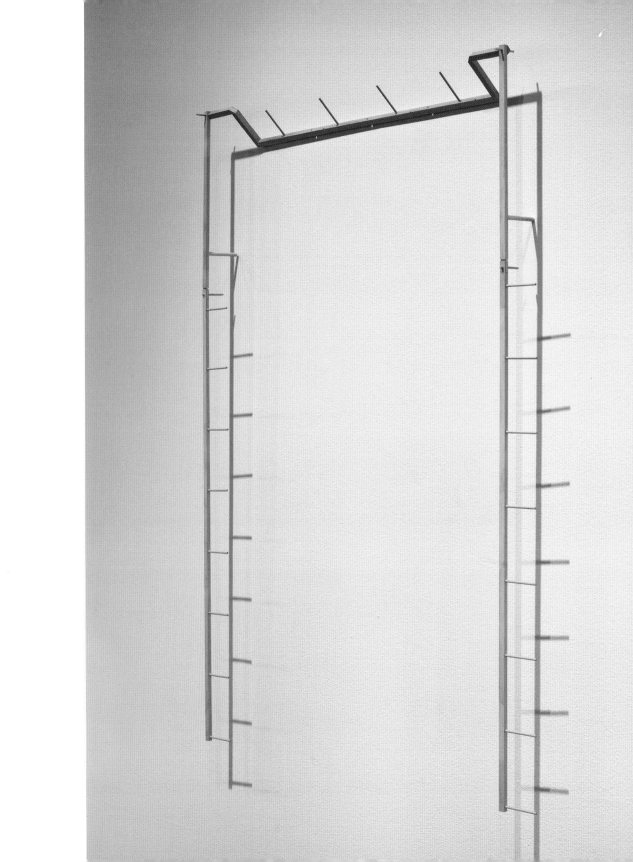

Paradise Gate, 1981
Pine, 43″ x 30″ x 3¹/₂″
John Paul Jones Estate

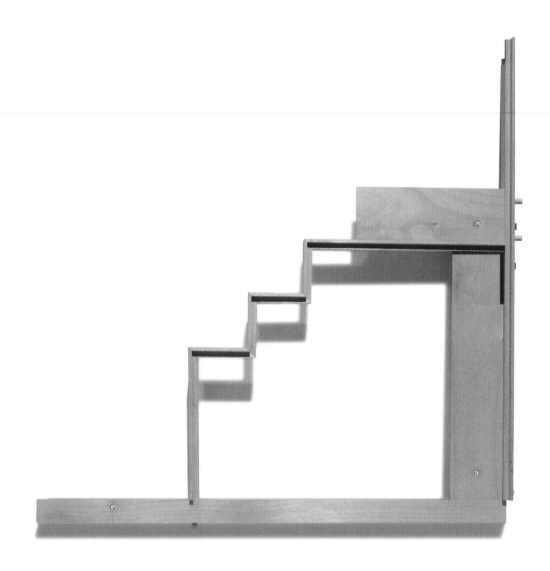

Parsons Attic, 1988
Sugar pine, 33"x 48"x 5½"
John Paul Jones Estate

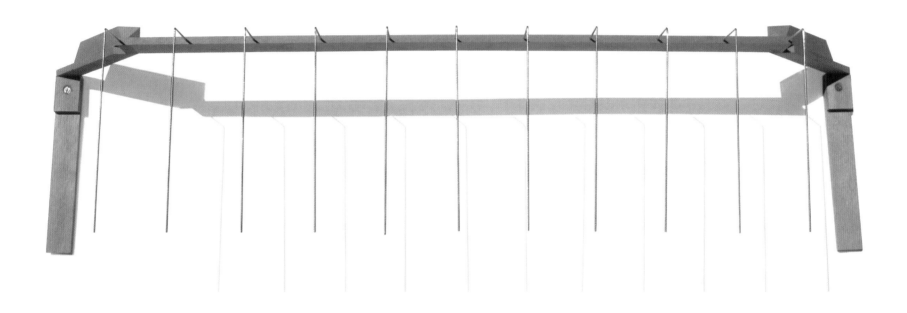

Yellow Wire, 1980
Sugar pine and aluminum, 6"x 23½"x 5"
Gary Martin Collection

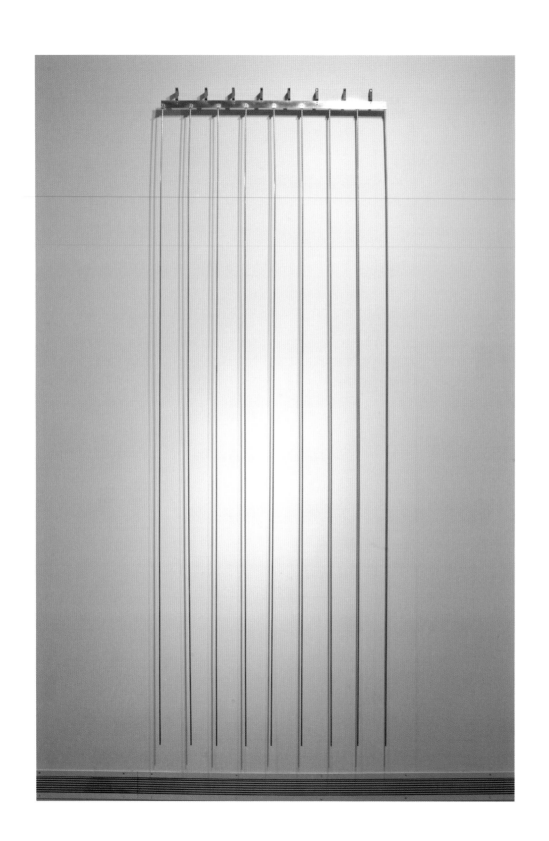

Neon Rivers, 1980
Sugar pine and aluminum, 124"x 45"x 3"
Laguna Art Museum Collection

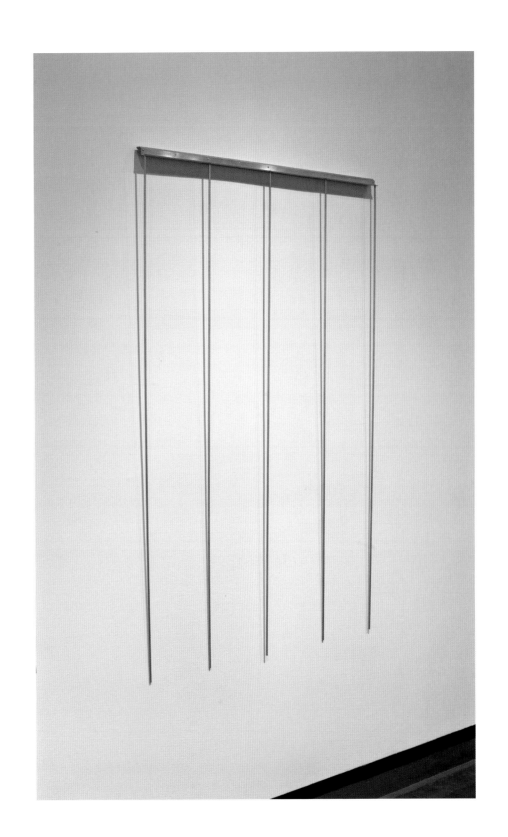

Silk Screen, c. 1980s
Aluminum, 61"x 40"x 1¾"
John Paul Jones Estate

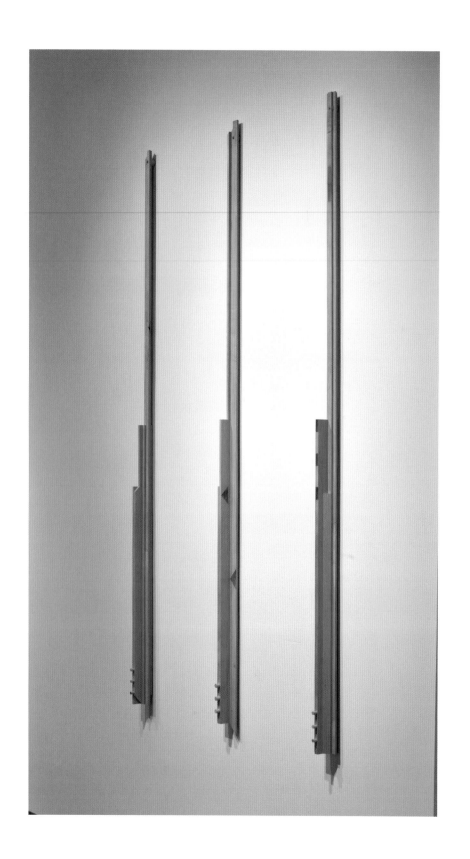

Cassandra Triptych, 1988
Alder with black inserts
78"x 2¾"x 2"
78"x 3"x 2"
78"x 3"x 2"
Chapman University Collection

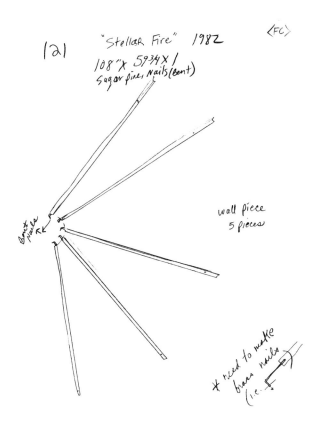

"Stellar Fire" 1982 ⟨FC⟩
|2|
108" x 59¾ x /
Sugar pine Nails (Bent)

wall piece
5 pieces

* need to make
brass nails
(i.e.

▲ John Paul Jones installation sketch for
 Stellar Fire, 1982
 Hudson and Noble Estate

▶ Stellar Fire, 1982
 Sugar pine and bent nails,
 108" x 59¾" x 1"
 Fullerton College Collection

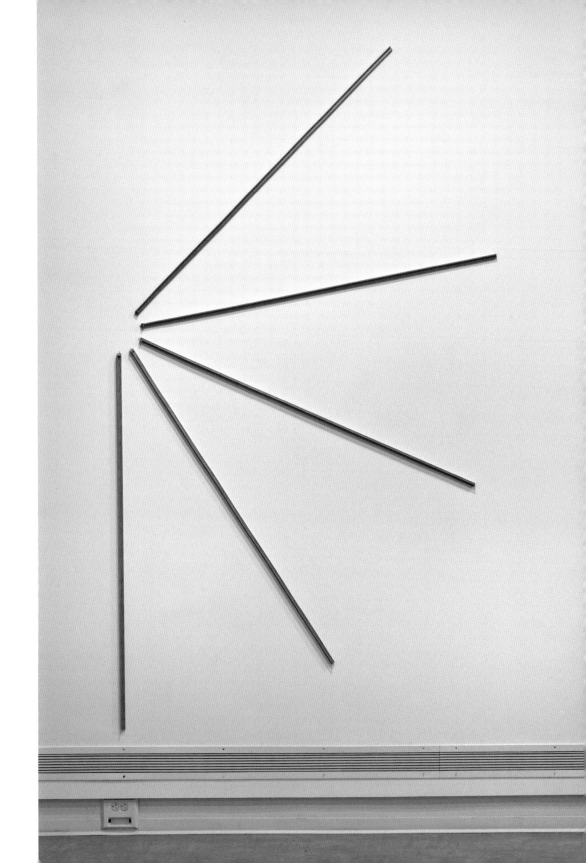

Installation at Main Art Gallery, California State University, Fullerton, CA, April 2009

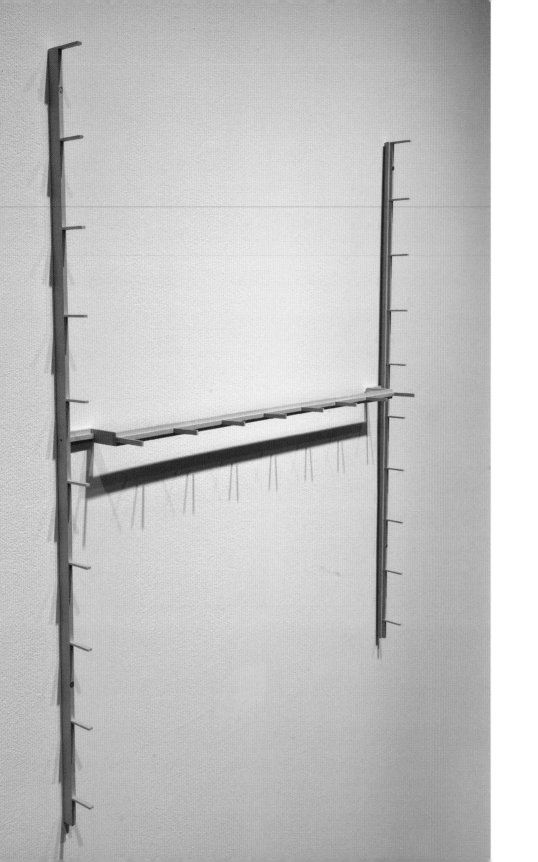

◀ **Title Unknown**, 1985
Pine, 43"x 37"x 3¼"
John Paul Jones Estate

▶ **Divining Rod**, 1983
Birch and sugar pine, 100 x 163¾ x 76½"
Orange County Museum of Art Collection

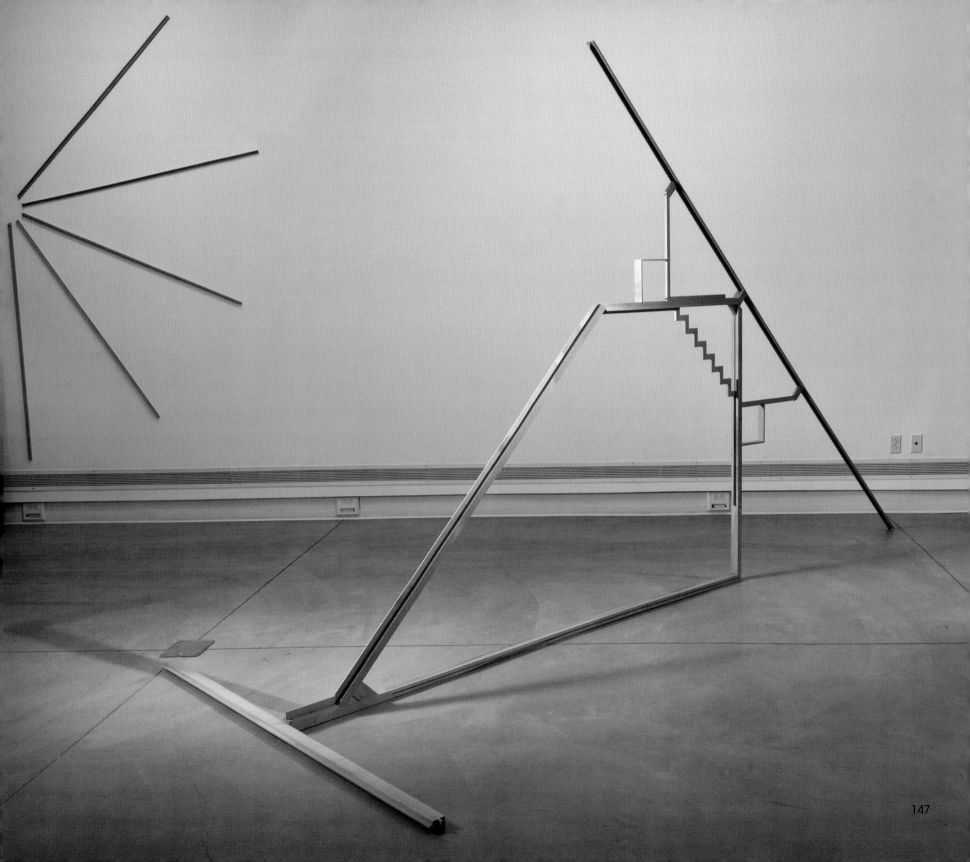

147

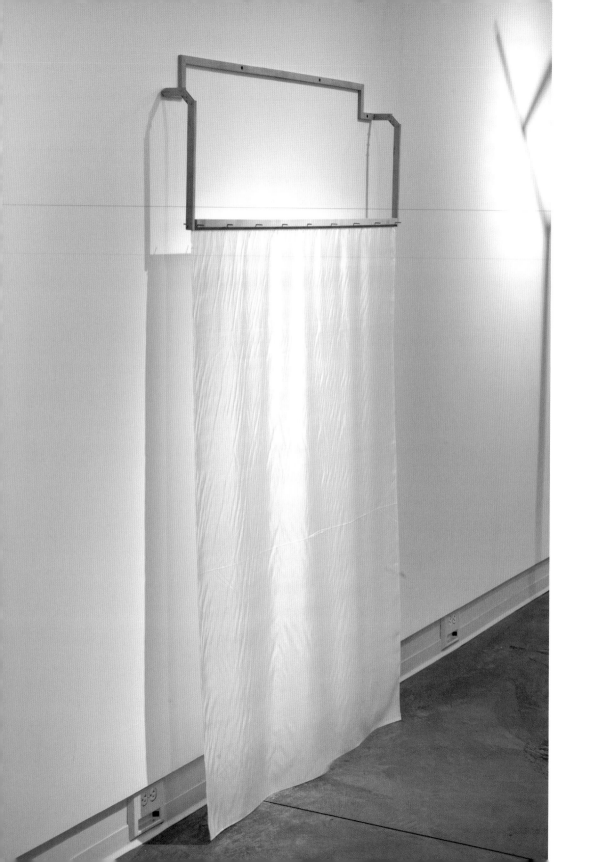

The New Empress, 1998
Silk and sugar pine, 79¼"x 72"x 1"
John Paul Jones Estate

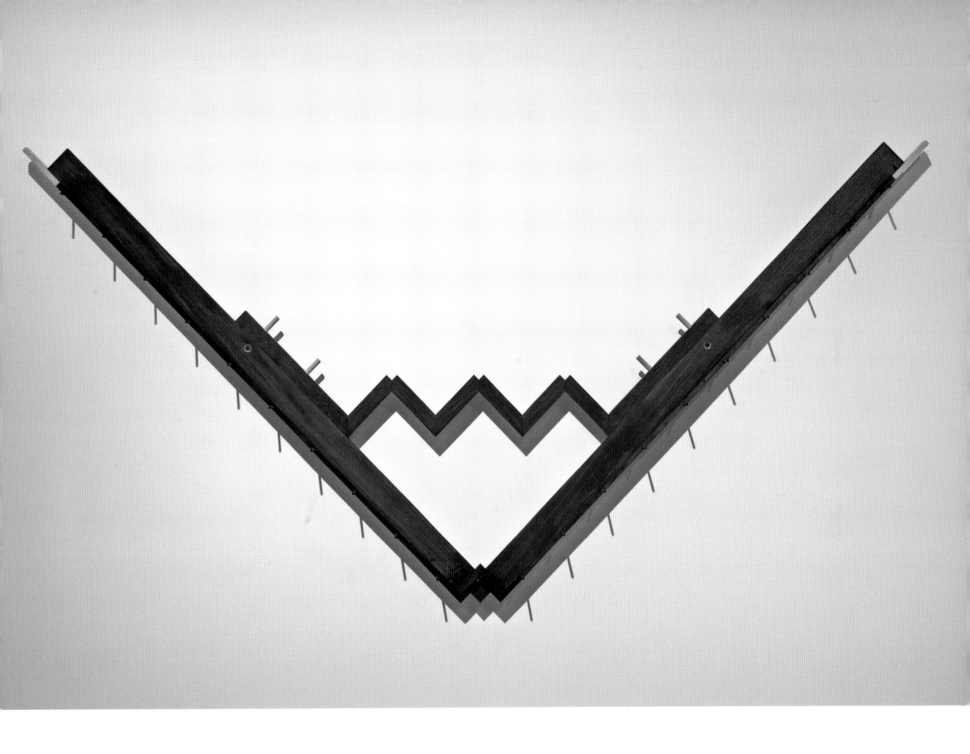

Knight's Bridge, 1987
Black dyed pine with white inserts, 24"x 47¼"x 3½"
Laguna Art Museum Collection

149

Algerian Sweet, c. 1989
Stainless steel and birch, 37¾″ x 23¾″ x 1″
John Paul Jones Estate

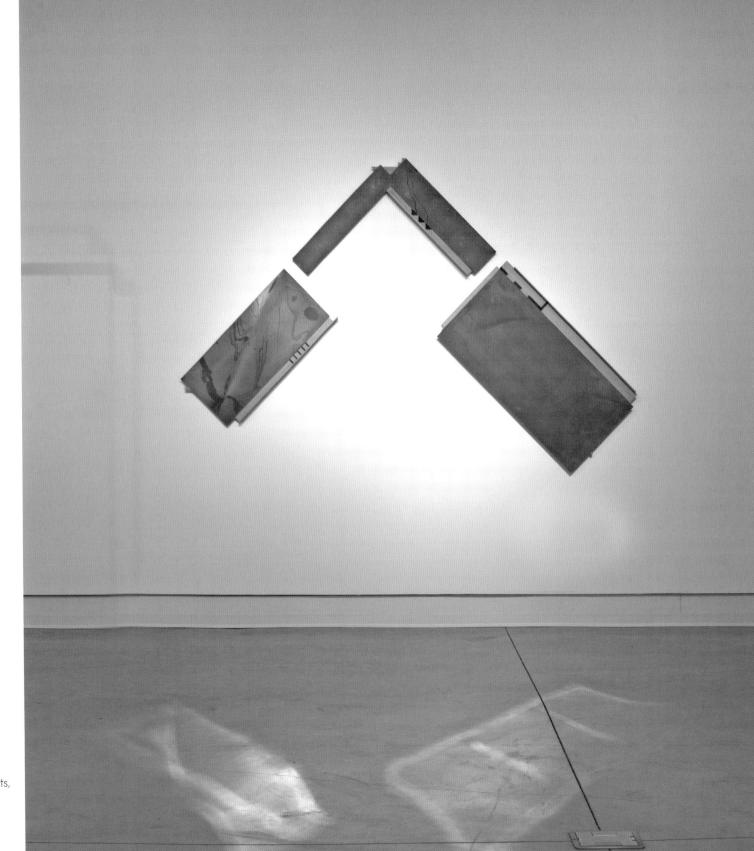

French Mirror, 1989
Brass and wood with black inserts,
60" x 90" x 1¾"
Noble and Hudson Collection

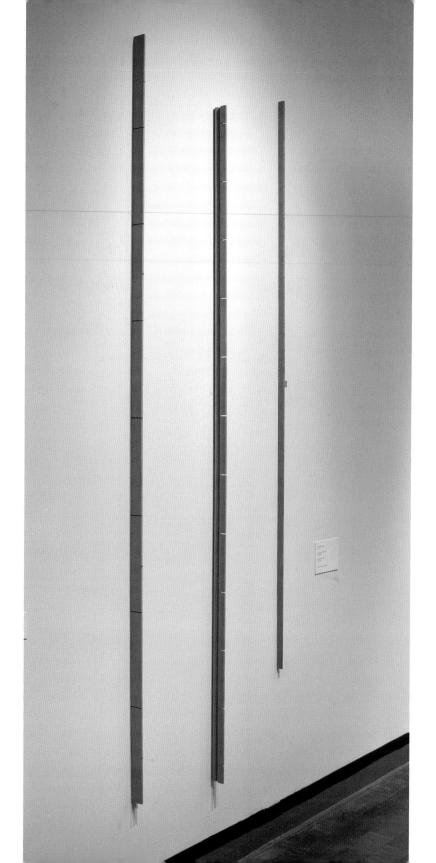

◀ **Blade Ladder 7**, 1979
Pine

Blade Ladder 6, 1979-1980
Sugar pine

Blade Ladder 1, 1979
Sugar pine
Various sizes, lengths: 85½" to 96"
Fullerton College Collection

▶ Details of **Blade Ladders**

Installation at Main Art Gallery, California State University, Fullerton, CA, April 2009

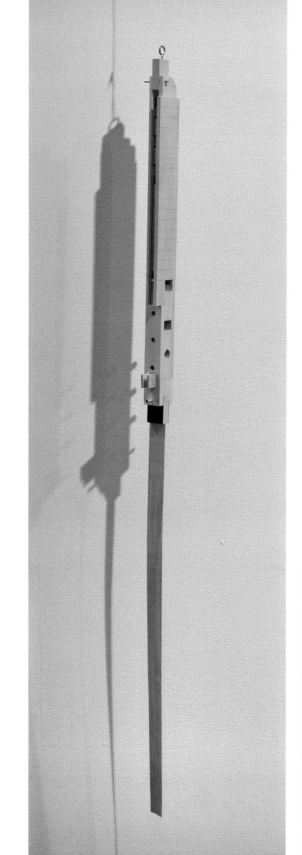
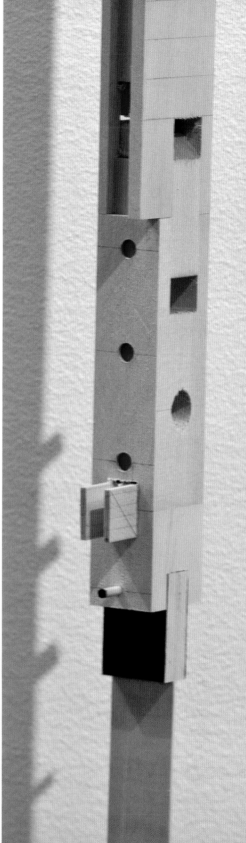

Near right
The Royal Blade Collection, Ceremonial/Queens, 1987
Pine and balsa, 41½"x 1"x 2"
John Paul Jones Estate

Far right
Detail of **The Royal Blade Collection**

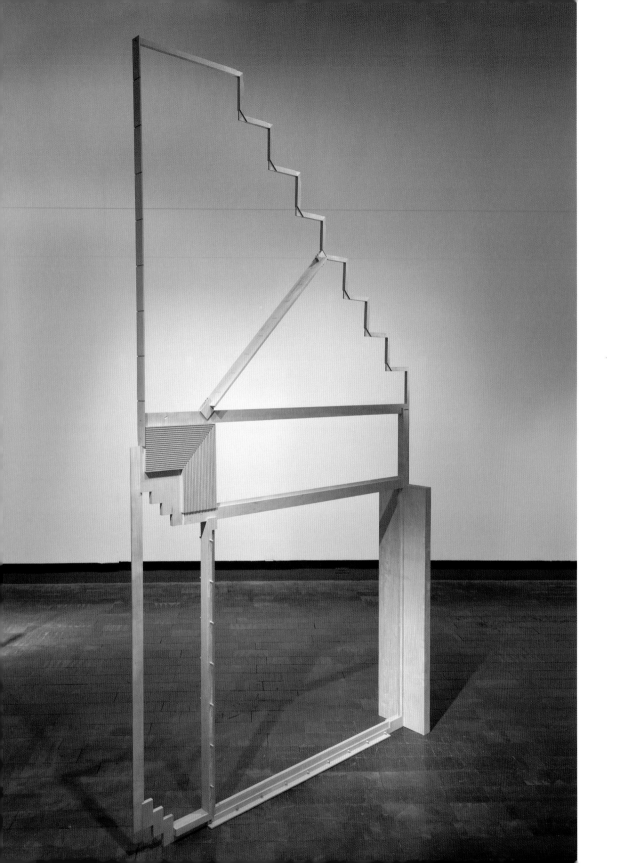

Catwalk, 1983
Jelutong and basswood,
109¾"x 62"x 11"
Laguna Art Museum Collection

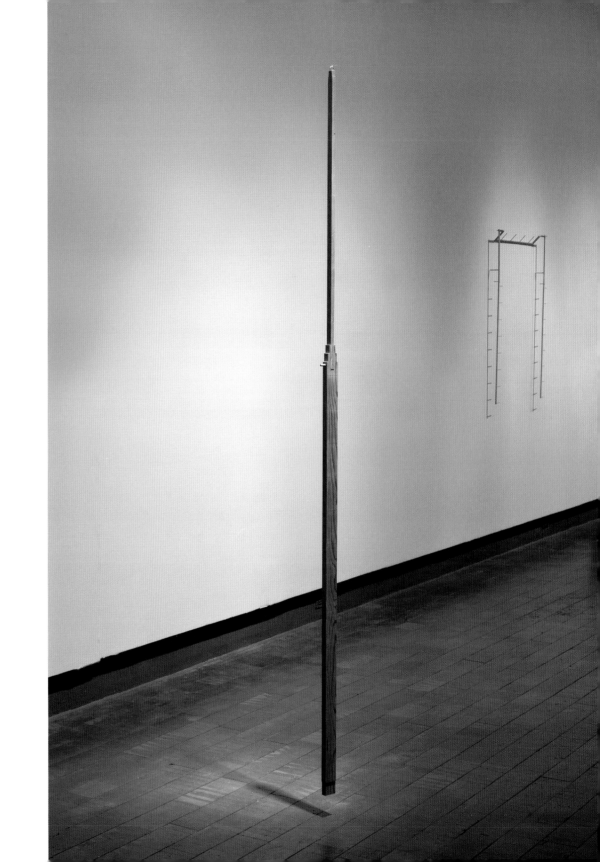

Foreground
Blade Ladder 1, 1979
Sugar pine, 85½″ x ½″ x ½″
Fullerton College Collection

Background
Paradise Gate, 1981

▲ **Sweet Rice #1**
Sugar pine, 1" to 14"
Fullerton College Collection

▶ **Bar Bridge** 1 through 8, (in mixed order), 1979 and
Carlsbad Bridge, 1979 (fourth sculpture from the bottom)
Sugar pine and pine, Various sizes, lengths: 84" to 96"
Fullerton College Collection

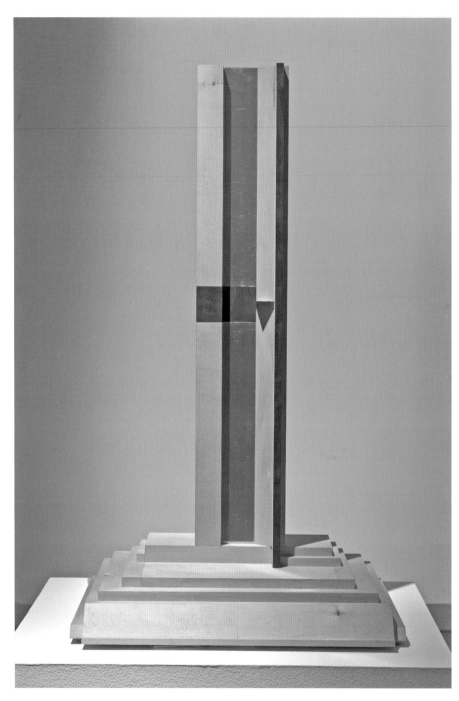

Tower 6 (maquette), 1988
Sugar pine, alder, black inserts and metal, 30"x 17½"x 17⅝"
Laguna Art Museum Collection

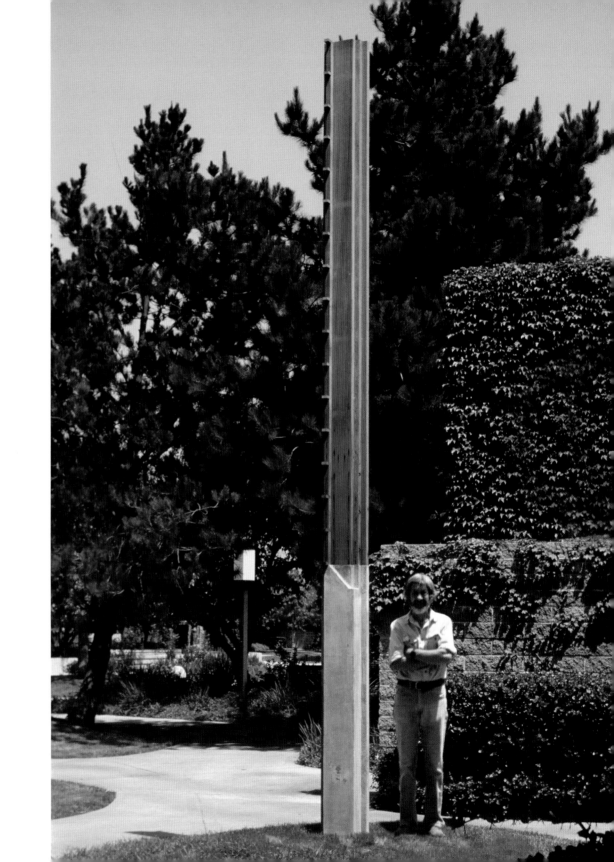

Chapman Tower, 1985
Redwood and concrete, 216" x 11" x 12"
John Paul Jones next to his sculpture
Chapman University Collection

Left
Plate 4, 1994, From "Series of Four: Pressman's Cabinet"

Middle
Plate 7, 1994, From "Series of Four: Pressman's Cabinet"

Right
The Balanchine Memorandum, 1994
All graphite on paper, each 18"x 18"
John Paul Jones Estate

Afterward 26, 1995-96
From "Series of Five Rounds"
Graphite on paper, 16" diameter
John Paul Jones Estate

Top
1G, 1995, From "Cartographer's Paper's Gang of Three"
Graphite and colored pencil on paper, 16"x 24"
John Paul Jones Estate

Bottom
2G, 1995, From "Cartographer's Paper's Gang of Three"
Graphite and colored pencil on paper, 16"x 24"
John Paul Jones Estate

Top
Blue Scraps-3, 1995
From "Series of Four: Blue Scraps Maproom"
Graphite and colored pencil on paper, 16"x 24"
John Paul Jones Estate

Bottom
3G, 1995, From "Cartographer's Paper's Gang of Three"
Graphite and colored pencil on paper, 16"x 24"
John Paul Jones Estate

Caprichos (triptych), 1996
Acrylic with graphite, 30"x 30" each panel
John Paul Jones Estate

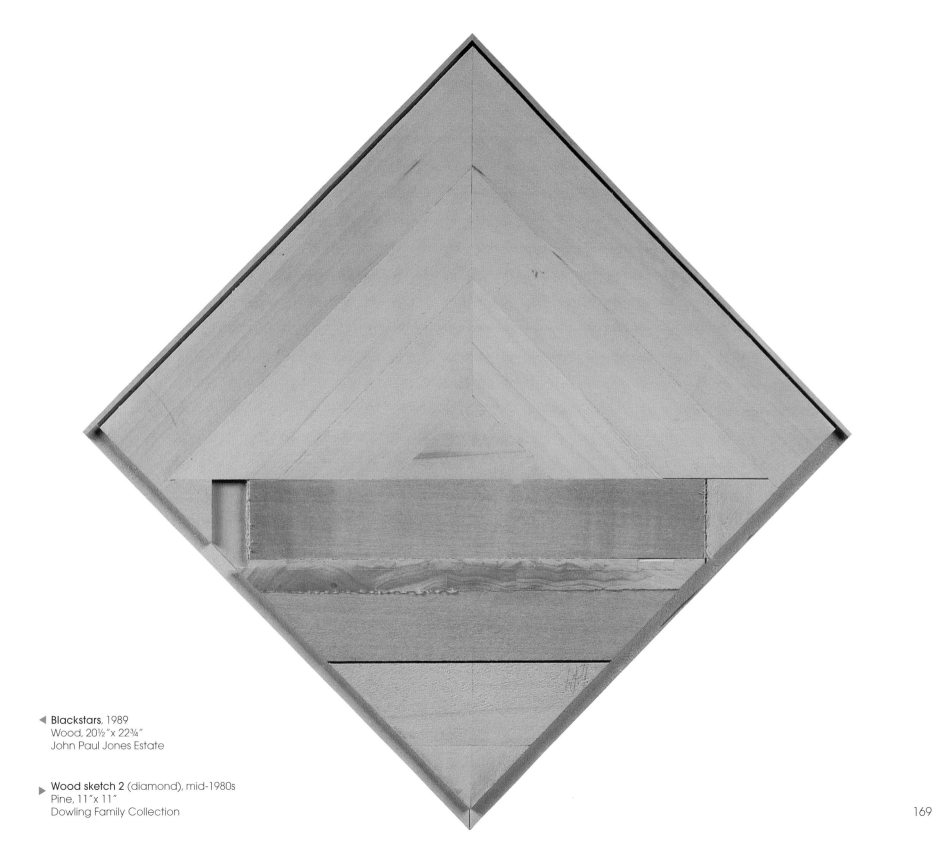

◀ **Blackstars**, 1989
Wood, 20½"x 22¾"
John Paul Jones Estate

▶ **Wood sketch 2** (diamond), mid-1980s
Pine, 11"x 11"
Dowling Family Collection

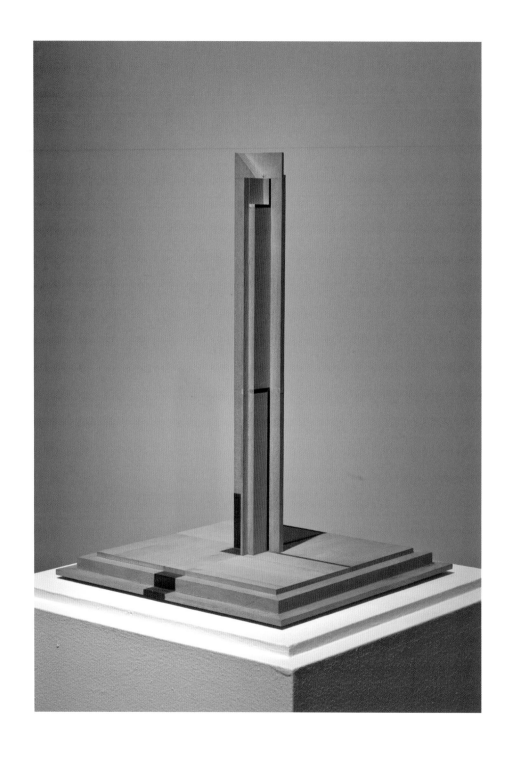

Tower 7 (maquette), c. 1988
Alder, black inserts,
22½"x 14½"x 14½"
Fullerton College Collection

83 "Front Gallery Table", 1981 ⟨EC⟩
36½ x 46⁷/₁₆ x 13¾
pine

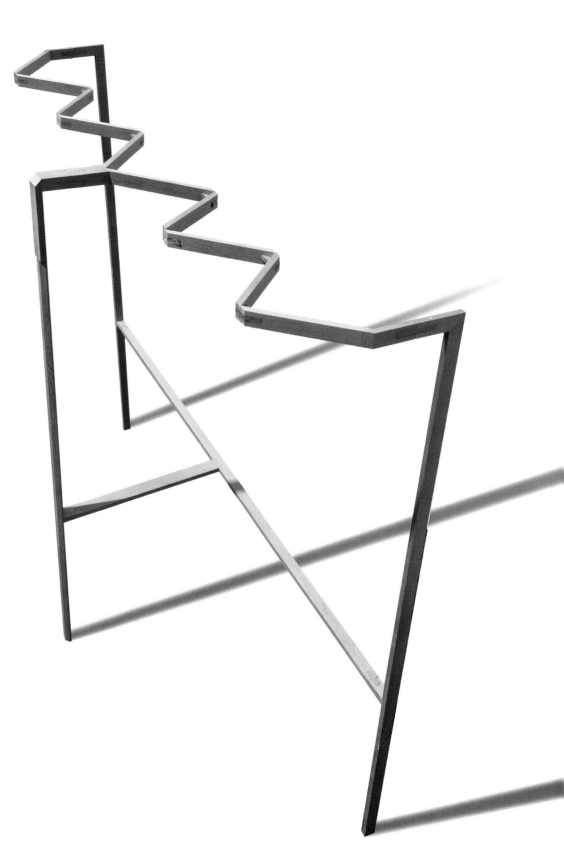

▲ John Paul Jones installation sketch for
Front Gallery Table, 1981

▶ **Front Gallery Table**, 1981
Pine, 36½"x 46⁷/₁₆"x 13¾"
Fullerton College Collection

◀ **Lavender Swing 1** (diptych), 1997
Acrylic with graphite on canvas, 42½"x 42½"
John Paul Jones Estate

▶ **Flag Patterns**, 1993-94
Graphite on paper, 36" x 24"
John Paul Jones Estate

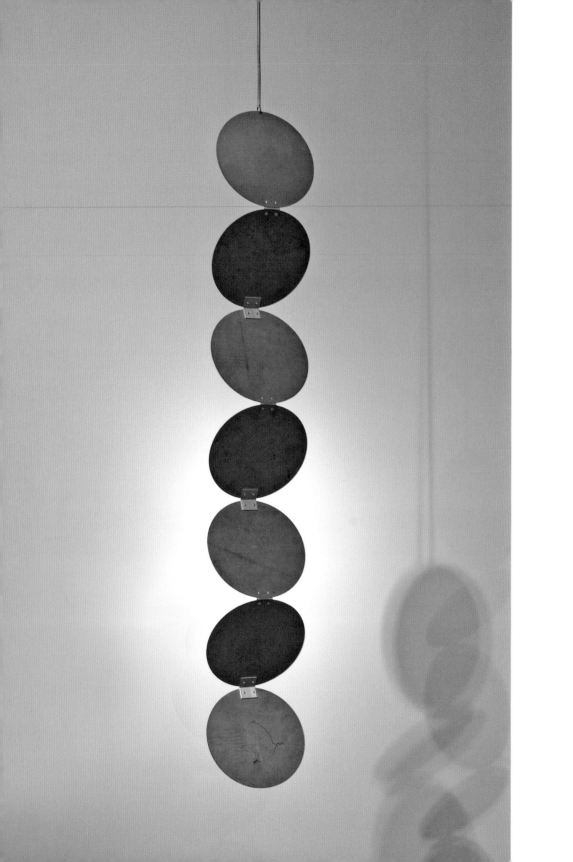
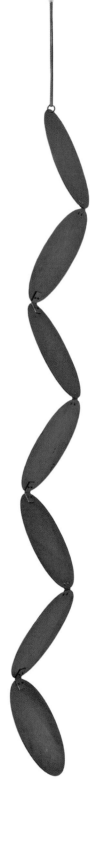

Two views
Seven Moons, ca. 1980-1982
Aluminum, 93½"x 9¼"x 4½"
Fullerton College Collection

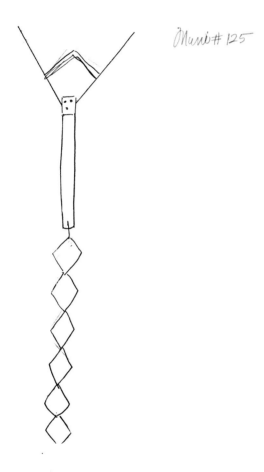

55 "Jelly Cutter" 1983 (LAM)
178 5/8 x 29½ x 13/16
basswood, aluminum

Mani # 125

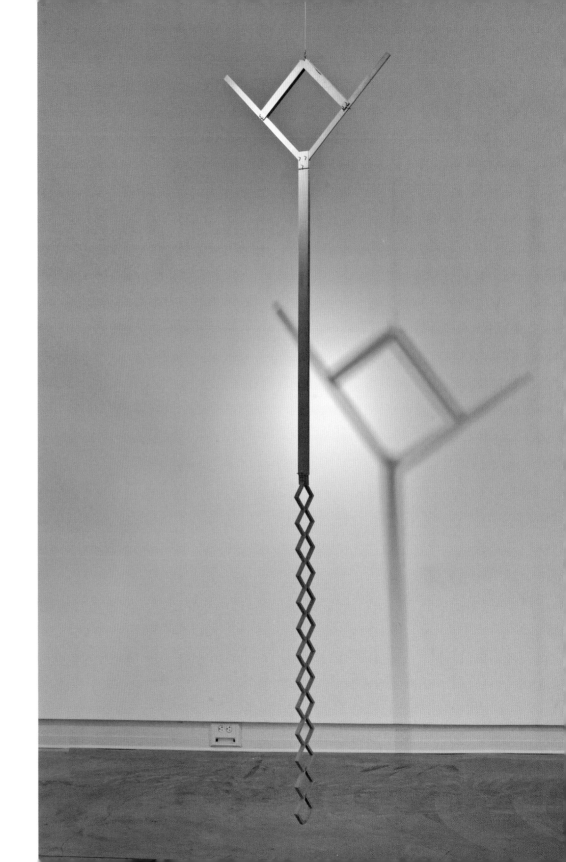

▲ John Paul Jones installation drawing for
 Jelly Cutter, 1983

▶ Jelly Cutter, 1983
 Basswood, aluminum, 178⅝"x 29½"
 Laguna Art Museum Collection

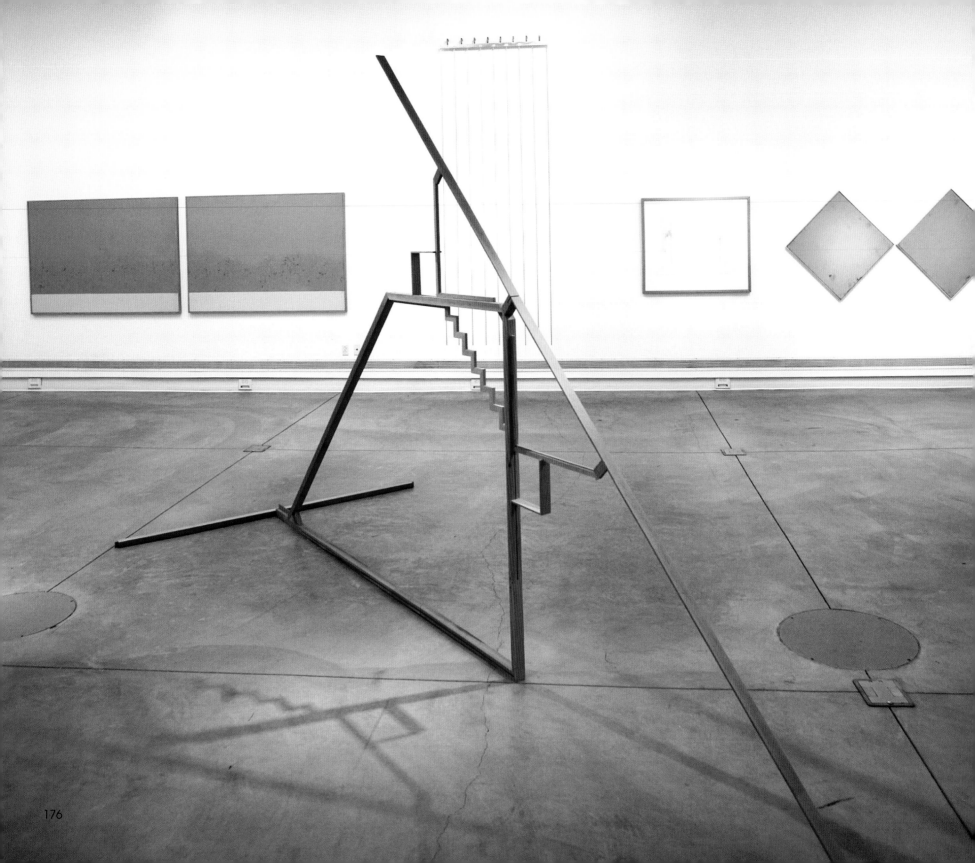

◀ Installation at Frank M. Doyle Pavillion, Orange
 Coast College, Costa Mesa, CA, April

▶ **Comb Table**, 1981
 Sugar pine, 38"x 36"x 36"
 Laguna Art Museum Collection

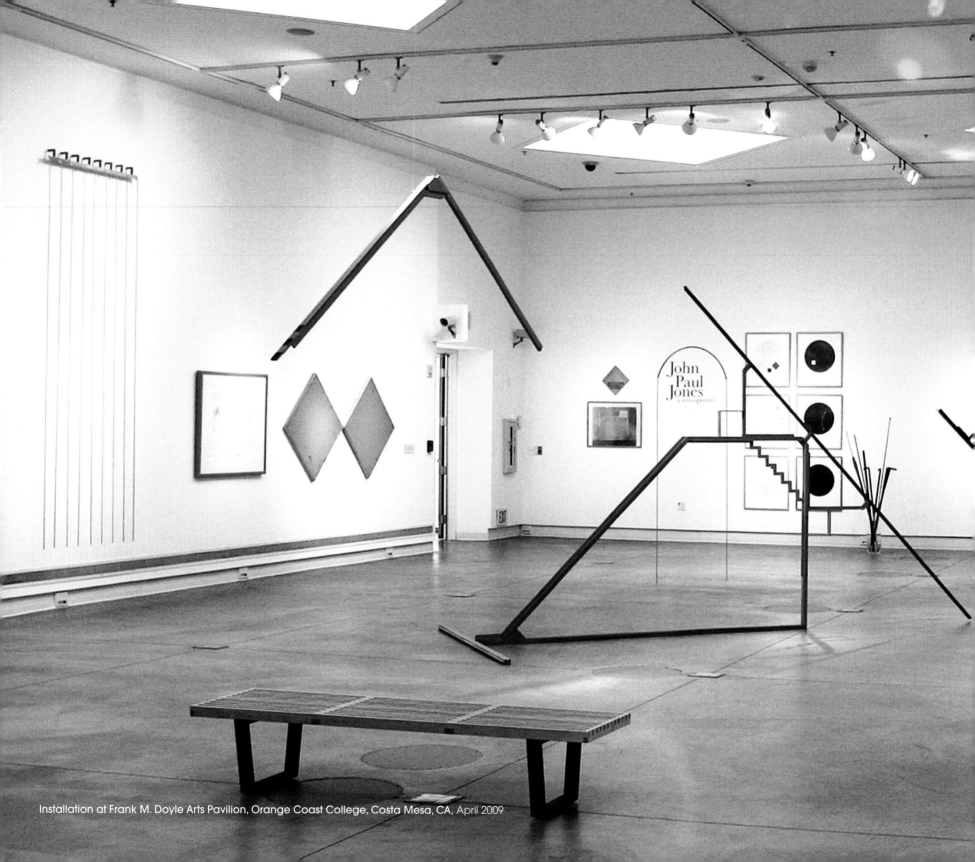

Installation at Frank M. Doyle Arts Pavilion, Orange Coast College, Costa Mesa, CA, April 2009

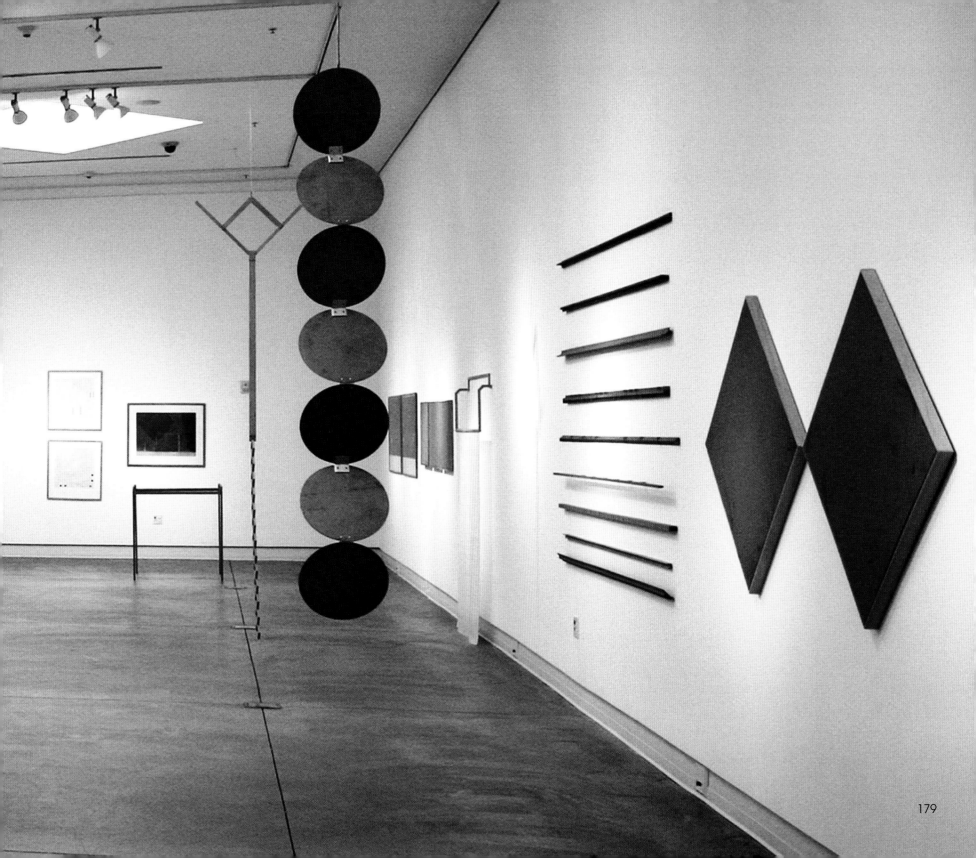

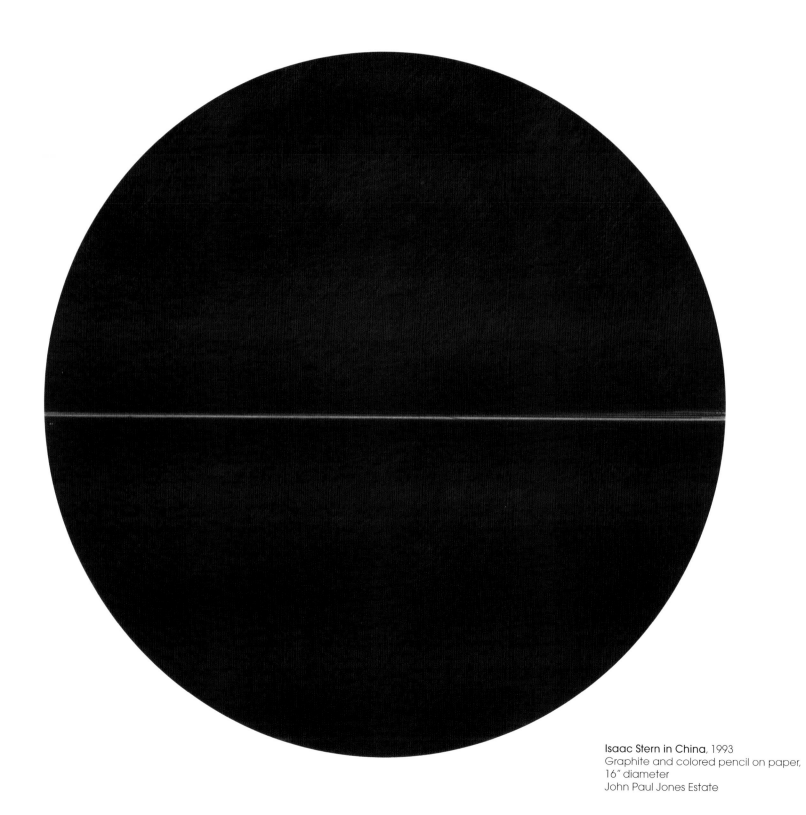

Isaac Stern in China, 1993
Graphite and colored pencil on paper,
16" diameter
John Paul Jones Estate

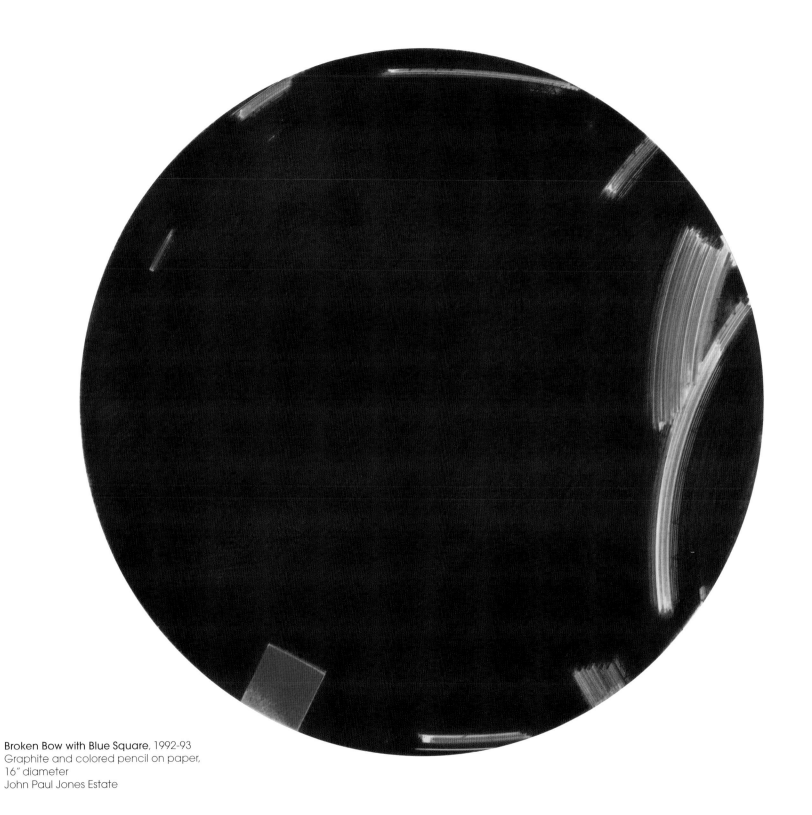

Broken Bow with Blue Square, 1992-93
Graphite and colored pencil on paper,
16″ diameter
John Paul Jones Estate

Sky Full of Moons, 1991-92
Proof on tracing paper, 1⁷/₈"x 9"
Susanne Nestory Collection

Ice Palace (gate), 1991-92
Proof on tracing paper, 2¼"x 9"
182 Susanne Nestory Collection

"Moondancer w/hat"

Moon Dancer with Hat, 1991-92
Proof on tracing paper, 5¼" x 6½"
Susanne Nestory Collection

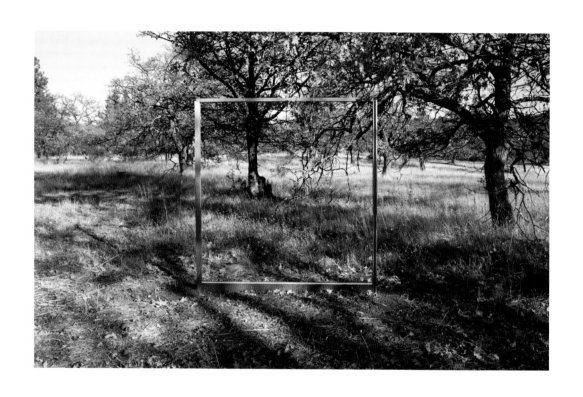

This page through page 188:
John Paul Jones outdoor sculpture installation
on his property in Ashland, Oregon, in various
stages of progress, 1991-1995

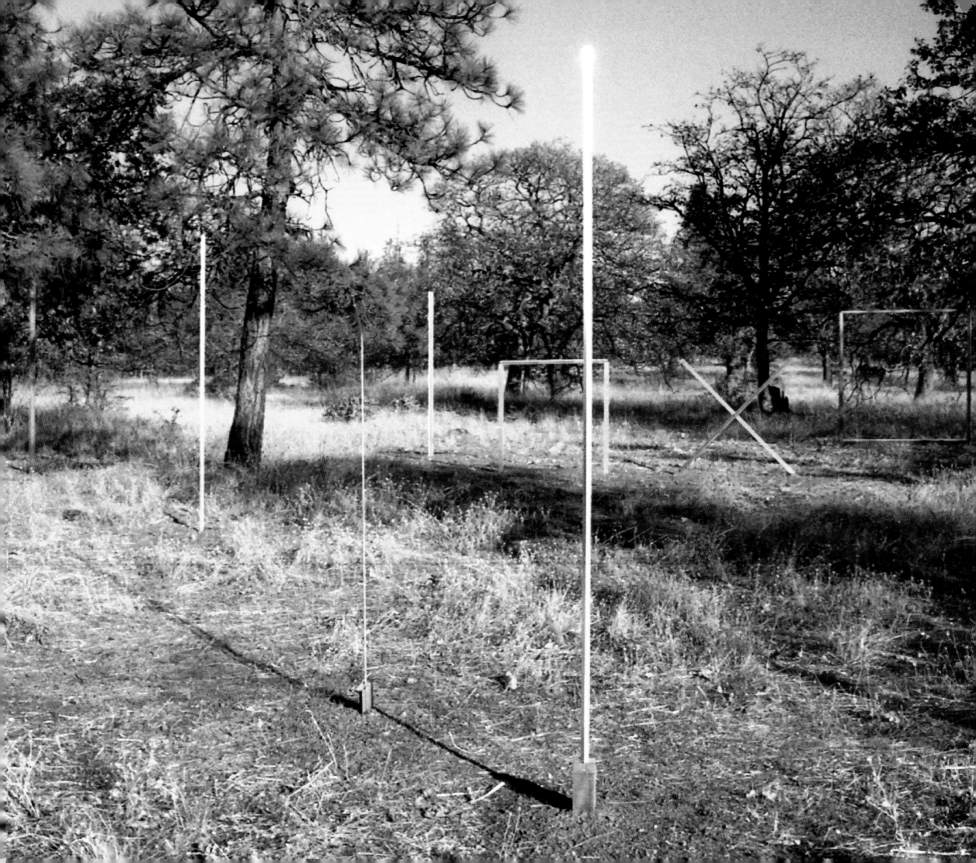

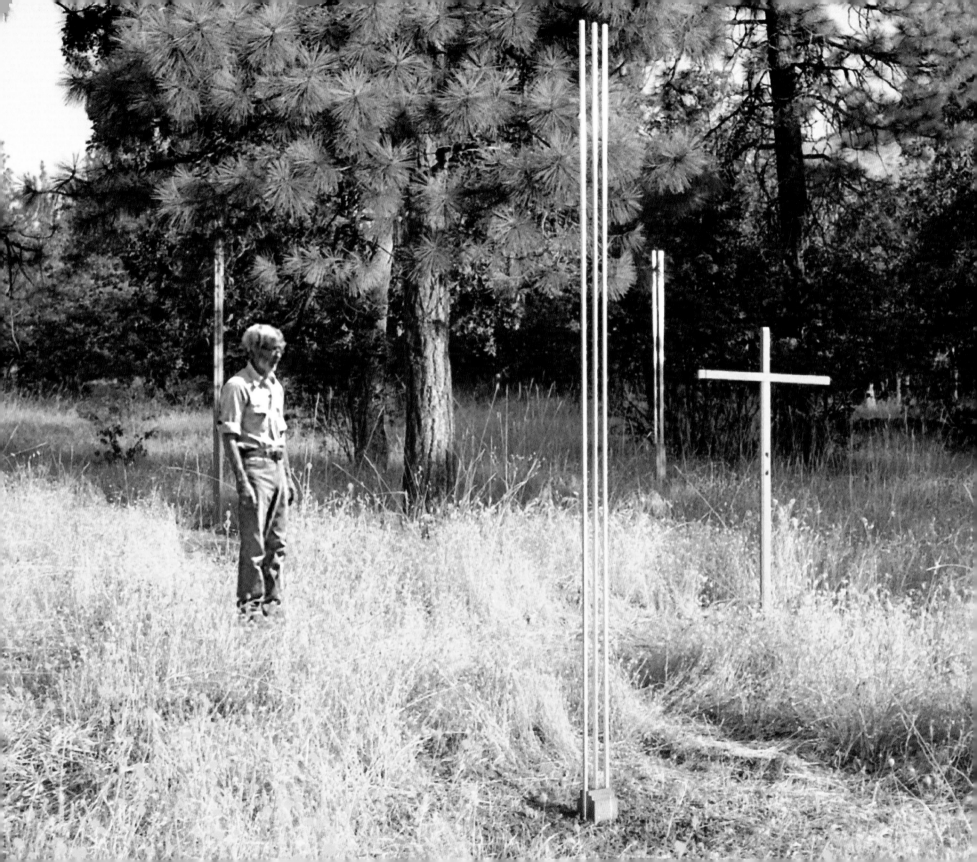

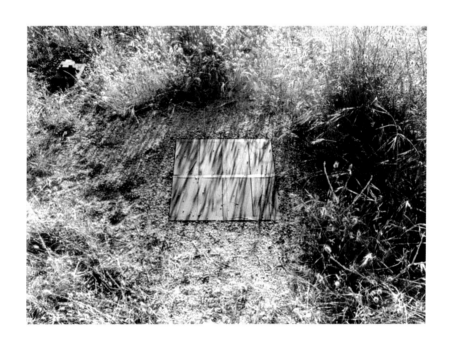

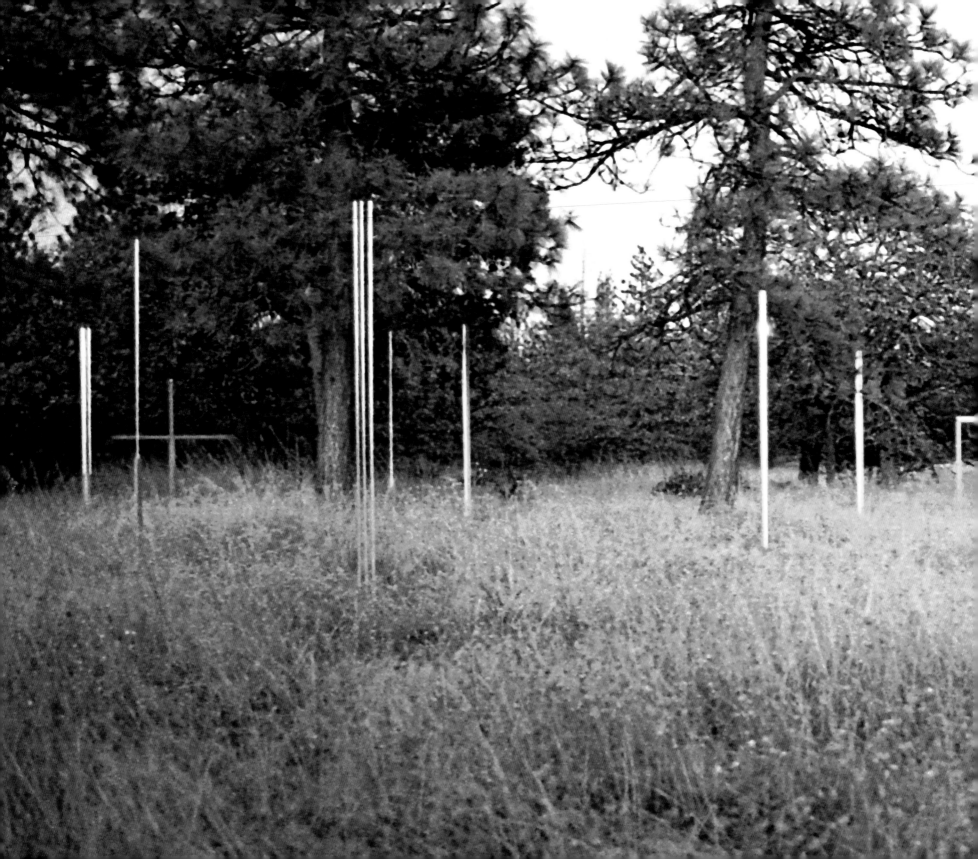

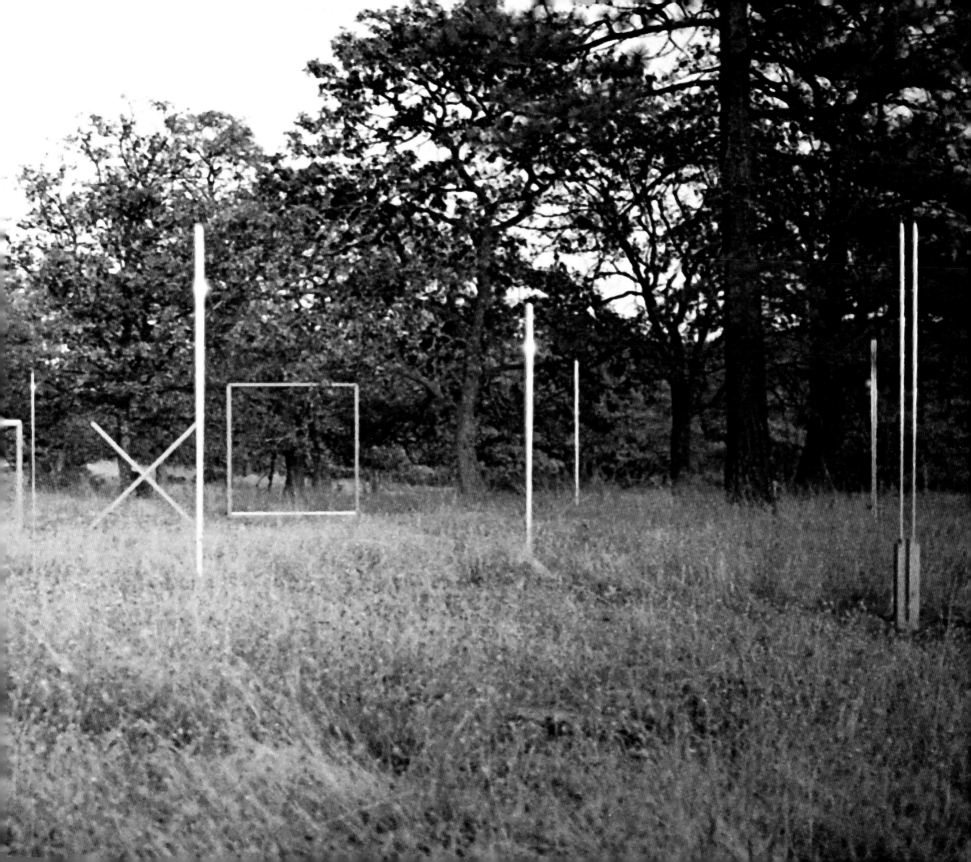

Chronology and Public Collections

Chronology

John Paul Jones
1924 Born in Indianola, Iowa.

1942 Attended Indianola High School, Indianola, Iowa: Played varsity basketball; appeared in the junior class high school play, "Almost Eighteen," in the role of Tommy.

1943 At Indianola High School played trumpet in the Jazz Band; appeared in the senior class high school play, "Lost Horizon," in the leading role as the High Lama. Elected to National Honor Society and received American Legion Award. Graduated from Indianola High School. Entered Simpson College in Indianola, Iowa, as pre-engineering major. Drafted in the Army in October.

1944-46 Served 15 months with Field Artillery, United States Army, in Hawaii and Okinawa.

1946 Honorably discharged from the Army. Enrolled at State University of Iowa, now the University of Iowa, in Iowa City, where he studied art history with Lester D. Longman; sculpture with Humbert Albrizio; painting with James Lechay, Stuart Edie, and Eugene Ludins; and printmaking with Mauricio Lasansky.

1948 Awarded: 2nd prize in printmaking at Art Exhibit, Iowa State Fair.

1949 Married Charlotte Jean Enger. Received B.F.A. degree at end of spring semester. Enrolled in M.F.A. program in printmaking at State University of Iowa in summer. **Awarded:** Honorable Mention for Painting, "Room Interior," Iowa Artists Annual Exhibition, Des Moines Art Center, Des Moines, IA; Purchase Prize for Painting, "Red Upon Red," Six-States Annual Exhibition, Joslyn Art Museum, Omaha, NB; 2nd Prize in Sculpture, "Monument," Iowa Art Salon, Iowa State Fair, Des Moines, IA.

Age 5 months

Age 17 high school band

Age 6

Age 18 with his mother

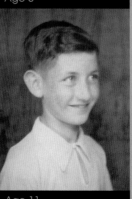
Age 11

Age 19 Joins the Army

Images of John Paul Jones as a child courtesy of:
Smithsonian Institution, Archives of American Art, Washington DC.

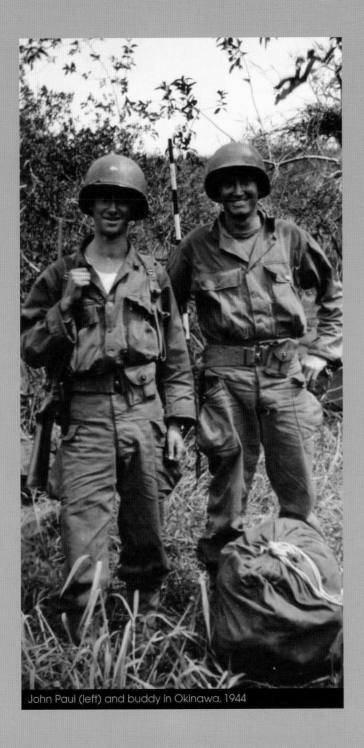
John Paul (left) and buddy in Okinawa, 1944

1950 Graduate assistant at State *University of Iowa*. **Group exhibitions:** *Painting, Prints, Mobiles*, Iowa Wesleyan College, Mt. Pleasant; *Paintings and Prints*, Des Moines Art Center, Des Moines: *Paintings and Prints*, Blanden Memorial Art Gallery, Fort Dodge; *Prints*, Witte Memorial Museum, San Antonio, TX.

1951 Received M.F.A. from State University of Iowa: prepared thesis in printmaking under Mauricio Lasansky. Thesis consisted of six original prints and a written statement, "A Search for a Direction." Appointed Instructor in Art at University of Oklahoma, Norman, Oklahoma. **Awarded:** Louis Comfort Tiffany Foundation scholarship for graphics; Purchase Prize, "Boundary," The *Brooklyn Museum Fifth National Print Exhibition*, Brooklyn, NY; Purchase Prize, "Boundary," *Northwest Printmakers International Print Exhibition*, Seattle Art Museum, Seattle, WA; Purchase Prize in Prints, "#607," *Iowa Artists Annual Exhibition*, Des Moines Art Center, Des Moines, IA; 1st Prize, "Yellow," *Bradley University National Print Annual*, Bradley University, Peoria, IL; 1st Prize in Painting, "Self-Portrait," 14th *Annual Iowa May Show*, Sioux City Municipal Art Center, Sioux City, IA. **First solo exhibitions:** *Painting, Prints, Mobiles*, Iowa Wesleyan College, Mt. Pleasant, IA; *Paintings and Prints*, Des Moines Art Center, Des Moines, IA; *Paintings and Prints*, Blanden Memorial Art Gallery, Fort Dodge, IA; *Prints*, Witte Memorial Museum, San Antonio, TX. **Group exhibitions:** *Fifth National Print Annual Exhibition*, Brooklyn Museum, Brooklyn, NY; *Contemporary Art in the United States*, Worcester Art Museum, Worcester, MA; *Prospectus*, Grace Borgenicht Gallery, New York, NY.

1952 Son Shawn Birdsall Jones born. Spent two months in New York City studying prints at various museums. Returned to State University of Iowa (now University of Iowa) in Iowa City as Instructor in Art. **Awarded:** Purchase Prize, Prints, "Landscape #2," *Biennial Exhibition of Paintings and Prints*, Walker Art Center, Minneapolis, MN; Purchase Prize, Prints, "Bouquet," *5th Southwestern Print and Drawing*

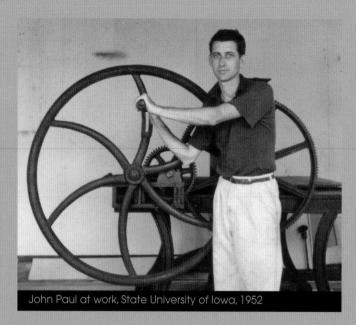
John Paul at work, State University of Iowa, 1952

Annual, Dallas Museum of Fine Art, Dallas, TX; Purchase Prize, Painting, "River Lights Grey," *2nd Biennial Art Exhibition,* Kansas State College, Manhattan, KS;. **Solo exhibition:** *Paintings and Prints,* University of Oklahoma, Norman, OK. **Group exhibitions:** *Fifth Southwestern Exhibition of Prints and Drawings,* Dallas Museum of Fine Arts, TX; Pennsylvania Academy of the Fine Arts, Philadelphia, PA; *Internationale Graphik,* Galerie Kunst Der Gegenwart, Salzburg, Austria; *American Watercolors, Drawings and Prints,* Metropolitan Museum of Art, New York, NY. Noted art historian Dore Ashton mentioned Jones in an *Art Digest* exhibition review; Ashton would write about Jones in many other reviews.

1953 Appointed Assistant Professor of Art at University of California at Los Angeles (UCLA). **Awarded:** Purchase Prize, "Suspension," *The Brooklyn Museum Seventh National Print Exhibition,* Brooklyn, NY; 1st Award for Prints, "Boundary," *Iowa Artists Annual Exhibition,* Des Moines Art Center, Des Moines, IA; Honorable Mention, "*Diversion,*" *13th Annual Exhibition of Etching,* The Print Club, Philadelphia, PA; Purchase

Prize, "Yellow," *1st National Print Exhibition,* Dallas Museum of Fine Arts, Dallas, TX. **Group exhibitions:** *Modern Amerikaanse Grafiek,* Gemeentemuseum's-Gravenhague, The Netherlands; *Prints: 1942-1952,* Brooks Art Gallery, Memphis, TN; *Young American Printmakers,* Museum of Modern Art, New York, NY.

1954 Awarded: Purchase Prize, "*Return,*" *The Brooklyn Museum Eighth National Print Exhibition,* Brooklyn, NY; Purchase Prize, "Diversion," *Bradley University National Print Annual,* Bradley University, Peoria, IL; Purchase Prize, Prints, "Diversion," *Biennial Exhibition of Paintings and Prints,* Walker Art Center, Minneapolis, MN; Purchase Prize, "Return," *Graphic Arts USA,* University of Illinois, Urbana; 1st Morrison Award, Gold Medal and Guest of Honor One-Man Show, "*Diversion,*" *Western Sculpture and Print Exhibition,* Oakland Art Museum, Oakland, CA; Honorable Mention, "Yellow," *California Art Show,* California State Fair, Sacramento, CA; Purchase Prize, "Yellow," *Young American Printmakers,* Museum of Modern Art, New York, NY. First solo exhibition at Felix Landau Gallery, Los Angeles, *John Paul Jones: Prints, Drawings, Paintings.* **Group exhibitions:** *12th National Exhibition of Prints,* Library of Congress, Washington, D.C; *Prints by California Artists,* Santa Barbara Museum of Art, Santa Barbara, CA; *Western Sculpture and Print Exhibition,* Oakland Art Museum, Oakland, CA. Received first mention in the *New York Times* (Stuart Preston, "American Graphics").

1955 Daughter Leah Margaret Jones born. **Awarded:** Special Honorable Mention, "Presentation," *Northwest Printmakers International Print Exhibition,* Seattle Art Museum, Seattle, WA; Honorable Mention, "Presentation," California State Fair, Sacramento, CA; 1st Purchase Award, Watercolor, "Red Still Life," *All-California Art Exhibition,* Laguna Beach Art Festival, Laguna Beach, CA; **Solo exhibitions:** Prints, Kalamazoo Art Center, Kalamazoo, MI. **Two-person exhibition:** *Henri Georges Adam and John Paul Jones,* Los Angeles County Museum of Art, Los

Angeles (catalogue with essay by Ebria Feinblatt, illus.) **Group exhibitions:** *Ninth National Print Annual Exhibition,* The Brooklyn Museum, Brooklyn, NY; *Painters of Los Angeles,* The Downtown Gallery, New York, NY; *Bay Printmakers Society 1st National Exhibition of Prints,* Oakland Art Museum, Oakland, CA (catalogue with foreword by John Paul Jones); *Art of the Pacific Coast at the IIIrd Biennial of Sao Paulo, Brazil, United States Section,* Pavilion of the Nations, San Paulo, Brazil and subsequent tour, organized by the San Francisco Museum of Art (catalogue) to Cincinnati Art Museum, Colorado Springs Fine Art Center, San Francisco Museum of Art, Walker Art Center; *California Painting: 40 Painters,* The Municipal Art Center, Long Beach, CA (catalogue, illus.); *Modern Art in the United States: Selections from the Museum of Modern Art, New York,* Tate Gallery, London (catalogue, illus.); *El Arte Moderno en Los Estados Unidos: Selections from the Museum of Modern Art, New York,* Barcelona (catalogue, illus.); *International Invitational Print Exhibition,* Washington University, St. Louis, MO, traveled to the University Gallery, Department of Art, University of Minnesota (catalogue).

1956 Awarded: Sachs-Allen Award, *Boston Printmakers Eighth Annual Exhibition,* Boston Museum of Fine Arts; Purchase Prize, *College Prints 1956,* University Art Club of Youngstown University, Butler Art Institute, Youngstown, OH; Purchase Prize, *All-City Art Festival,* Los Angeles, CA; Print Award, Purchase Prize, *National Print Exhibition,* Michigan State University, East Lansing, MI; Purchase Prize, *Recent Drawings, USA,* Museum of Modern Art, New York, NY; Purchase Prize, "Bride," *Bay Printmakers Second National Print Exhibition,* Oakland Art Museum, Oakland, CA; Purchase Prize, *California State Fair Art Exhibition,* Sacramento, CA; Purchase Prize, "*White Table,*" *15th National Exhibition of Prints Made During the Current Year,* Library of Congress, Washington, D.C.; Honorable Mention, *34th Annual Etching and Engraving Exhibition,* The

Print Club, Philadelphia, PA; Purchase Prize, "White Table," *Annual Watercolor, Drawing and Print Exhibition of the San Francisco Art Association,* San Francisco Museum of Art, CA. **Solo exhibition:** Prints, Oakland Art Museum, Oakland, CA. **Group exhibitions:** *Recent Drawings USA,* The Junior Council of the Museum of Modern Art, New York, NY (catalogue); *Ten Years of American Prints – 1947-1956,* The Brooklyn Museum, Brooklyn, NY (catalogue with essays by Una Johnson); *Drawings – 4,* Felix Landau Gallery, Los Angeles, CA; *Artists of Los Angeles and Vicinity,* Los Angeles County Museum of Art (catalogue), Los Angeles, CA;

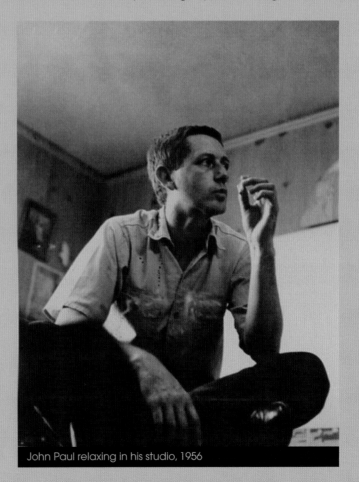
John Paul relaxing in his studio, 1956

Twenty-Eighth International Exhibition, Seattle Art Museum, Seattle, WA (catalogue, illus.); *Contemporary Arts of United States,* Los Angeles County Fair Association, Pomona, CA (catalogue with introduction by Arthur Miller). Jules Langsner mentions Jones in "Art News from Los Angeles," In *Art News;* this is the first of many times Langsner will write about Jones and that Jones will be written about in *Art News.*

1957 Solo exhibition: Laguna Blanca School, Santa Barbara, CA. **Group exhibitions:** *IV Monstra De Pittura Americana, Palazzo del Parco,* Bordighera, Italy (catalogue); *The Printmaker 1450 to 1950,* Achenbach Foundation for Graphic Art, Minneapolis, MN (catalogue); *California Palace of the Legion of Honor,* The California School of Fine Arts, San Francisco (catalogue); *American Paintings – 1945-1957,* The Minneapolis Institute of Art, Minneapolis, MN (catalogue); *California Artists 1957,* San Jose State College, San Jose, CA (catalogue); *29th International Exhibition,* sponsored by Northwest Printmakers, Seattle Art Museum, Seattle, WA (exhibition checklist); *California Drawings,* Long Beach Museum of Art, Long Beach, CA (catalogue).

1958 Awarded: Prize Award and Purchase Award, "Double Portrait," *1958 Annual Exhibition: Artists of Los Angeles and Vicinity,* Los Angeles County Museum /Exposition Park, Los Angeles, CA; Purchase Prize. *National Competitive Print Exhibition,* Pasadena Art Museum, Pasadena, CA. **Solo exhibitions:** Felix Landau Gallery, Los Angeles; Santa Barbara Museum of Art, Santa Barbara. **Group exhibitions:** *The One Hundred and Fifty-Third Annual Exhibition: American Painting and Sculpture,* The Pennsylvania Academy of the Fine Arts, Philadelphia, PA (catalogue), traveled to the Detroit Institute of Arts, Detroit, MI; *The Brooklyn Museum Eleventh National Print Exhibition,* The Brooklyn Museum, Brooklyn, NY (catalogue); *Arts of Southern California – II: Painting,* Long Beach Museum of Art, Long Beach, CA

(catalogue, illus.); *Modern Master Prints,* University of California, Berkeley, CA (catalogue); *2nd National Print Exhibition,* The Silvermine Guild of Artists, Inc., New Canaan, CT. Art historian H. H. Arnason includes Jones in his *Art in America* essay "New Talent in the U.S." (illus.). Acknowledged in University of Southern California professor Jules Heller's book *Printmaking Today: An Introduction to the Graphic Arts* (Holt, New York: the print "Boundary" was reproduced in the book).

1959 Awarded: Grand Prize in Graphics, Art: *USA: 59 – A Force, A Language, A Frontier,* presented by American Art Expositions, The Coliseum, New York, NY; Purchase Award, *Third Pacific Coast Biennial: An Exhibition of Sculpture and Drawings by Artists of California, Oregon and Washington,* a traveling exhibition organized by the Santa Barbara Museum of Art, Santa Barbara, CA. **Solo exhibitions:** Pasadena Museum of Art, Pasadena, CA; Taft Junior College, Taft, CA. **Groups exhibitions:** *Decade in the Contemporary Galleries – 1949-1959,* Pasadena Museum of Art, Pasadena, CA (catalogue, illus.); *Some Summer Surprises,* Felix Landau Gallery, Los Angeles, CA; *The One Hundred and Fifty-Fourth Annual Exhibition: Water Colors, Prints and Drawings,* The Pennsylvania Academy of the Fine Arts, Philadelphia, PA (catalogue); *First National Exhibition of Contemporary American Graphic Art,* sponsored by the Oklahoma Printmakers Society, Art Department, Oklahoma City University, OK (catalogue); *Three Graphic Artists from Three Countries: Mario Avati, Horst Janssen, John Paul Jones – Prints from the Mr. And Mrs. Fred Grunwald Collection,* UCLA Art Galleries, University of California, Los Angeles, CA (catalogue, illus.); *1959 Annual Exhibition: Artists of Los Angeles and Vicinity,* Los Angeles County Museum/Exposition Park (catalogue, illus.), Los Angeles, CA; *Arts of Southern California – V: Prints,* Long Beach Museum of Art, Long Beach, CA (catalogue); *Invitational Print Show,* Hetzel Union Building Gallery, Pennsylvania

State University, University Park, PA. Referenced in Yale professor Gabor Peterdi's book *Printmaking: Methods Old and New* (Macmillan Company, New York; originally published in 1959, revised edition printed 1971).

1960 Appointed John Simon Guggenheim Memorial Fellow in creative printmaking. Traveled and worked in England and Europe. **Awarded:** Prize Award, *Church Art Today*, Grace Cathedral, San Francisco, CA; Honorable Mention. *All-City Art Festival*, Los Angeles, CA.

1961 Awarded: Prize Award, *Los Angeles County Museum Annual*, Los Angeles, CA. **Solo exhibition:** *John Paul Jones: Disegni e Incisinoi,* Galleria Caderio, Milano, Italy.

1962 Received *Tamarind Fellowship*. Made series of small bronze sculptures. **Solo exhibitions:** Arizona State University, Tempe, AZ; *Drawings by John Paul Jones,* Felix Landau Gallery, Los Angeles, CA (monograph with essay by Henry J. Seldis, illus.). **Group exhibitions:** *4 Artists, 4 Directions, 3 Media,* Thorne Hall, Occidental College, Los Angeles, CA (catalogue, illus.); *American Prints Today*, Print Council of America, traveling exhibition. Henry J. Seldis writes the first of several feature articles he will write about Jones for the *Los Angeles Times* ("Jones Show Adds to Artist's Stature"). John Canaday writes a feature article in the *New York Times* ("Art: Prints and Drawings of John Paul Jones"); Canaday will write several other articles and reviews featuring John Paul Jones during his career as head art writer for the *Times*. Other reviews are published in *Arts* and *International Arts* (by Jules Langsner) magazines. A feature article about Jones is published in *Time magazine* ("Haunted House" by Bob Jennings; illus.).

1963 Resigned from UCLA at end of academic year to make art full time. Traveled to Spain and England. Divorced from Charlotte Enger Jones. **Awarded:** Spanish Government Fellowship in conjunction with *Arte de America y Espana* exhibition, Palacio de Velazquez, Madrid, Spain. **Solo exhibitions:** Los Angeles Municipal Art Gallery, Los Angeles, CA; University of New Mexico, Albuquerque, NM; *John Paul Jones: Prints and Drawings, 1948-1963,* Brooklyn Museum, Brooklyn, NY (monograph by Una E. Johnson, illus.); Terry Dintenfass Gallery, New

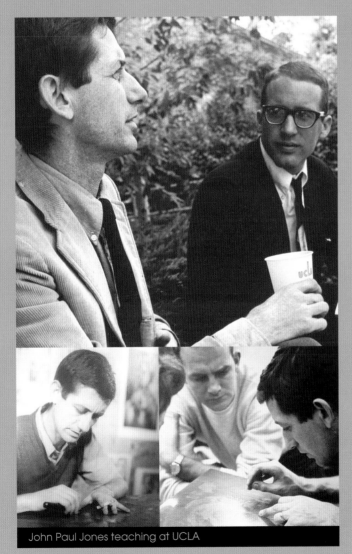

John Paul Jones teaching at UCLA

York, NY; Tweed Gallery, University of Minnesota, Duluth, MN; Sheldon Memorial Art Gallery, University of Nebraska, Lincoln, NE; University of Florida, Gainesville. **Group exhibitions:** *Arte de America y Espana,* Palacio de Velazquez, Madrid, Spain; *Second National Invitational Print Exhibition,* Otis Art Institute, Los Angeles, CA; *Pittsburgh International,* Carnegie Institute, Pittsburgh, PA; The J.B Speed Art Museum, Louisville, KY; Albright-Knox Art Gallery, Buffalo, NY; *American Painters from A to Z,* American Cultural Center, Paris, France; *66th Annual American Exhibition – Directions in Contemporary Painting and Sculpture,* The Art Institute of Chicago (catalogue, illus.), Chicago, IL. Reviews in *Art News* and *Arts International.*

1964 Married Chadlyn Smith. **Solo exhibitions:** *Recent Paintings by John Paul Jones,* Felix Landau Gallery, Los Angeles (monograph, illus.); Garelick's Gallery, Detroit, MI (with Jack Zajac). Featured in Una E. Johnson's book *Twentieth Century Drawings, Part II: 1940 to the Present* (Shorewood Publishers Inc., New York). Henry Seldis writes feature article in *L.A. Times,* "Essential Mystery of Jones Still Evident." First review in *Artforum* (by Curt Opliger).

1965 **Solo exhibitions:** Container Corporation of America, Chicago, IL; Terry Dintenfass Gallery, New York, NY; *John Paul Jones: Painting and Sculpture, 1955-1965,* Los Angeles County Museum of Art, Los Angeles, CA (monograph with essay by Henry T. Hopkins, illus.); Brook Street Gallery, London; *Graphics—John Paul Jones,* Champlain Gallery, Harpur College, State University of New York, Binghamton, NY (catalogue, illus.). **Group exhibitions:** *The Inauguration Exhibition,* San Jose State College, San Jose, CA; Arkansas Art Center, Little Rock; *California Printmakers,* San Francisco Art Institute, San Francisco, CA; *A Decade of American Drawings 1955-1965,* Whitney Museum of American Art, New York, NY (catalogue, illus.). Reviews in *Art News* and *Art in America* and by Henry Seldis in the *Los Angeles Times* and Fidel Danieli in *Artforum.*

Chad and Megan Jones, 1966

1966 Daughter Megan Hart Jones born. **Group exhibition:** *American Painting,* Virginia Museum, Richmond, VA. Mention and illustration in *Art in America* feature article "Los Angeles: The Way You Look at It" (by Occidental College professor Constance M. Perkins; she is also known for commissioning Richard Nuetra to design her Los Angeles home).

1967 **Solo exhibition:** Landau-Alan Gallery, New York, NY; *John Paul Jones,* Felix Landau Gallery, Los Angeles, CA (monograph with essay by Eugene N. Anderson, illus.). **Group exhibitions:** *Pittsburgh International,* Carnegie Institute, Pittsburgh, PA; *The Artist as His Subject,* an exhibition circulated by the Museum of Modern Art, NY. Reviews by John Canaday in *New York Times* and Henry Seldis in the *Los Angeles Times;* also a review in *Art News.*

1968 Group exhibitions: *Works on Paper*, Virginia Museum, Richmond, VA; *Drawings USA/'68*, St. Paul Art Center, St. Paul, MN; *Art in Politics*, Lytton Center of Visual Arts, Los Angeles, CA; *The Human Figure, Recent Images*, Scripps College, Claremont, CA. Mentioned in *Los Angeles Times* reviews of the Lytton Center (Henry Seldis; illus.) and Scripps College (William Wilson) exhibitions.

1969 Joined faculty at University of California at Irvine (UCI). Solo exhibition: Landau-Alan Gallery, New York. Group exhibitions: Northern Illinois University, DeKalb, IL; *Tamarind: Homage to Lithography*, Museum of Modern Art, New York, NY (catalogue, preface by William Lieberman; introduction by Virginia Allen; illus.); *The New Vein – Europe, International Art Program*, National Collection of Fine Arts, Smithsonian Institution, Washington, D.C. Review by John Canaday, *New York Times*; also reviews in *Art News*, *Arts*, and *Art International* magazines.

1970 Solo exhibitions: La Jolla Museum of Contemporary Art, La Jolla, CA (catalogue essay by Josine Ianco-Starrels, illus.); *John Paul Jones-Watercolors*, Felix Landau Gallery, Los Angeles. Group exhibitions: *American Painting*, Virginia Museum, Richmond, VA; *Graphics 71 West Coast, USA*, University of Kentucky, Lexington, KY. Review by Henry Seldis, *Los Angeles Times* (Landau exhibition).

1971 Group exhibitions: *Made in California*, University of California, Los Angeles, CA; St. Paul Museum of Art, MN; *Primera Biennal Americana de Arte Graphica*, Cali, Colombia. Review of La Jolla Museum exhibition (exhibition opened in 1970 but closed in 1971) by Henry Seldis, *Los Angeles Times*. Included in *The Tamarind Book of Lithography: Art and Techniques* (by Garo Z. Antreasian, with Clinton Adams, Harry N. Abrams, Inc., New York).

1972 Solo exhibition: Bay Cities Jewish Center Gallery, Santa Monica, CA. Group exhibitions: *80 Prints*, Purdue University, Lafayette, IN; *18th National Print Exhibition*, The Brooklyn Museum, Brooklyn, NY.

1973 Solo exhibitions: Jodi Scully Gallery, Los Angeles, CA; The Graphics Gallery, San Francisco, CA. Group exhibitions: California Palace of Legion of Honor, San Francisco, CA; *National Print Show*, Bradley University, Peoria, IL. Review by Henry Seldis, *Los Angeles Times*.

1974 Solo exhibitions: Charles Campbell Gallery, San Francisco, CA; *John Paul Jones—Thirty Monotypes*, Boehm Gallery, Palomar College, San Marcos, CA. Group exhibition: *Artistas de la Costa Occidental Norteamericana*, Museo de Bellas Artes, Caracas, Venezuela. Review in *Artweek*.

1975 Started series of collages that continued intermittently into 1980. Solo exhibitions: Jodi Scully Gallery, Los Angeles, CA; University of California, Riverside, CA; San Jose Art Museum, San Jose, CA; Thorn Hall, Occidental College, Los Angeles, CA. Group exhibition: *University of California, Irvine, 1965-75*, La Jolla Museum of Contemporary Art, La Jolla, CA (catalogue, illus.). Review by Henry Seldis, *Los Angeles Times*.

1976 Sabbatical (academic year 1976-77), lived and traveled in Spain for six months and Wales for three months. Awarded: Regents' Summer Fellowship in Creative Arts, University of California. Group exhibitions: *Gallery Group Show*, Jodi Scully Gallery, Los Angeles, CA; *California Print Invitational 76*, Golden West College, Huntington Beach, CA; *American Artists in Britain*, University of Hull and University of Leeds, England.

1977 Group exhibitions: *California Artists: Works on Paper*, Basel Art Fair, Basel, Switzerland; *Great Ideas – Container Corporation of America Collection*, California Museum of Science and Industry, Los Angeles, CA; *California Figurative Painting*, Tortue Gallery, Santa Monica, CA; *Made in the USA – American Artists*, Cologne International Art Fair, Cologne, Germany; *Southern California 100*, Laguna Beach Museum of Art, Laguna Beach, CA; *American Art from the Last Three Decades*, Santa Barbara Museum of Art, Santa Barbara, CA. Review by William Wilson, *Los Angeles Times*.

Megan and John Paul, 1978

1978 Started to make sculpture out of wood. **Solo exhibition:** *John Paul Jones: Paintings, Drawings and Collages*, Peppers Art Gallery, University of Redlands, Redlands, CA. **Group exhibitions:** *Gallery Artists*, Mekler Gallery, Los Angeles, CA; *Printmakers Invitational*, Bevier Gallery, Rochester Institute of Technology, Rochester, NY; *10th Annual Printmaking West Exhibition*, Utah State University, Logan, UT; *A Summer Exhibition – California State Capitol Building, Selected Works from the California State Fair Collection*, Sacramento, CA; *Tribute to Henry Seldis*, Laguna Beach Museum of Art, Laguna Beach, CA. Review in *Artweek*.

1979 Group exhibition: *Our Own Artists – Art in Orange County*, Newport Harbor Art Museum, Newport Beach, CA (catalogue with essays by Betty Turnbull, Victoria Kogan and Thomas H. Garver, illus.).

1980 Separated from wife Chadlyn Jones. **Awarded:** Tamarind Fellowship, Albuquerque, NM; created pivotal edition of "Paradise Gate" prints. **Two-person exhibition:** *David Romeo and Friend: John Paul Jones and David Romeo*, Saddleback College, Mission Viejo, CA (catalogue, illus.). **Group exhibitions:** *The Collector's Eye*, Laguna Beach Museum of Art, Laguna Beach, CA; *Printmaking: Processes/ Innovations*, Museum of North Orange County, Fullerton, CA. Review in *Artweek*. Included in Una E. Johnson's book *American Prints and Printmakers: A Chronicle of over 400 Artists and their Prints from 1900 to the Present* (Doubleday).

1981 Group exhibitions: *Southern California Artists: 1940-1980*, Laguna Beach Museum of Art, Laguna Beach, CA (catalogue with introduction by Maudette Ball, illus.); *Los Angeles Prints 1883-1980 – Part II*, Los Angeles County Museum of Art, Los Angeles, CA (catalogue with essays by Ebria Feinblatt and Bruce Davis, illus.); *Three Views at Space*, Space Gallery, Los Angeles, CA; *Contemporary American Prints & Drawings 1940-1980*, National Gallery of

Art, Washington, D.C. (catalogue); *Tony Delap, John Paul Jones, Gifford Myers,* Fine Arts Gallery, University of California, Irvine, CA; *Professors' Choice,* Montgomery & Lang Galleries, The Claremont Colleges, Claremont, CA; *Lithography IV,* University of New Mexico Art Museum, Albuquerque, NM.

1982 Solo exhibitions: *John Paul Jones—The Man Between: wood pieces, collages and drawings,* Cerro Coso Community College, Ridgecrest, CA (catalogue with essays by Donald Rosenberg and Glen Banister, illus.); Turnbull, Lutjeans, Kogan

Gallery, Costa Mesa, CA. **Group exhibitions:** *The 1st Art Exhibit,* Gensler & Associates/Architects, Irvine, CA; Rio Hondo College Art Gallery, Whittier, CA; *The American Vision: Printers' Prints 1932-1982,* Anderson & Anderson Master Prints and Drawings, Loveland, CO (catalogue). Review by Robert L. Pincus in *Los Angeles Times* and review in *Artweek.*

1983 Married Peggy Ann Easley. **Group exhibitions:** *Saddleback College Art Gallery: 5 Years of Art 1978-1983,* Mission Viejo, CA; *International Printmaking Invitational,* California State University, San Bernardino,

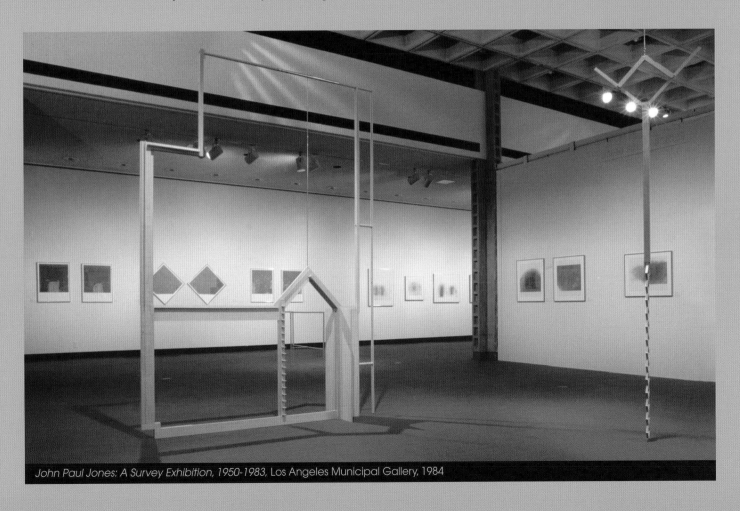

John Paul Jones: A Survey Exhibition, 1950-1983, Los Angeles Municipal Gallery, 1984

CA (catalogue with introduction by Connor Everts, illus.); *Vintage California*, Turnbull, Lutjeans, Kogan Gallery, Costa Mesa, CA; *Irvine Collects Contemporary Art*, Irvine Fine Arts Center, Irvine, CA. Review by Suzanne Muchnic, *Los Angeles Times*.

1984 Solo exhibitions: *John Paul Jones: A Survey Exhibition, 1950-1983*, Los Angeles Municipal Art Gallery, Los Angeles, CA (catalogue with essay by Susan C. Larsen, illus.); School of Fine Arts Gallery,

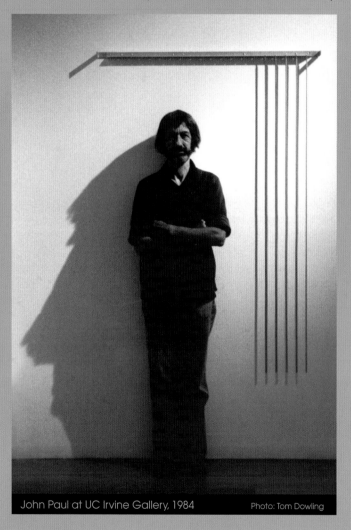

John Paul at UC Irvine Gallery, 1984 Photo: Tom Dowling

Bowling Green State University, OH; *John Paul Jones-Dreams and Lies in the Gatekeeper's House*, Fine Art Gallery, University of California, Irvine, CA (catalogue with essay by Melinda Wortz, illus.). **Group exhibitions:** *Drawings – A Personal Vision: Works by Orange County Artists*, Mills House Art Gallery, Garden Grove, CA; *Orange County Sculpture: Source and Process*, Guggenheim Gallery, Chapman College, CA; *Lithographs from Tamarind Institute*, Governor's Gallery, State Capitol, Santa Fe, NM; *In the Form of Furniture*, Irvine Fine Arts Center, Irvine, CA; *Sculpture Acquisition Program: 1984-1985*, Chapman College, CA (catalogue, illus.); *In All Dimensions*, Turnbull, Lutjeans, Kogan Gallery, Costa Mesa, CA. Review in Images and Issues magazine; mention in *Los Angeles Times*. Included in the books *The Art of California: Selected Works from the Collection of the Oakland Museum* (Christina Orr-Cahall, Chronicle Books) and *American Printmaking: A Century of American Printmaking, 1880-1980* (James Watrous, University of Wisconsin Press).

1985 Traveled to Europe. **Group exhibitions:** *Western States Print Invitational Exhibition*, Portland Art Museum, Portland, OR; *Fifty Artists – Fifty Painters*, University Art Museum, University of New Mexico, Albuquerque, NM (catalogue with preface by Clinton Adams); *Tamarind: 25 Years*, University Art Museum, University of New Mexico, Albuquerque, NM (catalogue with introduction by Marjorie Devon, forewords by Clinton Adams and June Wayne, and essay by Carter Ratcliff, illus.).

1986 Awarded; "Outstanding Contribution in the Arts" award, Orange County Arts Alliance. Made last editioned print. **Group exhibitions:** *Self-Portraits by American Artists in Prints*, Jane Haslem Gallery, Washington, D.C.; *The Faculty Exhibition*, Art Gallery, University of California, Irvine, CA (catalogue titled *The University of California, Irvine Fine Arts Gallery, 1985-1986, 20th Anniversary*, with introduction and essays by Melinda Wortz, illus.).

John Paul's Studio at UCI

1987 Divorced Peggy Ann Jones. Daughter Megan Hart Jones dies. Granddaughter Kristen Jones born. **Solo exhibitions:** *John Paul Jones,* Arizona State University, Tempe, AZ (catalogue with commentary by Rudy H. Turk, illus.); *John Paul Jones; Altered Sticks,* The Works Gallery, Long Beach, CA. **Group exhibitions:** *Cross Grain: A Survey in Wood,* Muckenthaler Cultural Center, Fullerton, CA.

1988 Included in *Dictionary of Contemporary American Artists* (5th ed.) (edited by Paul Cummings, St. Martin's Press).

1989 Sold large body of artwork to Nancy Noble and Dennis Hudson of Irvine, California, in preparation for retirement and moving to Ashland, Oregon.

1990 Retired from UCI and moved to Ashland, Oregon. Began working on completing construction

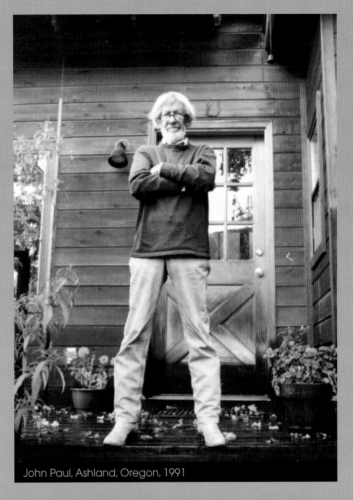
John Paul, Ashland, Oregon, 1991

of house. **Solo exhibition:** *The Mirror in the Man: The Constant Image,* Art Institute of Southern California, Laguna Beach, CA; *Top of the Crop: 10-Year Pick,* Irvine Fine Arts Center, Irvine, CA. Reviews of both exhibitions by Cathy Curtis in *Los Angeles Times.*

1991 Using small scraps of lumber from the construction of the house, began a series of woodblock prints. Finished proofs on tracing paper in 1992 but never completed as a finished set of prints. These were the last works on paper.

Began a series of outdoor sculptures (these sculptures were left on the property when it was later sold).

1992 Susanne Nestory became Jones' companion and moved to his Ashland home. Began series of 250 drawings that continued into 1996. **Group exhibition:** *Director's Choice*, Arizona State University Art Museum, Tempe, AZ.

1993 Group exhibitions: *Irvine Collects: 10 Years After*, Irvine Fine Arts Center, Irvine, CA; *Facing West: Art in Laguna Beach After 1945*, Laguna Art Museum, CA.

1995 Made last outdoor sculpture in the summer. **Group exhibition:** *From Behind the Orange Curtain*, Muckenthaler Cultural Center, Fullerton, CA (catalogue, illus.).

1996 Completed series of drawings—last formal series of drawings. Began series of acrylic paintings on canvas (26 paintings) and on paper (100 paintings) that continued through September 1997. **Solo exhibition:** *Einstein's Cross and Other Lies*, Merging One Gallery, Santa Monica, CA. **Group exhibition:** *Index 17: California Artists*, Merging One Gallery, Santa Monica, CA.

1997 Completed last paintings: the last paintings were all done on paper. After July, never again leaves house. **Group exhibitions:** *Organic Inter-Reactions of a Perfect Order, Inaugural Exhibition*, RTKL International Exhibit Gallery, Los Angeles, CA; *A Hotbed of Advanced Art—Four Decades of Visual Arts at UCI*, The Art Gallery, University of California, Irvine, CA (catalogue, illus.).

1998 Made one last group of sculptures in early 1998—these were the last works. Spent days sitting, reading, and listening to music. Daughter Leah visited in October.

John, Ashland, Oregon, 1999

1999 Died at home in Ashland, Oregon, Saturday, September 25. **Solo exhibition:** *On the Edge of Time*, Fullerton College Art Gallery, Fullerton, CA (October 13 through November 11).

2000 Included in the book *Tamarind: Forty Years: A Survey History of Tamarind Workshop* (University of New Mexico Press, 2000).

2004 Solo exhibition: Square Blue Gallery, Costa Mesa, CA. **Group exhibition:** *Leonard Edmondson vs. Werner Drewes: Intaglio vs. Relief*, Tobey Moss Gallery, Los Angeles, CA.

2007 Group exhibition: *Moving Past Present*, Claremont Graduate University, Claremont, CA.

2009 Solo exhibition: *John Paul Jones: A Retrospective*, Main Gallery, California State University, Fullerton, CA, and The Frank M. Doyle Arts Pavilion, Orange Coast College, Costa Mesa, CA

This chronology was organized by Mike McGee and was based upon notes by Dennis Hudson and Susanne Nestory, public records, and research by Julie Perlin-Lee.

Public Collections

Anderson Art Gallery, Cerro Coso Community College, Ridgecrest, California

Arizona State University Art Museum, Nelson Fine Arts Center, Tempe, Arizona

Ball State University, Muncie, Indiana

Bibliothèque Nationale, Paris, France

Blanden Memorial Museum, Fort Dodge, Iowa

Bradley University, Peoria, Illinois

The Brooklyn Museum, Brooklyn, New York

California State Fair Collection, Sacramento, CA

California State University Fullerton, Fullerton, CA

Capitol Records, Hollywood, California

Chapman University, Orange, California

Container Corporation of America, Chicago, Illinois

Coos Art Museum, Coos Bay, Oregon

Dallas Museum of Fine Art, Dallas, Texas

Des Moines Art Center, Des Moines, Iowa

Fine Arts Council of Pakistan, Karachi, Pakistan

The Fine Arts Museums of San Francisco, Achenbach Foundation for Graphic Arts, San Francisco, California

Fullerton College Art Gallery, Fullerton, California

Grunwald Center for the Graphic Arts, University of California, Los Angeles, Los Angeles, California

Hirshhorn Museum and Sculpture Garden, Smithsonian Institution, Washington, D.C.

Honolulu Academy of Arts, Honolulu, Hawaii

Iowa State Fair Collection, Des Moines, Iowa
Iowa Wesleyan College, Mt. Pleasant, Iowa

Joslyn Art Museum, Omaha, Nebraska

Jundt Art Museum, Gonzaga University, Spokane, Washington

Kalamazoo Institute of Arts, Kalamazoo, Michigan

Krannert Art Museum, University of Illinois, Champaign, Illinois

Laguna Art Museum, Laguna Beach, California

The Library of Congress, Washington, D.C.

Los Angeles County Museum of Art, Los Angeles, California

Marianna Kistler Beach Museum of Art, Kansas State University, Manhattan, Kansas

Michigan State University, East Lansing, Michigan

Minnesota Museum of American Art, St. Paul, Minnesota

Munson-Williams-Proctor Arts Institute, Utica, New York

Museum of Contemporary Art San Diego (formerly La Jolla Museum of Contemporary Art), La Jolla, California

Museum of Modern Art, New York, New York

National Gallery of Art, Washington, D.C.

The Nelson-Atkins Museum of Art, Kansas City, Missouri

New York City Public Library, New York, New York

Newcomb-Tulane College, Tulane University, New Orleans, Louisiana

Norton Simon Museum of Art, Pasadena, California

Oakland Museum of California (formerly The Oakland Museum), Oakland, California

Orange County Museum of Art (formerly Newport Harbor Art Museum), Newport Beach, California

Otis College of Art and Design (formerly Otis Art Institute), Los Angeles, California

Palomar College, San Marcos, California
San Diego Museum of Art, Balboa Park, San Diego, California
San Francisco Museum of Modern Art, San Francisco, California

Santa Barbara Museum of Art, Santa Barbara, California

Seattle Art Museum, Seattle, Washington

Sheldon Museum of Art (formerly Sheldon Memorial Art Gallery), University of Nebraska, Lincoln, Nebraska

Smithsonian Institution, Fine Arts Division, Washington, D.C.

University Art Museum, California State University, Long Beach

University of Calgary, Calgary, Alberta, Canada

University of Florida, Gainesville, Florida

Continued

University of Illinois, Springfield, Illinois

University of Iowa, Iowa City, Iowa

University of Louisville, Louisville, Kentucky

University of Nebraska, Lincoln, Nebraska

University of Northern Iowa, Cedar Falls, Iowa

University of Texas at El Paso, El Paso, Texas

University of Wisconsin, Madison, Wisconsin

Victoria and Albert Museum, London, England

Walker Art Center, Minneapolis, Minnesota

Yale University Art Gallery, New Haven, Connecticut

Youngstown University, Youngstown, Ohio

Curatorial discussion, Cal State University Fullerton

Credits

Published in conjunction with the exhibition
John Paul Jones – A Retrospective and in collaboration
with CSU Fullerton Main Art Gallery and
Frank M. Doyle Arts Pavilion, Orange Coast College

CSU FULLERTON MAIN ART GALLERY
800 N. State College Blvd
Fullerton, CA 92834-6850
www.fullerton.edu/arts/art

ORANGE COAST COLLEGE
FRANK M. DOYLE ARTS PAVILION
2701 Fairview Road
Costa Mesa, CA 92626
www.orangecoastcollege.edu

Installation April 2009, CSUF

ACKNOWLEDGEMENTS
CAL STATE UNIVERSITY FULLERTON
Dean, College of the Arts: Jerry Samuelson
Chair, Department of Art: Larry Johnson
Director, Main Art Gallery: Mike McGee
Assistant to the Director: Marilyn Moore
Gallery Technician: Martin Lorigan
Research assistances:
Jennifer Frias, Julie Perlin-Lee and Danielle Susalla.
Installation Assistants: David Brokaw, Maria Guadalupe
Hernandez, and Kimberly McKinnis
Exhibition Poster/Announcement Design: Debra Barba

ORANGE COAST COLLEGE
Dean, Visual and Performing Arts: Joe Poshek
Director, Foundation: Doug Bennett
Director, Frank M. Doyle Arts Pavilion: Andrea Harris-McGee
Gallery Technician: Matthew William Miller
Installation Consultants: Jennifer Irini and Cornelius O'Leary
Assistant to the Director: Eric Stone
Additional OCC support: Bebe Bach, Rich Pagel, Julia
Clevenger, Paul Wisner, David Michael Lee and Tom Dowling

COAST COMMUNITY COLLEGE BOARD OF TRUSTEES
Jim Moreno, Lorraine Prinsky, Jerry Patterson,
Mary L. Hornbuckle, Walter G. Howald and Student Trustee.
OCC Interim President, Denise Whittaker and Chancellor,
Ding-Jo Currie.

**SPECIAL THANKS to the collectors and institutions who
supported this publication and exhibition**
Susanne Nestory, Dowling Family, Nancy Noble and
Dennis Hudson, Fullerton College, Chapman College,
Laguna Art Museum, Landau Family, Maggi Owens,
Patricia Turnier, Bret Price family and David Price family.

EXHIBITION SPONSORS
Cal State Fullerton Art Alliance
Life Members: Robert Cugno and Robert Logan;
Benefactors: Lee and Nick Begovich,
Gene and Shirley Laroff; Donor: Joyce McCleery;
Patrons: Floyd and Maxine Allen, Dr. Joseph and
Voiza Arnold, Lois Austin, Renaud and Martha Bartholomew,
Gary and Lynn Chalupsky, Jean Fischer, Nancy Fix,
Leonard and Sylvia Garber, Bill and Millie Heaton,
Drs. Russell and Glory Ludwick, Peggy Martin,
Charlotte Oliva, Dr. Martin and Suzanne Serbin,
Margaret Starks, David and Cathrynn Thorsen,
Carole Wakeman, Loraine Walkington and Chiki Yamamoto;
Cal State Fullerton Department of Art and
Associated Students

FRIENDS OF JOHN PAUL JONES, CONTRIBUTORS
Mary Adams, Slater Barron, Jill Beck, Lois Benes, Janet Lusk
Hughes, Paul Darrow, Tony and Kathy Delap, Tom Dowling,
Dennis Hudson, Janet Lusk Hughes, Jennifer Irani, Shawn
Jones and Barbara Johnson, Gifford Myers, Nancy Noble,
Cornelius W. O'Leary, Suzanne Rosentsweig, Judy and Paul
Tichinin, Pam Toomey, and Dr. Jan and Linda Young

EXHIBITION DESIGN STUDENTS
Alexandra Duron, Jennifer Frias, Krystal Glasman,
Loriann Hernandez, Sarah Kuklick, Lilia Lamas,
Elizabeth Little, Trina Moreno, Jillian Nakornthap,
Jeffrey Rau, Heather Richards, Heather Rose,
Lynn Stromick and Elizabeth C. Tallman

PUBLICATION
Curator: Mike McGee
Publication Design Consultant: Gary Martin
Publication and Exhibition Coordination:
Andrea Harris-McGee
Editor: Sue Henger
Installation Photographs for CSUF: M.O. Quinn
Installation Photographs for OCC: Eric Stoner
Artwork Documentation Photographs: Gene Ogami

Printer: Permanent Printing Limited, Hong Kong, China
Typeface: Avant Garde

Publication © 2009 CSU Fullerton Main Art Gallery and
OCC Frank M. Doyle Arts Pavilion

Artwork © John Paul Jones Estate

*The artworks presented in the exhibition were not
all reproduced in this publication, and some of the
artworks reproduced in this publication were not
included in the exhibition.*

ISBN: 978-0-935314-75-5